Our Hero

Our Hero

Superman on Earth

Tom De Haven

YALE UNIVERSITY PRESS NEW HAVEN & LONDON

Set in Janson type by Tseng Information Systems, Inc.
Printed in the United States of America.

Library of Congress Cataloging-in-Publication Data
De Haven, Tom.
Our hero : Superman on earth / Tom De Haven.
p. cm. — (Icons of America)
Includes bibliographical references and index.
ISBN 978-0-300-11817-9 (cloth : alk. paper)
1. Superman (Fictitious character) I. Title.
PN6728.S9D3 2010
741.5'973—dc22 2009018206

A catalogue record for this book is available from the British Library.

This paper meets the requirements of ANSI/NISO Z39.48-1992
(Permanence of Paper).

10 9 8 7 6 5 4 3 2 1

Icons of America
Mark Crispin Miller, Series Editor

Icons of America is a series of short works by leading scholars, critics, and writers on American history, or more properly the image of America in American history, through the lens of a single iconic individual, event, object, or cultural phenomenon. Other titles in the series include:

To Santa
still the same

Contents

Acknowledgments

I would like to thank Art Spiegelman for suggesting me for this project, and the legion of writers who have tackled Superman the Icon before me, especially Thomas Andrae, Michael Citron, Tom Crippen, Les Daniels, Michael Eury, Jules Feiffer, Michael Fleisher, Robert C. Harvey, Gerard Jones, Jake Rossen, Bruce Scivally, Jim Steranko, James Vance, Bradford C. Wright, and Craig Yoe; without their trailblazing, even groundbreaking, work, *Our Hero* would not have been possible. To Nicky Brown I am much indebted for assistance in writing about her remarkable grandfather, Major Malcolm Wheeler-Nicholson.

For their suggestions, tips, referrals, and support, many thanks as well to John Beckman, Laura Browder, Russell Dunn, Steve Dunn, Jackie Estrada, Michael T. Gilbert, Elizabeth Hand, Tom Inge, Christopher Irving, Elizabeth Kaplan, Batton Lash,

Acknowledgments

Amanda Matetsky, Harry Matetsky, Eric Reynolds, Mark Svensson, Roy Thomas, and Kristy Valenti.

Finally, I want to express my deep gratitude to the Eastern Frontier Educational Foundation for offering me summer residencies on Norton Island, Maine ("the coolest place on earth"), where much of this essay was drafted, and to my great and generous friend Faye Prichard (mayor of Ashland, Virginia, "the center of the universe") for her editorial input and bibliographic expertise.

Our Hero

Over a span of three weeks in late spring 2006, I spent some part of almost every day on the telephone being asked and answering questions about Superman, Superman, Superman. Mostly it was newspapers and press services calling me, but a few radio stations did too, even a couple of podcasts. *Superman Returns*, the Bryan Singer movie starring Brandon Routh, was set to open in ten bazillion theaters worldwide, and American media were generating feature stories galore in breathless, complicit anticipation. But why call me for some (hopefully) pithy and (possibly) illuminating commentary about the character and the upcoming movie (about which I personally knew nothing)? Because half a year earlier, Chronicle Books had published a novel I'd written about Superman, my version of Superman, and that, somehow, qualified me as an authentic "Superman expert." Flattering to be so considered, but not really the case. *It's Superman!* had nothing to do with Singer's film, or with the *Smallville* television program, or with the Warner Brothers animated cartoon series, or even, for that matter, with the monthly Superman comic books. With the permission and approval of DC Comics (but without any input or strictures), I'd set my story during the Great Depression and placed Superman back in his original 1930s context—his first appearance was in *Action Comics* number 1, published in late

spring 1938. The fun for me had been to imagine the Man of Steel physically and morally, even politically, as he'd been portrayed at the start by Jerry Siegel and Joe Shuster, the two teenagers from Cleveland who created him. Written in noirish meter without *too* much kidding around, it was (yet another bildungsroman) about the farm boy Clark Kent once he discovers he's stronger than anyone else. And can fly. *It's Superman!* had been widely reviewed, so my name kept popping up during database searches for Superman authorities.

Although I don't enjoy being interviewed and I'm not savvy at it—I tend to meander—I almost never (okay: I never) turn down a request for one. Who doesn't like seeing his name in print or hearing her prerecorded voice on the radio, even when half the time you come off sounding like a real knucklehead? Besides, it's self-promotion. I could sell a few books, maybe. It's a theory, at least.

What I kept being asked pretty much boiled down to three questions, usually asked in the same order. Why has Superman lasted for almost seventy years? Can you explain his appeal? Does he still matter in the twenty-first century?

For the first two questions I had decent answers, I thought, despite their sounding canned by the last few interviews. Why has Superman lasted? To begin, he has the solid advantage of being the first comic book superhero. Cachet right there—no? But really, it's the premise. You can't beat it. Doomed planet, sole survivor, secret identity, Earth's mightiest hero. Beautiful. And

Brandon Routh, skinny Man of Steel, in Bryan Singer's *Superman Returns*, 2006 (PhotoFest Digital, © DC Comics)

its simplicity has enabled hundreds of writers (comics writers, screenwriters, songwriters, librettists, poets, novelists, bubble-gum-card miniaturists) working over a period of seven decades to dream up tens of thousands of Superman narratives.

Superman is forever a work in progress, changing, sometimes subtly, other times radically, but normally (not always, but normally) in ways that have kept him popular, to greater or lesser degrees, for several generations. At the same time, certain parts of his makeup—his essence, the crux of him—have never altered. Or when they have, corrections soon have been made, his integrity reconfirmed.

No matter the incarnation, Superman is a hardworking guy who gets things done. Whatever he puts his mind to. He's John Henry without the steam-drill competition and the fatal heart attack. As Tom Crippen, writing in the *Comics Journal*, put it, "Superman isn't there to live out our fantasies. . . . Half the time he's doing something you yourself would not want to do. But when he performs one of his feats, he's making a point on our behalf: that the universe is still our size. Existence is *so* built to our scale" ("Big Red Feet," 171).

In the 1930s Superman was Tom Joad in aerialist's tights: a gadfly, a caped vigilante, a working-class warrior fighting for better and more equitable social conditions. In the 1940s he became a personification of the American fighting spirit. Although in the comic books he by and large sat out World War II, somehow Superman emerged from it a totem of national indomitability,

enterprise, and victory. (The posterlike—*recruiting*-posterlike—comic book covers that showed him hoisting the Stars and Stripes or balancing a bald eagle on his forearm no doubt had much to do with that.) During the 1950s and '60s he seemed, despite being freighted with more and more superpowers, far less like a force of nature and more like, well, your favorite uncle—affable, available, a little bit melancholy, but just a big old kid at heart. (In the comic books, that is. On television he was George Reeves, maybe not your *favorite* uncle—too scowly—but surely the most capable one, the guy who would show up at your house grumbling a little and fix the furnace when your dad didn't have a clue.) In the 1970s Superman slimmed down, like Schwarzenegger after steroids, and was suddenly a Baby Boomer in robust early maturity. (And in the movies he was, indelibly, Christopher Reeve.) In the 1980s—

There, or right around there, I usually was interrupted. Why didn't I just go ahead and *explain his appeal?*

His appeal. Okay. Start with this: Superman is an immigrant, which gives him American cred instantly and automatically. But he's also the ultimate immigrant. The Patron Saint of immigrants. Superman (or baby Kal-El, his birth name) didn't just cross steppes and continents, borders and oceans to get here, he crossed the universe! (Come to think of it, he's also an *illegal* immigrant.)

Superman happens to be an orphan as well, and the orphan is a pretty fraught character type, his plight and opportunity a

recurring theme in everything from tall tales and folk ballads to children's literature and literary fiction. Popular fiction, too, for that matter. The orphan is charged with creating her own identity, often from scratch; the orphan either has none, or loses all, of his social status; the orphan prizes self-reliance, and lives self-reliantly.

But Superman isn't a *mere* orphan; he is (at least in the original and "classic" version) a *double* orphan, having lost two sets of parents, first Kryptonian, then Kansan. Nobody showed him how to change the course of mighty rivers or bend steel in his bare hands; the poor kid had to learn it all by himself.

Then there's the matter of mobility. American exceptionalism would have it that we don't end up in the same place we started, and is there a more basic national fantasy, from James Fenimore Cooper through Bruce Springsteen, than the imperative to pull up stakes, hit the road, and light out—*to go and go now?* Who is more unfixed, unfettered, or freer, than a man who can fly?

And of course I couldn't not mention Superman's religious, or parareligious, trappings: savior from the sky, messiah from heaven, *looks* human but *isn't*. The Christian symbolism. *And* the Jewish. Moses in the reeds, all of that.

I had good answers to the first two standard questions; glib ready-mades, but still pretty good. Third question, though? Always gave me trouble. Does Superman still matter in the twenty-first century? Matter. Matter *how?* Superman's name, his image, his Big-S graphic, even his logo are recognized by practi-

cally everyone on Earth, and his unalterable baggage (Krypton/ Kents/Metropolis/Lois/Luthor/*Daily Planet*) remains an effortlessly retrievable part of our shared cultural knowledge. Comic books featuring Superman continue to sell—nowhere near the number of copies they once did, but at three bucks a pop they still make money. *Smallville* is a multiseason hit, one of the biggest in television syndication, and Warner Communications hardly would have burned through two hundred million dollars bankrolling and marketing a movie about him if the company wasn't confident that there existed a large audience, a worldwide audience, eager to see him back in action. So yes, Superman still matters—that way. As a lucrative property, an aggressively protected trademark, a dependable, familiar entertainment franchise.

But *matters*-matters? Matters as something emotionally powerful, as a signifier of virtues and qualities we automatically profess to esteem, as an avatar of American-ness? Or matters the way, for example, *The Simpsons* does now, or Batman or Spider-Man or Indiana Jones—as both a cultural touchstone and a meaningfully coded tile in the national mosaic? Does Superman still matter in any of those ways? His anima, drive, and motives, let's face it, seem fundamentally out of sync: he's not alienated, he airs no grievances, and he doesn't seek vengeance. (While discussing John Ford's *The Searchers* one Sunday in the *New York Times*, the film critic A. O. Scott wrote that "the monomaniacal quest for vengeance undertaken by a lone hero at odds with the society he's expected to protect: it's sometimes hard to think of a movie from

the past 30 years from *Taxi Driver* to *Batman Begins* that *doesn't* take this theme." Well, there were always the Superman movies.)

Despite his omnipresence, Superman looked to me suspiciously like a relic, sole survivor not only of Krypton, but of a USA where truth, justice, and the American way were unambiguous concepts, not in the least ironic or slippery. In the civilization of You Tube, Facebook, Grand Theft Auto, dogmatic politics, checkbook justice, and an inexhaustible fascination with creepy athletes and detoxing celebrity blondes, *could* Superman possibly matter in ways he once did? Or was he now, and from now on, essentially a blue-red-and-yellow cash cow/Boy Scout that kicked some ass in fan-driven monthly comic books and the occasional expensive movie?

Whenever I was asked during an interview whether Superman still mattered "today," I hesitated—how should I answer this?— but then always took the easy way out: of *course* he still matters, I said, even if characters like Batman and Spider-Man are currently more popular, and speak in more compelling ways to contemporary audiences—even so, for as long as we value kindness for its own sake, fair play, ingenuity, versatility, tolerance, altruism, and honesty, Superman's pride of place in the pantheon of American mythic heroes is fully guaranteed. That's what I said, every time. In so many words. Then I'd hang up the phone feeling not only like an unpaid shill for Warner Brothers but like the world's most clueless cornball. And a total bullshitter. "As long as we value kindness for its own sake." Oh, please.

2

Weeks later that summer, after the interviews ended, the newspaper stories ran, the taped radio programs were broadcast, and *Superman Returns* opened to generally mediocre reviews (I didn't see it myself till the following September; I thought it was okay; fundamentally dumb, but okay), I was living on a small island off the coast of northern Maine. I'd gone to an artists colony there to work on a novel, a manuscript I'd put aside two and a half years earlier to write *It's Superman!* It felt good to be finished with the Man of Steel.

One morning I volunteered to help with the laundry and grocery shopping on the mainland. Several of us—writers, musicians, painters, and sculptors—drove from Jonesport to Machias, and between waiting for the wash to be done at the laundromat and then heading off to the supermarket, I had an hour to kill, so I wandered around town, found a thrift store called the Bag O' Rags, and ended up pawing through racks and cartons of sport coats, skinny ties, and T-shirts imprinted with pictures of bright-red lobsters and the names of fundamentalist summer camps. On my way out, I checked the secondhand books. Jammed in with the Stephen King, Dean Koontz, and James Patterson novels, I found a dogeared and well-thumbed copy of *The Death of Superman*, a trade paperback that collected eleven comic books originally published in late 1992 and early 1993. *The Death of Superman*. For crying out loud, I'd forgotten all about that.

During the final stretch of the Clinton/Bush/Perot presidential campaign, rumors found their way into the media that DC Comics intended to kill off their flagship character and cancel publication of all four Superman titles. Front page of New York *Newsday*, a spread in *People* magazine: "Is This Truly the End for the Man of Steel?" Suddenly Superman's impending demise (DC at first denied it, then teased the whole thing along, then confirmed it) was something everyone, overnight, knew about.

The collected *Death of Superman* cost me a dime at the thrift store. Ask me why I bought it and I couldn't tell you—for one thing, I already owned a copy in much better condition back home in Virginia; for another, I'd thought I was done with Superman. Whatever. I purchased it and stuck it in with a bagful of T-shirts that cost a quarter, and left.

That evening, instead of writing fiction, which I'd intended, I pulled out the trade paperback and started reading. The credits list four writers, four pencilers, five inkers, four letterers, two colorists and two editors. And this: "Superman created by Jerry Siegel and Joe Shuster."

Virtually the entire 150-plus pages is devoted to a pitched battle, a fistfight-to-the-mutual death, between Superman and an unstoppable nonverbal alien predator called Doomsday (ash-gray skin, tattered green pants and seven-league boots, multiple bony protrusions). An astonishing amount of real estate ends up smashed to smithereens. It's all standard comic book roughhousing, except that on the final page, comprising a single, rubble-

strewn panel, a battered, bloodied Superman lies dead (we're told in the boxed caption) as Lois Lane swoons with grief and Jimmy Olsen records the historic moment with his 35mm single-lens reflex camera.

That image originally appeared on the last page of *Superman* number 75, published in mid-November 1992, just weeks after Bill Clinton's election.* With the presidential campaign over, the news media, tiring quickly of Socks, the president-elect's cat, had seized upon Superman's passing, paying him the kind of lavish obsequies (it's the end of an era/the world will not see his kind again) ordinarily reserved for ancient movie actors, comedians, singers, ballplayers, or politicians who have been out of the public eye for what seemed like centuries.

Even *Saturday Night Live* did a skit about it.

I feel like a big dope admitting this, but I was among those throngs of credulous Americans who lined up outside comic book shops on Wednesday afternoon, November 18, 1992, to buy a copy of the "death issue." Which you could get either plain or deluxe, the deluxe edition sealed inside a black polybag stamped with a bleeding S. A black armband and the *Daily Planet*'s obituary were thoughtfully enclosed. What *was* I doing standing in a cold

*In 1986 the name of the original *Superman* comic book, which had been in continuous publication since 1939, was changed to *The Adventures of Superman;* the numbering carried on from the original series. At the same time, a new comic book entitled *Superman* began publication; it was this title that reached number 75 in late 1992.

drizzle at a dying suburban strip mall, me and about fifty other guys—guys, all guys—ranging in age from fifteen to seventy, the majority of us obviously not regular comic book readers? (How do I know that? Because almost everyone looked around with amazed expressions—a whole store that sells *nothing but comic books?* Wow.) Willingly I'd become part of a minor but notable national moment.

Despite a lifelong passion-bordering-on-mania for cartooning, both the art and the profession, by the 1990s I'd lost interest in (and patience with) mainstream comic books, almost exclusively by then grim and violent superhero titles published by DC or Marvel or Dark Horse or Image. Superhero comics, the DC line in particular, had turned radically doomy in the wake of Frank Miller's *Dark Knight Returns* and Alan Moore and Dave Gibbons's *Watchmen*, both published in 1986–87, and I didn't like it much. The stuff managed to be both pitch-dark *and* garish. I disliked the glossy paper and the computer coloring, the digital lettering, the overdrawn and overdialogued panels overpopulated by absurdly yeasted physiques, and I especially disliked the self-important, dizzily convoluted continuities. The ambience was paramilitary, and the prevailing level of mental health among the so-called superheroes a fair equivalent of the mental health level of the supervillains, which was pathological.

I still was reading comics, still sought them out; I just had no use for the superhero stuff. And that included Superman. *Still.* Still, I'd felt . . . obliged—I'd felt *obliged* to see how it all turned

out, after more than fifty years and tens of thousands of stories. It seemed a matter of respect.

Goofy, I know. I know it.

But I wasn't the only one who felt that way and stood in line. On average, in 1992 individual Superman comic books (*Action, The Adventures of Superman, Superman: The Man of Steel,* and plain old *Superman*) sold roughly a hundred thousand copies apiece each month. *Superman* number 75 sold more than six million.

I bought just one copy (the regular version, not the deluxe), but a lot of people bought multiple copies, entire cartons of them, anticipating that the issue would accrue in value. Of course it never did. I'm guessing, and probably on the low side, but when, say, three million out of the six million copies sold were carefully preserved in archival bags with acid-free cardboard backing boards, how could it *ever* be worth anything? (Supply and demand? Remember supply and demand?)

Even so, it was a time when publishers partly created and then vigorously exploited a singular moment of capitalist lunacy, when new comic books, especially first and "pivotal" issues (a major character's death, a marriage, a costume change) were considered a perfectly sound investment.

If first issues sold colossally, then maybe a final one might sell phenomenally. And if the death of a major series character could generate media attention (the demise of Batman's second Robin in 1988 comes to mind), imagine the attention if the geez-they-really-did-it demise were that of the world's most famous super-

hero. The Doomsday story line had all the earmarks of something planned carefully for maximum profit, a cynical all-points bulletin to fans and speculators alike: get out your wallets, boys.

In fact, it was an impromptu decision, virtually last-minute. Superman never was meant to *stay* dead, and his death happened at all only because an intended comic book "story arc" that culminated in the wedding of Lois Lane and Clark Kent (they'd become engaged in 1990, *Superman* number 50) all of a sudden had to be postponed, indefinitely.*

Turns out, it wasn't Doomsday that killed Superman back in 1992; it was a television show then in production but not yet aired called *Lois and Clark: The New Adventures of Superman.* Pitched as *Moonlighting* in Metropolis, the ABC series, to star Teri Hatcher as Lois Lane and Dean Cain as Clark Kent, would focus on romance, not adventure, and take Lois and Clark from competitive colleagues at the *Daily Planet*, to flirtatious rivals, to (assuming the ratings held) newlyweds. Until the TV people gave the go sign, the team of fifteen or sixteen writers and artists responsible for planning and getting out a new Superman comic book every week had to postpone the marriage.

Which left a huge gap in the comics' plot line that needed plug-

*When the nuptials happened, really and truly, in 1996, after Superman was resurrected and had resumed his career, it drew only a fraction of the media attention his death had. And while in the comic books Lois and Clark have been married for well over a decade by now, I'll bet you it would come as news to just about anyone not a devoted Superman reader.

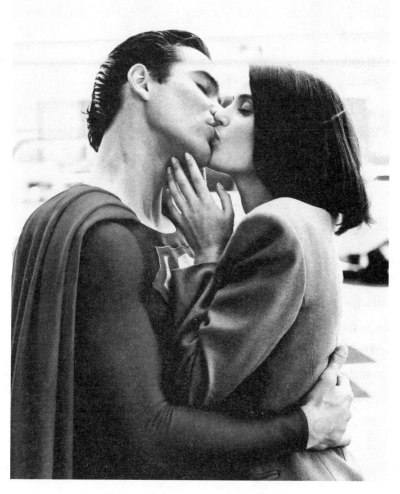

Dean Cain and Teri Hatcher in the ABC television series *Lois and Clark: The New Adventures of Superman*, 1993–97 (PhotoFest Digital, © DC Comics)

ging. When some wise guy in the group facetiously suggested, "Let's kill him," heads snapped up, eyes narrowed, and from that point on it just snowballed. A gimmick, sure—but one intended to last for only about six months. Then Superman would return from the dead.

It was just one of those things, a fluke, that Superman's death drew so much attention—"I can't believe that people went for it as hard as they did," said Mike Carlin, the Superman line's editor in chief, sounding like Orson Welles after *War of the Worlds*—but once the attention became a full-blown event, the creative team exploited it. "All we could do was try to keep up with it, and that's what we did." There were weeks of funeral preparations, dramatized in other comic books in the DC "universe," then eulogies and expressions of disbelief by a humbled superherodom-at-large. Then burial in a crypt in Metropolis's version of Central Park.

"We did eight issues of Superman's funeral, where he was literally a dead body," said Carlin, "and we thought that was the most daring part of the whole plan. There was a strong analogy for how we felt, which was that Superman was being taken for granted. We wanted to remind people that some of the values that Superman stands for are still important" (quoted in Daniels, *Superman*, 168).

Between the real-world election of Bill Clinton and the massive explosion that rocked the foundation of the World Trade Center, Superman died and was buried. Then, sometime be-

tween that first terrorist attack on the Trade Center and the disastrous raid on the Branch Davidians' compound in Waco, his body disappeared from his casket. (That revelation was the "big event" of the five-hundredth issue of *The Adventures of Superman*.) Finally in October 1993 (the same month *Lois and Clark* premiered on television), the Man of Steel returned (thanks to some nifty Kryptonian technology warehoused at the Fortress of Solitude), sporting long rock-star hair but otherwise none the worse (or wiser) for temporarily shuffling off this mortal coil.

3

The morning after I'd read the *Death of Superman* collection in Maine, I Googled for the rumors, reactions, and public phenomenon originally surrounding it. Op-ed pieces and editorials, even a column by Frank Rich in the *New York Times*, drew the same conclusion: that Superman had become obsolete in both the gloomy, relativist precincts of modern comic books and the caustic, sneering "post-heroic" world of the expiring twentieth century. Like vinyl records, rotary phones, and electric typewriters, he was yesterday, the day *before* yesterday, and no longer needed. May he rest in peace.

There was anger, cynicism, nostalgia, grief, satisfaction, even snarkiness, and everybody, it seemed, viewed Superman's death as a metaphor for . . . something. It meant the end of wholesomeness, the end (yet again!) of our innocence. It exemplified corpo-

rate arrogance and self-regard, the primacy of profit. It marked the happy disappearance of still another outdated symbol of the white male status quo. It symbolized the annihilation (and either it was a crying shame, or about time) of the national platitude that Americans, like Superman, do the right thing because it's the right thing, not because of any expectation of reward. It said something, something or other, about the decline of America the superpower.*

Apparently Superman still mattered in 1992. Significantly. Even though he mattered most for not mattering.

But now here it was 2006 and the Man of Steel was still around, still in narratives, still marketed; a new movie, a hit TV series, the comic books. Web sites, discussion boards, pop songs, gimme caps, postage stamps, key chains, cuff links, roller coasters, T-shirts. (Is there one dresser drawer in one bedroom in all of the United States of America that doesn't contain at least one Superman T-shirt?) It was, and remains, impressive how much Superman iconography, how much Superman *stuff*, we can register every day either directly or peripherally.

*In the *Time Annual* for 1992, Lance Morrow pop-contextualized the national mood in the year Superman died: "The cold war was over: the fact had a telling effect on American social and moral psychology. Americans, who more than other people require some sense of national purpose, some coherent idea of themselves and their mission, were living in a new unfamiliar context. The struggle against communism, by which Americans had defined their purpose for more than 40 years, had ended in a decisive and even surreal fashion: the other side simply disintegrated. Now Americans felt disoriented. They told pollsters they had come to feel their own country had somehow gone off the track. The old stabilities of American life seemed unreliable. Something was wrong" (134).

After I'd come home from Maine and after *Superman Returns* ended its theatrical run, I gradually realized that, without intending to, I'd started keeping track of Superman, of Superman's *presence* in the world.

Sufjan Stevens's "Metropolis" playing on a friend's docked iPod got me started counting Superman songs. By Three Doors Down, Laurie Anderson, the Spin Doctors, Bon Jovi, the Kinks, Eric Clapton, B. B. King, R.E.M., Crash Test Dummies, Alanis Morissette, Barbra Streisand. There are (I know because I've since checked) nearly four hundred pop songs about, or mentioning, Superman . . . by Ian Dury and the Blockheads, Donovan, Don McLean, Jim Croce, Five for Fighting, Iggy Pop . . .

At a mall kiosk one afternoon I stopped to buy a battery and there was a yard-wide black velvet card displaying a variety of Superman watches, junky to jeweled, in the showcase.

On a rainy morning I gratefully took a lift from a guy I know—and he had Superman floor mats in his Audi!

At the park on a beautiful autumn Sunday, a wrinkled old Vietnamese man was hawking two-foot-tall Superman balloons; at the State Fair of Virginia, more than half of the game booths had prize shelves crammed with soft Superman dolls.

In the refrigerator case at the back of a convenience store, close to the beer and malt liquor, I came upon Superman Super Power Adult Energy Supplement in sixteen-ounce silver cans with stylish black graphics. (Yes, I bought one, and yes, it was horrible.)

At Hallmark: Superman gift bags, birthday cards, anniversary cards, graduation cards. And a "collectible" Superman Christmas tree ornament. Two. Three. Three different Christmas tree ornaments.

At Barnes and Noble: a Superman phonics book, a dozen paperbacks reprinting recent comic book stories, a half-dozen *Smallville* novels, a hardbound collection of 1940s-era Superman newspaper strips.

At an independent bookstore: a 2002 collection of poems by Bryan D. Dietrich about Superman, Lois Lane, and Lex Luthor called *Krypton Nights*. Winner of the 2001 *Paris Review* Prize. ("Home from a hard day's Armageddon / slipping out of spandex and into spectacles.")

Standing on a ladder power-washing my neighbor's house is a long-haired young guy with droopy jeans, and his boxer shorts are patterned with the Superman crest.

My grown daughter, home from California for the Christmas holidays, is watching a *Seinfeld* rerun—and there's that Superman magnet on Jerry's refrigerator.

I'm reading in the *New York Times* about a young choreographer who has created a dance for Mikhail Baryshnikov. It's called "Leap to Tall," because, she explains, Baryshnikov is "'a Superman'" to her, and like Superman, he leaps "'to tall buildings.'" Incredibly, she has misquoted the famous mantra ("able to leap tall buildings in a single bound"), but my point is, she made the reference (quoted in Sulcas, "Reflections").

A graduate student finally returns a stack of David Mamet paperbacks he borrowed from me more than a year ago; idly I flip open one of the books—to an essay I'd never noticed before entitled "Kryptonite: A Psychological Appreciation." ("I enjoyed the Superman comics as a boy. I enjoyed their very dullness and predictability. The story never varied, and, even as a child, I remembered thinking, 'What a dull fantasy.' But I enjoyed them" [*Some Freaks*, 176].)

Driving past a stock car raceway, I notice an old blue Pontiac junker idling outside the gates and chuffing greasy exhaust; "Man of Steel" is sprayed across both passenger-side doors in red and yellow paint.

On the eleven o'clock news a sullen and heavily armed child-soldier somewhere in Africa is wearing a ball cap embroidered with the Superman patch.

All right, I'll stop.

But it just went *on* like that. Every day, something Superman hit me in the face. But is Superman's ubiquity just that—ubiquity? Saturation marketing? Or is there more to it? You wear a Superman T-shirt *because* . . . ? A Superman wristwatch *because* . . . ? A Superman belt buckle? Associating ourselves, *accessorizing* ourselves, with Superman and Superman imagery does *what* for us, *to* us, exactly? Does it have any meaning? It must, I decided. We use him as a metaphor, as shorthand, as self-projection—boasting, seriously or ironically, I'm Damn Good. I don't know how many small Superman S-logos I've seen tattooed

on people's shoulders, men *and* women. One day on the beach I counted four.

That autumn, already several years ago now, I found myself recalling how I'd answered all of those does-he-still-matter questions back in May and June—and decided, corny or not, that I'd said *exactly* what I meant. As dispirited as I felt in 2006 about our politics and culture, and as deeply pessimistic, I could not dismiss—*could not diss*—Superman. He wasn't to blame! Nor could I use my own cranky bad faith, my own small contribution to the national malaise, to deny something I felt to be true: Superman *does* matter. Even in the twenty-first century. He still mattered to me—why else would I have jumped at the chance to write a novel about him when the special projects editor at DC Comics floated the idea? I can't imagine being even slightly tempted by a comparable offer to write about any other famous fictional character. But Superman, Superman I could not turn down. Because he resonated. He still mattered.

But whenever I mentioned Superman, or somebody mentioned Superman to me in the context of either my novel or Bryan Singer's movie, what I'd usually hear was this: "I never was that big on Superman. I was never a Superman guy."

No? Well, I was, and I had the Superman posters, statues and toys, mugs, banks, and cookie jars in my home and university offices to prove it. For me it's always been Superman. I've always been a Superman Guy.

4

I put away my unfinished novel, again, to work on this essay. It seemed logical to begin with the first comic books and from there track the character and his gathering significance over time. But despite being a carrier of the completist gene, the DNA responsible for such loony behavior as collecting every Frank Sinatra recording, or tracking down first editions by John O'Hara (and not just the fiction, mind you, but the plays and the essays and the dyspeptic newspaper columns), I couldn't read *every* Superman comic book and newspaper strip, watch *every* Superman cartoon and TV program, or listen to *every* Superman radio broadcast—even though, incredibly, almost all of it is commercially available. Just *sampling* the stuff consumed the better part of two years. There's so much! I think it's safe to say that no other fictional character in the world has been portrayed—drawn, acted, chronicled, parodied, and bootlegged—as often, or in as many media and venues, as Superman. Think about it.

Thanks to the work of comics historians and the recollections and anecdotes of comic book professionals, over the course of those two years I became more, much more, familiar with, and interested in, the story of Superman as a commodity. The commercial (trademarked, copyrighted, licensed) exploitation of Superman, and the plain old exploitation (Sign here. And here.) of his two hapless creators, is a story at least as compelling and pertinent, and American, as the story of how and why the charac-

ter achieved and maintained special cultural significance. Superman the icon and Superman the commodity. He matters because he is both of those things. A large-hearted fictional character. And a property worth billions.

Our hero.

5

The credit appears now whenever Superman's name, or the character of Superman, is used in dramatic or narrative media, comic books to movies to PlayStation games: "Created by Jerry Siegel and Joe Shuster." But from 1948 through 1975, it was absent—banished—from everything Superman-related, initially struck after Siegel and Shuster sued unsuccessfully in the state of New York to get back ownership of their famous creation. Superman, it was the court's opinion, belonged to the company that purchased all rights to him for $130. A deal's a deal, fellas. Following that, Siegel and Shuster—as punishment for their ingratitude and presumption—were fired by National (today's DC) Comics, and their byline was disappeared. Who created Superman? Nobody.

For $130 the company secured ownership of Superman in perpetuity, but what it actually bought sometime in February of 1938 was thirteen pages of story and cartoon art for a planned new monthly periodical to be called *Action Comics*.

Before *Action* number 1, before Superman arrived on Earth with powers and abilities far beyond those of mortal men, comic

books were negligible things in the Darwinian world of New York publishing and national magazine distribution. By 1933, 7½-by-10-inch pamphlets featuring recycled newspaper comic strips were published regularly by Eastern Color Printing Company, but as promotional premiums given away to customers by retailers and manufacturers—Procter and Gamble, Kinney Shoes, Canada Dry, Gulf Oil, Wheatena. These thirty-two-page freebies proved so popular, writes M. Thomas Inge in *Comics as Culture*, that M. C. (Max) Gaines, a salesman at Eastern Color, "believed that young readers might pay at least ten cents for such books, just as they purchased the 'Big Little Books' which also traded on popular comic strip characters. Early in 1934, Eastern Color printed 35,000 copies of *Famous Funnies, Series 1*. . . . They sold out immediately in America's chain stores, so in May the first monthly comic magazine under the same title began" (140).

Famous Funnies and its inevitable imitators—*Popular Comics, Tip Top Comics, King Comics*—were chunky stapled sixty-four-page pamphlets with glossy covers that reprinted months-old Sunday color comics like "Mutt and Jeff" and "Dick Tracy." They sold well enough—Eastern Color lost four thousand dollars on the first issue but was netting thirty thousand per by the twelfth—that several enterprising publishers risked producing "original material" comic books full of unimaginative "Dick Tracy" and "Mutt and Jeff" knockoffs. Seemed you could make a little bit of money, providing you kept your costs low. Which was done—although it meant crappy art produced on the fly by

boozehound cartoonists, third-rate illustrators, or untrained and inexperienced young men, still teenagers in many cases, willing to work cheap.

"The early comic book originals were, for the most part, awful," wrote Ted White in his essay "The Spawn of M. C. Gaines." "It must also be said that comic book publishers were, all in all, a thieving, grasping lot. Not to dwell too long upon the point, they were crooks. In many instances they were men with a good deal of money, recently earned during Prohibition, who were seeking legitimate businesses into which they might safely move. Comics . . . seemed like a good bet" (21).

Working as an editor at the McClure features syndicate in 1937 was a nineteen-year-old whiz kid named Sheldon Mayer, enthusiastic, funny, and crazy about the comics. He was also a delightfully deft and fluid cartoonist, who contributed humor strips he both wrote and drew to some of the earliest comic books. Mayer's boss was Max Gaines, who had moved to McClure after leaving Eastern Color.

One day, Mayer spotted an unsolicited submission titled "Superman" in the slush pile. At that point Siegel and Shuster were still hoping to sell their creation (by then nearly four years old) as a syndicated comic strip. It was amateurish and nutty— and Mayer loved what he saw. There was an exuberance about "Superman" that made competence seem beside the point, and he urged Max Gaines to have a look. But like virtually every other

syndicate editor in the country by then, Gaines could not imagine such a thing catching on with newspaper readers, it was just too . . . juvenile. For a syndicate to take a chance on a new strip, its appeal needed to cross, or show potential to cross, generations and amuse the "whole family." Nonetheless, he had to admit the concept was strong.

"By this time, Gaines was printing [National's] comic books on McClure presses," and was aware that a new title called *Action Comics* had been scheduled, writes R. C. Harvey in *The Art of the Comic Book*. "If the syndicate didn't want the [Superman] strip, he did: if he could persuade [National] to use it in the new comic book, printing that book would keep the presses rolling" (18). In most versions of the "discovery" story, Gaines sent Mayer to show the strip to Vincent Sullivan, *Action*'s editor.

Sullivan decided that it was different enough to warrant a try-out, and on the tenth of January 1938, he typed a brief letter to Siegel and Shuster, who were not unknown to him. For the past couple of years they'd been contributing other, more conventional strips to National—swashbucklers and hardboiled detective stuff, for the most part. "I have on hand several features . . . in connection with the new magazine that is still in the embryonic stage," Sullivan wrote. "The one . . . I like best and the one that seems to fit in the proposed schedule is that 'Superman.' From the drawing I can readily see that Joe Shuster was the person who handled the pen-and-ink end of the job." I imagine Shuster was

tickled by *that*. Identified by his style! "With all the work Joe is doing now, would it be possible for him to still turn out thirteen pages of this new feature?" (quoted in Daniels, *Superman*, 31).

Would it be *possible?* Come, now.

6

Although *Action Comics* number 1 is dated June 1938, given the way that periodicals, the cheapest ones at least, were distributed back then, it probably appeared on sidewalk newsstands and in drugstore spinner racks sometime around late April, early May.

On the cover Superman (who is not *identified* there as Superman) has the build of an acrobat, not a Frigidaire—the bulk would come later. Joe Shuster draws him hoisting a green four-door turtle-back touring sedan—hoisting it high, tipping it down, smashing it against . . . what *is* that, a boulder? He's demolishing the fender, the grille, and the front end. One of the hood panels has torn free, and a wheel, separated from its axle, bounces away. A conical headlamp pops into the air like an ejected cartridge. The sky behind the scene (or perhaps it's supposed to be a dramatic burst, as on cereal boxes) is buttery yellow. The landscape is chocolate-brown, treeless, desolate. Where could this be, this undulating plain? Death Valley? *Mars?* And then you wonder: *Where's the road?* If there's a car, shouldn't there also be a road? Is the absence deliberate? Subtraction with a purpose, simplification for dramatic effect? Or just lazy corner-cutting? The

drawing *does* look a bit rushed—like something made in the wee hours at a kitchen table that wobbled despite an improvised shim, a job that had to be finished by morning, and was, although just barely.

But all in all, an effective composition. Because once Shuster directs our attention to the figure of Superman, dead center, we look precisely where he wants us to, and see everything in a deftly predetermined narrative sequence. The diagonal that defines Superman, the single rising line, begins at his left boot heel. Our eyes follow the curve—calf, knee, thigh, torso, arm, clenched fist—to the top of the sedan, then look sharply down the roof to the hood and the crumpled fender. From there, our glance ricochets back across Superman to the panicky Munch-like figure in the lower left-hand corner, then bounces straight up. The diagonal created by the running man's outstretched right arm and the flipped-up tail of his sport jacket sweeps our attention back across the picture plane (and across Superman too, bolstering his centrality: by now it's the third time we've registered him) to the crawling man, whose curved back, the curved *line* of his back, redirects it over to the tire frozen in midair. Our eyes rest there for just a moment before our imaginations automatically complete the action: the tire drops to the ground. *Whump.*

Not bad for a myopic twenty-three-year-old whose art training consisted of a couple of classes in high school and some drawing lessons that cost him ten cents each. Joe Shuster never was a great draftsman, or even a good one, but the artistry in car-

Action Comics number 1, spring 1938 — the first appearance of Superman.
Art by Joe Shuster (PhotoFest Digital, © DC Comics)

tooning rarely is conveyed through draftsmanship, and is almost never about it. He drew well enough to get the job done, to put across an idea—a vivid instant, a violent action—with minimal lines and scarcely a flourish. ("Slickness, thank God, was beyond his means," Jules Feiffer once quipped [*Great Comic Book Heroes*, 20].) Shuster absorbed his influences, primarily pulp magazine illustrations and newspaper comic strips, then adapted them to his skill level and developed the baseline rubrics of super-hero imagery, the core poses, postures, and gestural shorthand. That said, if comic books hadn't come along, it's a safe bet he would have ended up a frustrated wannabe, not a professional cartoonist.

But comic books did come along.

7

Filled with hopeless cartooning printed in garish color usually out of register, those first original comic books are macabre things to look at today. The stuff (you hate to say it, but it's true) is lamebrained, but it's deliriously weird, too, *spooky*, a species of outsider art with an aesthetic separate from/antipodal to that which prevailed at the time in newspaper comics.

For decades American cartooning was socially and profession-ally a matter of the swells and the bums: the well-paid newspaper stripmen and magazine gag cartoonists versus the straitened comic book hacks. In the early 1950s, when comic books were

under investigation by Congress, members of the former gladly lined up to testify to the invidiousness of the latter. The profession's two camps were also by and large divided by region, class, ethnicity, and religion: midwestern small-town educated WASPs versus East Coast urban Jews with high school diplomas, if that.

In its level of craft—everything from composition to modeling to coherence—the earliest comic book art isn't more accomplished than the stuff you find in pornographic Tijuana Bibles, drawn and published around the same time, and in many cases it's far inferior. The guys who created the big-phallused knockoffs of Jiggs and Dagwood often had a lot more panache, and a better command of simple anatomy, than the guys knocking out cowboy and jungle stories and zany science fiction for the first comic books.

Later on, formalists like Jack Kirby, Lou Fine, and Will Eisner would finesse the haphazard strategies of comic book drawing, but not until the 1940s. At the outset it was chaos, as violent and willfully transgressive as punk music would be forty years in the future. Sometimes you can't tell what you're looking at—is that a grizzly bear or the Rock of Gibraltar? Other times the clarity is so stark the image registers before the mind knows it. The figures and props are flat, emblematic, and ugly, direct from the id to the page, and the dialogue is fantastic, asinine, hilarious, like Richard Foreman's Dadaesque incantations. Everything is dreamy, dreamlike, otherworldly, so fucking crazy.

8

Both Jerry Siegel and Joe Shuster were born in 1914, the sons of struggling Jewish immigrants. Joe's father—who had moved the family from Toronto to Cleveland when Joe was nine or ten—earned a precarious living as a tailor. Jerry's father, a haberdasher, died of a massive heart attack precipitated by a late-afternoon holdup of his shop in 1929. When it happened, Jerry was fifteen, youngest in the family, the mama's boy. Unlike his five siblings, he wasn't forced to go out and find a job. He stayed in school and could always wheedle a little change from his mother to buy some magazines.

In his reading Jerry gravitated toward the junky and the sensational, specifically to the kooky expansiveness of the science fiction pulp-paper magazines. *Amazing Stories. Astounding Science Fiction. Science Wonder Stories.* Anything with robots, or spindle-towered cities of the future. Spacemen with fishbowl helmets and knobby ray guns. He loved that stuff. Tentacled monsters, giant malevolent brains. He just loved it.

So did Joe Shuster. He read the same pulps Siegel did, but he read and collected bodybuilding magazines, too, picking up used copies of both kinds at a back-issues shop. He worked out with barbells, could somersault nimbly, and was a bit of a health faddist, interested in, and often trying, the things he read about in Bernarr Macfadden's *Physical Culture* magazine, things like fasting and wheat germ and the Milk Diet.

While Shuster enjoyed sketching from life, he preferred "drawing funny," taking inspiration (and often swiping characters, props, gags, and compositions) from some of the best-known purveyors of the boisterous and hyperbolic "bigfoot" style of newspaper cartooning—the configurations and marks he found in Fred Opper's *Happy Hooligan* and Billy De Beck's *Barney Google*, Rube Goldberg's *Boob McNutt*, Roy Crane's *Wash Tubbs*, and Elzie Segar's *Thimble Theatre*. But he also delighted in (though he could never hope to imitate) the slick illustrative work in Alex Raymond's *Flash Gordon*, Harold Foster's *Tarzan*, and especially Winsor McCay's *Little Nemo in Slumberland*.

"It was a very imaginative strip and it even had a touch of science fiction in it," Shuster recalled during an interview in 1992, near the end of his life. "McCay's depiction of the city of the future, the planets, all the things I loved. That was among the things that turned me on to fantasy and science fiction" (Andrae, Blum, and Coddington, "Of Supermen and Kids with Dreams," 8).

They met, Siegel and Shuster, at Cleveland's Glenville High School during the fall of 1931. "It was," said Jerry, "like the right chemicals coming together" (8). Movies, pulps, the daily and Sunday comics. Radio serials, cereal box premiums. That was the stuff they both loved. Plus, they both wore eyeglasses (Joe's considerably thicker, his vision significantly poorer), and neither played ball. They didn't date much. They didn't date, period. Zero dates.

Joe Shuster was sweet-faced and mild. The kind of neighborhood kid older people in a neighborhood often describe as "too solemn." Joe's cousin, the comedian Frank Shuster (Wayne and Shuster? *The Ed Sullivan Show*?), recalled that while "Joe believed in lifting weights and making himself strong . . . he was never one for actual activity. He looked like the stereotypical 90-pound weakling getting sand kicked in his face" (quoted in Mietkiewicz, "When Superman Worked at the Star").

Jerry was plodding and sluggish, a most unphysical boy—although if he got excited about something, a new writer or a new movie, he could become animated raving about it. He liked the Shadow and Tarzan and Doc Savage—Doc Savage, the "Man of Bronze," as he was dubbed in his monthly adventure magazine, a character who maintained a secret arctic headquarters dubbed the "fortress of solitude."

Jerry also liked a novel by Philip Wylie titled *Gladiator*. Originally published in 1930, Wylie's book, part science fiction, part misanthropic screed, concerns a midwestern boy named Hugo Danner who is given super powers chemically by his daft father, a college biology teacher. The boy grows up performing miracles— ripping open bank vaults, repelling bullets, and leaping unimaginable distances. Jerry Siegel liked the book so much he wrote a glowing review of it for his high school newspaper.*

*According to the novel—which Wylie drafted while working as a staff writer at the *New Yorker*—Hugo Danner's strength "is an application of the same prin-

Nights in his bedroom, Siegel banged out original jungle stories and intergalactic epics on a big, clacking typewriter. Joe illustrated some of them on butcher paper or the back of discontinued wallpaper, rolls he'd scavenged from the trash behind paint stores. Sometimes he drew directly on mimeograph masters, arranging his pictures to fit around Jerry's badly typed prose, and they ran off several dozen purple copies.

Jerry often dropped by the Shuster family's apartment on late afternoons, and the two guys would just hang around talking about—whatever. Douglas Fairbanks, Jr., as Zorro, the current storyline in *Buck Rogers*, maybe some new intrigue or personality clash at the school newspaper (to which Joe also contributed), and then, more and more frequently as time passed, talking— with gathering excitement and seriousness—about how they ought to create a comic strip together, why not? Something they could sell and that could run every day of the week in hundreds of newspapers. With Jerry writing and Joe drawing—no fooling around, they could make a fortune. It was worth trying. What could they lose?

Over the next three, four years, throughout high school and

ciples of nature which gives insects like the ants the ability to handle great loads" (29). Siegel used the identical metaphor—substituting grasshoppers for ants—in the first page of the first Superman story. In the early 1940s Wylie sued Siegel and Shuster and National Comics for plagiarism, but the case was dismissed. Every month by then *Action* and *Superman* comics were selling millions of copies. According to Wylie's biographer, Truman Frederick Keefer, *Gladiator* had sold only 2,568 (*Philip Wylie*, 46).

continuing afterward, the two collaborated constantly. "[Joe's] family had financial problems, and his apartment . . . didn't have heat," Siegel remembered. "Joe would be working often wearing gloves and several sweaters and a jacket or two—he was working under that handicap on top of his vision problems" (Andrae, Blum, and Coddington, "Of Supermen and Kids with Dreams," 15).

For each separate comic strip, Jerry scripted a few weeks' worth of daily sequences—panel descriptions, captions, and dialogue. Joe penciled, inked, and lettered them. "[Jerry] would describe each scene and the shot used," Joe recalled. "Long shot, medium, close-up, overhead shot. It was marvelous" (18).

One strip they created was about a caveman (à la Alley Oop). One starred Laurel and Hardy; another, an imaginary Hollywood ingénue. And then, in 1934—*probably* in 1934 (a few accounts insist it was considerably later)—they created "Superman," about a human-looking alien baby who comes to Earth in a rocket ship and grows up to become the world's greatest hero, but for some reason decides to go about his business wearing tights, trunks, high boots, and a cape, and to maintain a separate identity as a self-effacing newspaper reporter named Clark Kent. Clark, Siegel would say, from Clark Gable, Kent from Kent Taylor, two of his favorite movie actors. (Although it's possible he swiped the first half of it from Doc—real name: Clark—Savage.) "When all the thoughts were coming to me," Siegel once said, "the concept came . . . that Superman could have a dual identity, and that in

one of his identities he could be meek and mild, as I was, and wear glasses, the way I do" (19). It seemed to have slipped Jerry's mind that his partner was even more unassuming than he was. And also wore glasses.

"The truth," wrote Jules Feiffer in *The Great Comic Book Heroes*, "may be that Kent existed not for the purposes of the story but for the reader. He is Superman's opinion of the rest of us, a pointed caricature of what we the non-criminal element really look like." (A sentiment reiterated by Quentin Tarantino and put, practically verbatim, into the mouth of David Carradine in *Kill Bill, Vol. 2*.) "His fake identity was our real one. That's why we loved him so. For if that wasn't really us, if there was no Clark Kents, only lots of glasses and cheap suits which, when removed, revealed all of us in our true identities—what a hell of an improved world it would have been" (19).

In the realm of Superman fandom, Internet and otherwise, a perpetual controversy rages about which persona, Superman or Clark Kent, is the "real" guy. Which is the ego and which the alter? In Siegel's version, the version that lasted with and without him for more than four decades, there was never any question it was Superman, Superman was the bona fide and Kent the invention, the disguise, the put-on. John Byrne's 1986 comic book reboot of the character, however, made Clark Kent the bona fide and Superman a professional role, a career, like quarterback, trombonist, dental hygienist. In recent years, depending

on who's been writing the monthly comics, it has flip-flopped. The Richard Donner/Richard Lester/Bryan Singer movies have sided with Siegel, *Smallville* with Byrne. (In our time of Homeland Security, the whole business of assuming and maintaining a "secret identity" seems impossible, anachronistic; Batman at least wears *gloves*. And in a culture of celebrity worship, the very idea that anyone would *want* not to be recognized as famous 24/7 seems cheesy and inauthentic, counterintuitive.)

The original "Superman" strip was a hodgepodge of elements freely borrowed from science fiction (Edgar Rice Burroughs's John Carter of Mars series, John W. Campbell's novel *The Mightiest Machine*, and of course Philip Wylie's *Gladiator*); from the adventure pulps (Zorro, the Scarlet Pimpernel, the Shadow, Doc Savage); and from the funny papers (Popeye, the Phantom, Buck Rogers, Flash Gordon). But it was a synthesis, too, artless and sincere, something . . . different; something, as the illustrator Jim Steranko points out (in his modestly titled *Steranko History of Comics*), that "embodied and amalgamated three separate and distinct themes: the visitor from another planet, the superhuman being, and the dual identity" (37).

Siegel and Shuster had never seen anything quite like their creation before, so maybe somebody else, somebody important, *somebody in charge*, would feel the same way and want to buy it.

Yeah, maybe.

9

As they had done with previous creations, the partners shopped around "Superman" to big and small newspaper syndicates (really, it was Jerry who kept samples in the mail; from the start it was Jerry with the drive and persistence). The package was always returned, with either no encouragement or outright disdain. Joe shrugged. (But probably his feelings were hurt.) Jerry fumed.

The decade of the 1930s was the Great Age of American newspaper funnies, of fiendishly addictive and nationally popular comic-strip masterpieces like *Terry and the Pirates, Captain Easy, Little Orphan Annie, Krazy Kat,* and *Li'l Abner,* written and drawn either with skilled high panache or pleasing idiosyncrasy, or both. It "was a remarkably fertile period," writes Brian Walker in *The Comics Before 1945.* "The funnies pages resembled a three-ring circus, with daredevils, clowns, jugglers, and animal acts all performing simultaneously. The syndicates released dozens of new features that exploited the full range of thematic possibilities and graphic techniques" (193).

Jerry Siegel's concept may have had some merit—wish fulfillment always does—but according to syndicate editors his storytelling was ludicrous and jumpy, atrociously dialogued, and Joe Shuster's artwork was poorly staged, inconsistent, scratchy. "Unprofessional" and "immature" were adjectives used often in rejection letters. Finally, the boys—boys! they were young men by then—ran out of places to send the damn thing.

Discouraged, they put "Superman" aside. They could figure out what to do with it later. In the meantime they'd lower their sights and revise their marketing strategy. If newspapers weren't interested in what they could offer, maybe comic books—where "unprofessional" and "immature" were never disqualifying attributes—might be more welcoming.

They were.

"Whereas comic strips depended on newspapers to reach their market," writes Ian Gordon in *Comic Strips and Consumer Culture*, "comic books were packaged as discrete products. The production and consumption of comic art independent of newspaper distribution transformed its market. Comic book publishers assumed they had a younger audience than those who purchased newspapers, and the initial content and marketing of comic books demonstrated this belief. Comic book creators were also young" (128).

Like Jerry Siegel and Joe Shuster.

10

Before the sale of "Superman," the team of Siegel and Shuster (a.k.a. Leger and Reuths whenever their own byline appeared too often in a single comic book) sold lesser work at rates of five and seven dollars an inked-and-lettered page, exclusively placing their output of single- and multiple-page stories ("Dr. Occult," "Slam Bradley, "Federal Men," "Radio Patrol") with a fledgling

company in New York City called National Allied Publishing.* The founder and owner of the company, the first company to publish original material created expressly for comic books, as well as the one that went on to introduce Superman to the world, was a former professional soldier named Malcolm Wheeler-Nicholson, universally portrayed in various histories of American popular culture as an eccentric rogue with variously green or rust-colored teeth, as an affected Dickensian mountebank, an embellisher, a bald-faced liar, and a wretched businessman who let untold wealth slip through his fingers—ousted from his own company months before it struck gold publishing Superman.

In the earliest comics histories, those from the 1940s by Martin Sheridan and Coulton Waugh, Wheeler-Nicholson is not even mentioned; one J. S. Liebowitz gets all the credit for presenting Superman to the world. In later histories and encyclopedias, continuing into recent books by Gerard Jones and David Hajdu, the "Major" is portrayed at best as a minor player, a notorious early casualty of the heartbreak/cutthroat comics business, a vague legendary figure, and a synonym for cosmic bad luck. Any biographical material whose source was Wheeler-Nicholson himself

*As related by Joe Shuster, National Comics had accepted their first submissions, which (because the two Clevelanders still hoped their favorite creation might one day yet sell as a newspaper strip) didn't include "Superman." "But [the editors] did say 'We like your ideas, we like your scripts and we like your drawings. But please copy over the stories in pen and ink on good paper.' So I got my mother and father to lend me the money to go out and buy some decent paper, the first drawing paper I ever had, in order to submit these stories properly" (quoted in Mietkiewicz, "When Superman Worked at the Star").

has always been taken with a generous grain of salt; he "apparently" had been a cavalry officer who had "supposedly" chased Pancho Villa through Mexico. He spoke with a drawl, probably phony, and postured as the southern gentleman.

All of the standard comics histories agree that in 1924 Wheeler-Nicholson left the military under a cloud. Something to do with an imprudent letter he'd written. To President Warren G. Harding.

Living in New York City in the early 1930s, Wheeler-Nicholson had contributed fiction to the hero pulps. Half-penny a word, penny a word, penny and a half. He could churn it out. Whatever was needed. Sea stories. Desert stories. War stories. Then one day, after a brief and unsuccessful stint as a syndicator of cut-rate newspaper features, he opened an office on Fourth Avenue in midtown Manhattan and declared himself a player in the nascent and wobbly comic book business. National Allied Publishing stenciled on the door.

Wheeler-Nicholson ordered up a certain number of pages of narrative comics (an adaptation of *Ivanhoe* and some further knockoffs of popular newspaper comics) from several art-and-production services, then put out an oversized—ten-by-fifteen-inch—original-material comic book called *New Fun*. Only the cover was printed four-color. Each of the one-page black-and-white or one-color comic strips inside came with a title banner—a "logo"—as if any reader, no matter how young, would believe those crude scratchings, those crowded and often misspelled

words in the dialogue balloons, ever had been published previously in a Sunday newspaper.

Despite *New Fun*'s poor sales, Wheeler-Nicholson brought out a second title, *New Comics*. Creditors pestered him, contributors did too. Checks were, apparently, either rubber or never written. He changed the names of his two publications, to *More Fun* and *New Adventure Comics*, and reduced their size—to the standard seven by ten. They didn't sell any better. Creditors hounded him now. He'd vanish for days at a time. He was said to own a big house in the ritzy northern suburbs, Whites Plains, Great Neck, Tarrytown. Maybe yes, maybe no.

Comic book historians always milk the drama in the next part of the story, and rightly so. The Major's printer and distributor, unpaid for too long and fed up at last, finally went to court and got himself made Wheeler-Nicholson's legal partner. This would be Harry Donenfeld, a short, animated, loudmouthed New York tough guy, a bootlegger back in the day, as ruthless as he was gregarious. After muscling in, he moved quickly to push the Major out. Wheeler-Nicholson launched a third title, *Detective Comics* (the first themed comic book and the one that introduced Batman in 1939), but that was it for him. He made plans to publish a fourth title, *Action*, but was gone—here's your coat, don't forget your beaver hat—before the first issue was slapped together, using Siegel and Shuster's refitted "Superman" newspaper strip as the lead feature.

When it comes to Major Malcolm Wheeler-Nicholson,

everything in popular and refereed comics scholarship pretty much corroborates everything else, and always much is made, and often a bit sneeringly, of the man's unfortunately timed, and cringe-making, exit. If the Major had held on for just a few months more, he would've ended up rich. If. If he'd held on. But he hadn't. Donenfeld got rid of him, and after that we don't hear any more stories, entrepreneurial or otherwise, about Major Malcolm Wheeler-Nicholson. He died in 1968, a classic American Loser, footnote division, in the judgment of comic book history. But comic book history is notorious for a tendency to print the legend, and for reliance upon anecdotes rather than evidence; for cartoonish simplification. If it makes a good story, especially a gasper, it's worth repeating. Thus: Major Wheeler-Nicholson, the goat.

For the past several years, though, a woman named Nicky Brown has been trying to give his story a bit more dimension, and earn the man some respect. Brown is the Major's granddaughter. She never met him and didn't become intimate with Wheeler-Nicholson's extended family until adulthood. But because of all the stories she kept hearing from aunts, uncles, and cousins, particularly from the relatives who *had* known the Major, and realizing how they so drastically contradicted so much of the so-called biographical details, Brown, in the late 1990s, began doing her own research.

In 2006, after Gerard Jones had recapped the usual Wheeler-Nicholson legend in *Men of Tomorrow*, his acclaimed history of

the early comic book industry, Brown contacted him and offered him her clarifications, her refutations, a few of which appeared later in the paperback edition. Then Brown was irked in 2008 when David Hajdu again repeated the same old legends about the Major in *The Ten-Cent Plague*, which primarily deals with the furors over crime and horror comic books in the 1950s.

Brown, for one thing, disputes the notion that the Major was a fop. "He was very conservative in his manners and behavior," she told me. "He was very European in his attitudes. To the young kids who worked for him drawing comic books, he probably seemed ridiculous." Which accounts, possibly, for some of the macabre detailing in those firsthand accounts of daily life at National Allied Publishing; the kids who worked for the Major probably mistook his scuffed shapeless felt fedora for a beaver hat; and his habit of draping his coat over his shoulders, Brown believes, may have spawned the stories that he wore a Victorian cape. He did use a long cigarette holder, though.

A lot of what happened around the time Wheeler-Nicholson lost control of his company is still murky, including details of how he ended up being cut out of things so completely, but Brown has verified a lot of the stories about her grandfather's precomics days. He actually *had* gone in hot pursuit of Pancho Villa. Not only did it actually happen, but it happened while Wheeler-Nicholson commanded Troop K of the 9th Cavalry's African-American Buffalo Soldiers. What do you know! Somebody should make a movie. He also soldiered in the Philippines,

fighting Moro rebels, and later worked as a military intelligence liaison in the Japanese embassy in Siberia. He married a Swedish aristocrat in Paris. (Maybe not at the top of the Eiffel Tower, though.)

And he was definitely a southerner. Born in Tennessee, 1890.

Brown is convinced that her grandfather's involvement with the publication of the first Superman story is far greater than previously thought. Her father, the Major's son, recalled the strip being discussed around the dinner table during the period when *Action Comics* was in the planning stage. The Major "didn't claim to create Superman," Brown told me, "but he was a publisher and an editor, and like any good publisher and editor he had his input."

After Harry Donenfeld grabbed National Allied Comics, Wheeler-Nicholson went back to full-time writing, adventure fiction for men's magazines and scholarly books on military strategy. He wouldn't talk about Superman, about losing Superman, that subject was taboo. But naturally it was a big source of family lore and understood by all as a great personal tragedy. "If you lose a plumbing business," said Brown, "that's one thing. If you lose Superman, that's big."

11

Although initially he had had grave misgivings—who was going to lay out a Depression dime to read anything so preposterous?—

Harry Donenfeld soon came to relish his elevated new status as the man who owned and published Superman. To protect his property, writes Ian Gordon, Donenfeld "registered [Superman's] image, name and the title logo as trademarks. Trademark protection gave Superman a legal identity as a business symbol, an asset of property, above and beyond that of a fictional character. That status guaranteed [the company's] ownership and control of Superman for all time since trademark protection, unlike copyright, can be renewed perpetually" (*Comic Strips and Consumer Culture*, 133).

Known previously as a rackets-connected magazine distributor and the rascally publisher of smutty pulps like *Spicy Detective* and *Gay Paree*, Harry Donenfeld was now admired as one smart cookie. Superman's boss. He started calling himself as much in nightclubs and hotel bars, and whenever he gave a luncheon talk. Superman's boss. That's who Harry Donenfeld was. That's who he was *now*.

Donenfeld had a business associate named Jack Liebowitz, Liebowitz the accountant—tall and lanky with an anchovies mustache and a supercilious manner. Had he been a character actor in motion pictures, Liebowitz could have played either the insufferably oily East Coast snob who loses the girl to a loose-limbed regular guy from the heartland, or a dangerous gentleman gambler in the mode and manner of John Carradine. When he was younger he'd kept the books for the International Ladies

Garment Workers Union. He'd also been a committed Socialist. Well, that was then. Blame it on his youth.

Shortly after Liebowitz quit his job with the union, he'd gone to work for Harry Donenfeld, who was running several companies that he owned or partly owned—a printing company, a distribution company, two or three small publishing companies—and trying to keep from going broke. Liebowitz made a smooth, steady, undemonstrative contrast to Donenfeld's motormouthed spontaneity. He insisted that Harry pay his bills on time, and that Harry's customers pay theirs. He made himself indispensable.

Appointed by Donenfeld as the publisher of the newly renamed National Comics, Liebowitz (who probably had masterminded the Wheeler-Nicholson putsch) took charge knowing little if anything about the product. A careful man, a cautious man, after the first issue of *Action Comics* was sent to the printer, he'd instructed Sullivan, the editor, to replace Superman on subsequent covers with commercially safer pulp-influenced images like parachutists, big-game hunters, Canadian Mounties, and giant gorillas. But then, in the fall of 1938, a survey of news dealers revealed that it was Superman, no question, that was moving *Action Comics*, and that kids showed up after school asking for "the magazine with Superman in it." From then on, *Action*'s covers belonged exclusively to Superman.

Soon after Vincent Sullivan had purchased the first story, Jack Liebowitz informed Siegel and Shuster that it was "customary

for all our contributors to release all rights to us. This is the businesslike way of doing things." He treated them both like hicks, always called them "boys," but once Superman became a hot property, Liebowitz offered the creators ten-year contracts at a steep increase in their page rate—thirty-five dollars, highest, by far, in the business. And promised them five percent of all revenues, his arithmetic.

As sales figures for *Action Comics* crept steadily toward the half-million mark, Liebowitz gave Superman his own comic book, the first devoted to a single character. *Superman* number 1 was cover-dated Summer 1939 but published and distributed in late April.

Between the spring of 1938 and the following spring, between *Action* 1 and *Superman* 1, Germany invaded Austria, Japan's motorized army crunched through China, Franco and the Falangists mopped up in Spain. The so-called second depression worsened throughout the United States, and Orson Welles broadcast *The War of the Worlds*, his Mercury Theatre's Halloween radio prank that caused legendary hysteria. People were jumpy. Another world war was brewing. Mothers glanced uneasily at their young sons, reading *Superman* comics, and saw them marching off in uniforms.

12

Of all the thousands of characters dwelling in Superman's universe, only Lois Lane has been present from the start, entering

in the forty-seventh panel of the first story published in *Action Comics* number 1. There she sits behind her big city-room typewriter wearing an orange plaid dress and looking formidable and haughty. Standing slump-shouldered at her desk, Clark Kent asks, "W-what do you say to a—er—date tonight, Lois?" Her reply sets the tone that'll stick around for decades: "I suppose I'll give you a break . . . for a change."

I suppose I'll give you a break . . . for a change.

In the next panel, Lois and Clark are dancing cheek to cheek in a "roadhouse" straight out of Dashiell Hammett. Playing his best mope, Clark asks her why she keeps avoiding him at the office. "Please, Clark!" she says. "I've been scribbling 'sob stories' all day long. Don't ask me to dish out another." Siegel not only steps on and underscores Lois's sarcasm but suggests the reason for it. She's not a working reporter but a sob sister, a lonely-hearts columnist. Obviously, Lois Lane feels that she is made for better things. (By the very next Superman story, she's already introducing herself as a reporter and acting the role. Seems as though Jerry Siegel had second thoughts about what he wanted Lois to be, or else his editor did.)

Also at the roadhouse is a table of beefy generic thugs, and when one of them ogles Lois and tells Clark to scram, a caption explains, "Reluctantly Kent adheres to his role of a weakling." Telling choice of adverb, there: *reluctantly*. The word that kicks the series into full throttle, introducing readers to the emotional, the social, even the sexual, downside of being Superman. Till this

point—and granted, it's only fifty panels into the first story—Superman has taken gleeful pleasure in his absurd disguise; it's a hoot to fool people, he's like some neighborhood kid on Halloween. Now he's discovering it can be a pain in the neck. And maybe—*probably*—truly embarrassing.

Clark gives Lois up without a fight ("Dance with the fellow and then we'll leave right away"), whereupon she hauls off and slaps the bullying Butch Matson, then storms from the club. Outside, she ducks into a taxi, calling Clark "a spineless, unbearable coward!" His first mortification of millions.

Matson, meanwhile, is ticked off. Blustering that he'll "show that skirt" she can't make a fool of him (the way she did Clark), he and his cronies pile into their sedan, overtake the taxi and kidnap Lois.*

Clark strips to his "action costume," outraces Matson's sedan, scoops it up, and—in the scene that inspired Shuster's famous cover—smashes it against a giant boulder after first shaking out all of its occupants, Lois included. Completely astonished by the guy in the blue tights and red cape, she doesn't speak a word as he great-leaps her to safety. Her eyes bug, though.

Over the span of thirty comic-strip panels, the primary con-

*One of Jerry Siegel's favorite comic strips was Chester Gould's *Dick Tracy*, which premiered in 1931. In the first sequence, Tracy's fiancée Tess Trueheart is similarly kidnapped, which may well have stuck in Siegel's memory. In any event, implications of rape invariably are the subtext of spontaneous abductions like this one in the comics.

ventions and patterns that would direct and drive the series for nearly five decades are thoroughly established: Lois's contempt for Clark, her awe at Superman. And her need to be rescued by him.

According to Michael Fleisher, Lois falls into deadly jeopardy time after time for one of four reasons: "(a) In pursuit of a news story, Lois fearlessly—and recklessly—places herself in mortal danger; (b) criminals attempt to harm her in retaliation for her articles exposing their rackets in the pages of the *Daily Planet*; (c) evildoers kidnap her and attempt to hold her hostage as protection against Superman or to force the Man of Steel to do their bidding; and (d) evildoers attempt to harm Lois as an indirect means of wreaking vengeance on Superman" (*Great Superman Book*, 148).

During the mid- to late 1940s, solo stories featuring Lois Lane appeared as a back-of-the-book feature in *Superman* comics (issues 28–40 and issue 42). A half-page Lois Lane "topper" accompanied the Sunday newspaper strip during the same period. Although usually played for laughs (even the art was cartoonier), the vignettes presented Lois Lane as a single-minded reporter covering her beat without help from you-know-who. While the tone was amused and vaguely, sometimes not-so-vaguely, condescending, it was also affectionate, unbegrudging, and the stories left no doubt she could do her job capably, despite being a "girl reporter."

Siegel's original Lois felt attracted to Superman, but she wasn't a swooner, and matrimony isn't much, if ever, on her mind. She had more important things to do than get married and raise a family, and for quite a while she wasn't even curious about "who" Superman might be in "real life."

Michael Fleisher points out that while Lois first met Superman in 1938, she never evinced "even a mild interest in learning his secret identity" till early in 1940. Until the end of that same year she never expressed any "real desire to ferret it out." Early on, when threatened with torture unless she reveals Superman's secret identity, Lois replies, "But I've no idea who he is. As a matter of fact, I have no reason to believe that he has more than one identity." She first raised "the possibility that Clark Kent might possibly be Superman" in the summer of 1941, but not till the following summer did she "actually begin to suspect that Clark Kent and Superman are one and the same" (419).

While gee-whizzing stunts and last-second rescues filled most episodes during the early and middle years of Superman comics, what gave everything its texture, its wink as well as its sex, was the Lois/Clark/Superman triangle. "It seems that among Lois Lane, Clark Kent and Superman," writes Jules Feiffer,

> there existed a schizoid and chaste ménage à trois. Clark
> Kent loved but felt abashed with Lois Lane; Superman saved
> Lois Lane when she was in trouble, found her a pest the rest
> of the time. Since Superman and Clark Kent were the same

person this behavior demands explanation. It can't be that Kent wanted Lois to respect him for his false self, to love him when he acted the coward, to be there when he pretended he needed her. She never was—so, of course, he loved her. A typical American romance. Superman never needed anybody—in any event Lois chased him—so, of course, he didn't love her. He had contempt for her. Another typical romance. (*Great Comic Book Heroes*, 20)

Because of how she was drawn (tall, slender, black-haired, a swishy dress, a rakish cloche hat) and particularly because of the way she behaved (confident to the point of recklessness, sarcastic, clever, and practiced in journalism), it has generally been assumed that Siegel and Shuster based the character of Lois Lane on Hildy Johnson as played by Rosalind Russell. The problem with that is, Howard Hawks's production of *His Girl Friday* came out two years after the first issue of *Action Comics*. But tough, wisecracking "news hens" had been a staple of American movies since the first talkies—Loretta Young in Frank Capra's *Platinum Blonde* (1931), Bette Davis in Michael Curtiz's *Front Page Woman* (1935), Joan Blondell in Ray Enright's *Back in Circulation* (1937). According to Siegel, in a letter published in *Time* magazine in 1988, the real inspiration for Lois Lane came from a series of late-thirties Warner Brothers B-pictures about a fast-talking big-city girl-reporter named Torchy Blaine. Nine Torchy Blaine films were released between 1937 and 1939, and all except two

starred Glenda Farrell, a favorite of Jerry Siegel's. For one 1938 release, *Torchy Blaine in Panama*, the reporter was played by Lola Lane—and that's where Siegel said he came up with the alliteration and the last name of his heroine.

Physically, Lois was based on a Cleveland girl named Joanne Kovacs. As she said during an interview published in *Nemo: The Classic Comics Library*:

When I met them I was struck by Joe's age. We met during the Great Depression. I was just a teenager, and my father was out of work; so in order to have any spending money I had to earn my own. . . . I found that no one would hire me because I had no skills or training, and even grown people were having trouble getting jobs. I had read an article about modeling, and I thought maybe I could get away with that. So I practiced various poses in front of a mirror, and I put an ad in the *Cleveland Plain Dealer* in the Situations Wanted column, advertising myself as a model, and Joe happened to see it. We corresponded, and he signed all his letters "Mr. Joseph Shuster," so I thought he was an older man. We set up an appointment at his apartment, where he lived with his parents, brother, and sister. I went there on a Saturday afternoon because I was going to school during the week. I was so nervous, because I thought he was going to say I was too young.

It was freezing cold day, and I was absolutely frozen by the time I got there, because I lived on the other side of town. I

pounded on the door; and it opened a little bit, and I saw a young boy on the other side, and I said, "I'm the model that Mr. Shuster is expecting." He said, "Come on in," and we got to talking. I asked if I could leave my coat on, because I was still cold. Right away we got excited, we were talking about not only the weather but movies and everything. Finally I said, "Does Mr. Shuster know that I'm here?" And he said, "I'm Mr. Shuster." That was the way we met. (2: 12)

She posed that Saturday and on several others in the weeks that followed, and I find it flabbergasting, but also impressive, that Siegel and Shuster, who must have been around twenty years old at the time, each still living at home and neither gainfully employed, had gone and hired a model. They were serious about all of this, obviously. Jerry would come over whenever Joanne Kovacs was at the Shuster apartment, to keep his eye on his, you know, creation. The three hit it off—all of them had worked on their high school newspapers—and remained friends, staying in touch even after Joanne moved away.

Years later, they met again in New York City—at a cartoonists' convention in the Plaza Hotel—and Jerry, whose marriage had ended and who was depressed over the recent loss of the first Superman copyright suit, asked Joanne for a date. They married in 1948. They were still married when Jerry died in 1996.

13

A daily comic strip, scripted by Jerry Siegel but drawn by ghost artists over Joe Shuster's hurried layouts, debuted in newspapers on January 6, 1939. A Sunday page followed on November 5.

The Supermen of America fan club (motto: "Strength-Courage-Justice") announced itself in the centerfolds of *Action* and *Superman* comics early in 1939. For ten cents, a kid could join and receive in the mail a wallet-size membership card and a button with Superman's picture (bursting chains) on it in full color. Also a decoder for secret messages. Within three years the club had registered a quarter of a million "charter members," including New York City mayor La Guardia's two children.

And on Thanksgiving Day 1939 a bulging, bobbling, cable-straining eighty-foot Superman helium balloon debuted in the Macy's parade.

He wasn't Mickey Mouse, not that kind of popular, not yet— but getting there.

In 1940—February 12—*The Adventures of Superman* began its long run on radio: a fifteen-minute serial broadcast three times a week at first, then every weekday, with an early-evening time slot that captured a few million grown-ups too. Bud Collyer, a lawyer-turned-actor, played both Clark Kent and Superman in more than two thousand broadcasts, changing vocal registers to distinguish them—going from milquetoast tenor to bottomless

baritone, from mild mannered to near-bombastic: "This is a job . . . for . . . SUPERMAN!"*

Licensed Superman merchandise, playsuits to paint sets to jig-saw puzzles and coloring books, showed up in department stores, mom-and-pop candy stores, the local five-and-dime. Party balloons, moccasins, gum cards, Milton Bradley board games. Two different ones. A battery-operated metal ray gun that projected a comic-strip picture on the wall every time you squeezed the trigger. And at the grocery store you could buy Superman brand sliced white bread, each "super flavored loaf extra rich in vitamins."

In 1940 National Comics produced a special *World's Fair* comic book featuring Superman, and thirty-six thousand children attended the fair on Superman Day. (They also hired an actor, Ray Middleton, to put on a cheesy Superman suit and wave to the crowds. The first actor to wear the suit. Ray Middleton, ladies and gentlemen.)

That Christmas, a Superman exhibit at Macy's department store drew an audience of one hundred thousand.

Paramount Pictures purchased animation rights to Superman and contracted with Max and Dave Fleischer to produce a series of Technicolor cartoons. In his book about the Fleischers, Leslie Cabarga explains that the studio, famous already for its Popeyes and Betty Boops, was reluctant at first to take on the

*During the first several years of the program, Collyer acted the part anonymously, uncredited, because listeners were supposed to believe it was the real Superman, appearing "as himself." Oh. And whose bright idea was *that?*

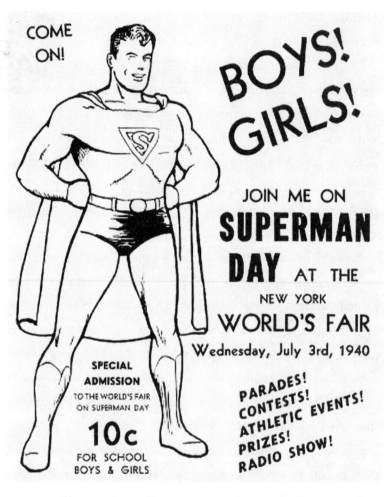

Scarcely a year after his debut in comic books, Superman was popular enough to warrant his own special day at the New York World's Fair (from the collection of Harry Matetsky, © DC Comics)

The dramatic and Modernist Superman from the first of the Fleischer Studio's
Technicolor cartoons, 1941 (PhotoFest Digital, © DC Comics)

project because it would have to be animated realistically and the
characters drawn with human proportions. "As sophisticated as
animation had become by 1941, this would be difficult and costly.
Paramount decided, however, that Superman was worth it and
paid the extra cost. The animators solved the drawing problem
by substituting blocks and wedges for the usual circles and ovals
that all comical cartoon characters were composed of. Interest-
ingly enough, the Fleischers' Superman was better drawn than
the comic book hero" (*Fleischer Story*, 136). Late in 1941 the first
of seventeen cartoons—moody, shadowy, and self-consciously
Modernist—showed up on movie screens in first-run theaters.

The same year, the *Saturday Evening Post* reported in an article profiling Jerry Siegel and Joe Shuster that the *Superman* comic book had grossed $950,000 for National in 1940. As for the two triumphant "boys from Cleveland," their joint income had amounted to roughly $70,000. Which they spent lavishly on roadsters, houses, and top-notch Florida vacations. (There's a good, and maybe even a true, story about Joe Shuster, ever scruffy despite his new status, being arrested as a vagrant during a winter trip to Miami Beach. When he made a sketch of Superman at police headquarters, the cops let him go.)

Nobody knew how long all of this magic was going to last, might last, could last, but for the time being things were great in the Superman business.

Then, bam, Pearl Harbor.

And things got even better.

14

As related by Jerry Siegel in different interviews over his lifetime, the origin of the origin of Superman sounds a little fishy to me, the kind of apocryphal episode you find in juvenile biographies of famous men. Jerry insisted that the idea came to him out of the blue one hot summer night in 1934, and from then on he was tossing and turning in bed, inspiration gathering, beating at his conscious mind, breaking in. A little over a year earlier he had written a novelette (under the stodgy pseudonym Herbert S.

Fine) about a superman, small-s, and Joe Shuster had illustrated it for a mimeoed fanzine they'd briefly published (*Science Fiction: The Advance Guard of Civilization,*" cover-dated January 1933). But *that* superman was a villain. This was different. Better.

"'I hop right out of bed and write this down,' he said, 'and then I go back and think some more for about two hours and get up again and write that down'" (quoted in Steranko, *History of Comics*, 35). All night long it went on—Jerry pondering in the dark, thumping to the floor, snapping on a lamp, and typing up the Story So Far.

By daybreak, according to Siegel, the capital-S Superman who came to Earth as a baby in a rocket ship from a doomed (not-yet-named) planet and wears a costume and has a civilian identity had been conceived, his powers determined (leap an eighth of a mile, outrace trains, planes, even bullets, lift incredible weights, bend steel, everything Hugo Danner could do in Philip Wylie's bad novel) and explained (Earth's lighter gravity). As for his personality, the original Superman was, as Bradford Wright puts it in *Comic Book Nation*, "actually a tough and cynical wise guy, similar to the hard-boiled detectives like Sam Spade who also became popular during the Depression" (9).

Forgoing breakfast, Siegel "dashed" (his usual verb of choice) from his house on Kimberly Avenue all the way to Joe Shuster's apartment twelve blocks away, bringing with him both the typescript and his stupendous enthusiasm.

"Jerry reversed the usual formula of the superhero who goes

to another planet," said Shuster, who spoke, unfailingly, of his partner with the reverence and awe of a kid brother. "He put the superhero in ordinary familiar surroundings, instead of the other way around, as was done in most science fiction. That was the first time I can recall that it had ever been done" (Andrae, Blum, and Coddington, "Of Supermen and Kids with Dreams," 15).

Working together, fortified by sandwiches, they decided upon the character's appearance. Average build, average height, a cross between the movie cowboy Tom Mix and Captain Easy from the funny sheets. The bespectacled look of Clark Kent, meanwhile, was based on Harold Lloyd, the silent-film comedian. Superman's skintight body suit, the cape, even the trunks almost certainly were inspired by the weirdly Ruritanian wardrobes of Alex Raymond's *Flash Gordon*. (And if Jerry's memory wasn't, um, playing tricks, and indeed this all happened during the summer of 1934, it might explain the choice of red, yellow, and blue for their hero's costume: those just happened to be the tricolors of Flash Gordon's clothing that June, July, and August.)

At first Superman's chest insignia—Flash Gordon's doublet sported one, also in bright yellow—was a double-bordered isosceles triangle with a scraggly *S* hemmed in; Shuster had, he said, "a heraldic crest" in mind (14). (The graphically classy five-sided shield came much later, the result of gradual finagling over more than a decade by a platoon of Superman ghost artists.) They discussed whether he should wear a domino mask. Maybe a cowl?

A hood? A helmet? Jerry inclined toward adding a mask of some kind, Joe was against it.

Oh, what the hell—Jerry conceded: no mask.

As for the cape, Jerry suggested it, and Joe went for it. "It really helped," he said, "and it was very easy to draw" (14). (Or to copy: in the funny papers that summer, Flash Gordon's lissome girlfriend Dale Arden ran around planet Mongo in a long crimson cape that billowed out behind her.)

Once the costume and the concept were finalized, all that remained to do, *all that remained for Joe Shuster to do*, was to pencil, ink, and letter a couple of weeks' worth of daily strips.

It's possible that Jerry Siegel's memory was true, but the story seems overly shaped and more than a little self-heroicizing. Jerry is the protagonist, the inspired genius, Joe the agreeable sidekick. Jerry is the creator, Joe the facilitator. Jerry has the brainstorm, Joe provides the drudge work. Joe suggests, Jerry decides. But who knows, it could have happened that way.* And besides, what

*According to the comics blogger Jeff Trexler, the "origin of Superman" story is a lot murkier than Siegel invariably recalled it during interviews. "In preparing the termination notice to regain the Superman copyright," Trexler wrote in late 2008, "the Siegel family found a box of old Superman material." Among the material were photostats of mid-1930s scripts written by Jerry Siegel that present a very different Superman, as well as samples of Superman artwork drawn by Russell Keaton, who at the time was ghosting the *Buck Rogers* Sunday pages. Trexler continues, "In 1934 Joe Shuster had become discouraged with the Superman newspaper strip and decided to let it go. His departure prompted Siegel to look for a replacement, so he sent an inquiry to Keaton. . . . Based on the surviving artwork, it would appear that Keaton did indeed prepare a set of sample daily strips for the [Bell] syndicate to review. . . . The material also provides a decidedly different take

matters finally is the creation itself, the character—the big-S Superman that combined and synthesized all of Jerry Siegel's juvenile and adolescent influences, and probably many if not most of Joe Shuster's, and was a transparent, ecstatic, slightly vengeful projection of their matching insecurities and fantasy lives.*

But you can look at Siegel and Shuster's brainchild and glimpse something else, too, another twist, another fillip, another spontaneous variation on an idea much in the air at the time, part of the 1930s zeitgeist: the feasibility of a perfectible human being. The feasibility and *consequences* of a truly advanced specimen, a *super* man.

In "From Menace to Messiah: The History and Historicity of Superman," Thomas Andrae points out that while the superman theme in science fiction had been explored and mined since the beginning of the twentieth century, "it did not really catch on until the early thirties, when a flood of stories about mental and physical supermen hit the newsstands as either book length novels or short stories" (125). Most of which young Jerry Siegel would have been familiar with, intimately.

on Superman's origin. In this version, the infant Superman arrives here from the future via a time machine, sent to 1935 by 'the last man on earth.' The couple that discovers him: Sam and Molly Kent."

*Or as Jim Steranko puts it: "Siegel and Shuster . . . were in their own way, striking back at a world of bullies that had threatened, bruised and beaten them" (*History of Comics*, 39). Well, maybe—except there's no evidence that either of them ever was actually "bruised and beaten" by *anybody*. More likely, as teenagers, they were there-but-not-there, unnoticed, dismissed. Like *Peanuts* creator Charles Schulz.

SIEGEL & SHUSTER

The Heartbreak Boys from Cleveland—Jerry Siegel and Joe Shuster,
creators of Superman (PhotoFest Digital, © DC Comics)

What would a true superman *be?* Be *like?* How would he act?
What would he feel toward the rest of us? Pity? Disgust? And of
course what would we feel about *him?* According to Andrae, in
science fiction of the period, the superman is (as Jerry's original
prose version was) almost always a "sinister figure . . . obsessed
with his power and . . . contemptuous of mankind . . . who cannot
be permitted to exist" (125).

Siegel and Shuster's innovation, their originality, Andrae concludes, "was in differentiating their creation from his predecessors . . . by being neither alienated from society nor a misanthropic power-obsessed nemesis but a truly messianic figure . . . the embodiment of society's noblest ideals, a 'man of tomorrow' who foreshadows mankind's highest potentialities and profoundest aspirations but whose tremendous power, remarkably, poses no danger to its freedom and safety" (125).

The small-s superman wasn't only the stuff of purplish science fiction, it was also the stuff of university debates and debunkings (especially around biology and philosophy departments), the nudist movement, Bernarr Macfadden's publishing empire — and Nazi politics. Nazi politics and National Socialist mythology. *Triumph of the Will.* Aryans. The 1936 "Hitler Olympics." The Übermensch. The Master Race. And if the New Deal never had man's perfectibility in mind, it nonetheless assumed his steady improvement. That the capital-S Superman was a product of that particular time and cultural tumult makes perfect sense. Siegel and Shuster were alive in the world, and it all just seeped in, all of that stuff. Had to have.

"What led me into conceiving Superman in the early thirties?" Jerry considered.

Listening to President Roosevelt's "fireside chats" . . . being unemployed and worried during the depression and knowing hopelessness and fear. Hearing and reading of the oppression

and slaughter of helpless, oppressed Jews in Nazi Germany
. . . seeing movies depicting the horrors of privation suffered
by the downtrodden . . . reading of gallant, crusading heroes
in the pulps, and seeing equally crusading heroes on the
screen in feature films and movie serials (often pitted against
malevolent, grasping, ruthless madmen) I had the great urge
to help . . . the despairing masses, somehow. How could I
help them, when I could barely help myself? Superman was
the answer. (quoted in Weisinger, "I Flew")

15

Later he would pay for them, solicit them from other, often
better writers, but in the beginning, and for the first few years,
Jerry Siegel never ran out of ideas. Footing it from his place over
to Joe's (or, later, to the cramped office they rented for thirty
bucks a month in downtown Cleveland), he could make up two,
three Superman stories, often basing them on something he'd
read five minutes earlier at breakfast in the *Plain Dealer*. A cave-
in at a Tennessee coal mine, American arms dealers being wined
and dined in Rome and Berlin, a sudden spike in traffic accidents
attributed to shoddy car manufacturing. This is a job for Super-
man. That, too. And that.

At Joe's, sometimes he'd act out scenes and situations, strik-
ing action poses, extemporizing dialogue—which overall was
crummy but functional: "Gentlemen, it's obvious you've been

fighting only to promote the sale of munitions! Why not shake hands and make up?" Siegel's civics lessons and presentation of global politics were at fifth- and sixth-grade thinking and reasoning levels, but that was perfect since his readers, for the most part, were fifth- and sixth-graders.

Jerry's scripts kicked off with a melodramatic premise followed by short, rapid episodes strung together. But they were all basically about the same thing. They were all about having fun, rambunctious and boyish fun, while remaining selfless and pure and living out a passion. "My name is Superman," he introduces himself one time during the first year of the newspaper strip, "and my hobby is making daydreams come true." Such a kid. And such a kid thing to say.

"Jerry and I always felt the character was enjoying himself," Shuster said. "He wasn't taking himself seriously, it was always a lark" (Andrae, Blum, and Coddington, "Of Supermen and Kids with Dreams," 14).

Superman goes somewhere (banana republic, ballpark, prison, factory, slum, orphanage, movie set) and then either stops something (war, lynching, earthquake, sabotage, plague) or causes something to happen (peace treaty, urban renewal, restitution, acquittal). Whatever he does, he does philanthropically, often for just one poor soul in despair (having been swindled, wrongfully jailed, or driven by the powerful to the brink of suicide) but always, too, for the common good. He accepts no reward, modestly waves off any applause. "I like to help people when I

see someone in a tough spot. I feel an irresistible urge to play guardian angel. I'm funny that way."

As depicted in *Action Comics* number 1, the first thing he does, Superman's inaugural public act, is to smash into the governor's mansion to save an innocent woman scheduled to die in the electric chair. The second thing he does is deck a wife beater. From the beginning, as Mark Waid puts it, Superman was "as close as contemporary Western culture has yet come to envisioning a champion who is the epitome of unselfishness" ("Real Truth," 10).

When Jerry Siegel composed every story, Superman functioned as a freelance do-gooder with the demeanor and gumption of a laughing caballero, a rabble-rouser devoted to ameliorating social ills with his fantastic powers. According to Marshall McLuhan, Superman was "ruthlessly efficient in carrying on a one-man crusade against crooks and anti-social forces. In neither case is there any appeal to the process of law. Justice is represented as an affair of personal strength alone" ("From the Mechanical Bride," 105). Well, there was that, yes.*

He took it upon himself to raze urban slums and expose unsafe

* Bradford Wright observes that "Superman's America was something of a paradox—a land where the virtue of the poor and the weak towered over that of the wealthy and powerful. Yet the common man could not expect to prevail on his own in this America, and neither could the progressive reformers who tried to fight for justice within the system. Only the righteous violence of Superman, it seemed, could relieve deep social problems—a tacit recognition that in American society it took some might to make right after all" (*Comic Book Nation*, 13).

labor conditions, target crooked congressmen, crooked lobby-
ists, crooked factory owners. Racketeers of every ilk, from those
fixing prize fights to those fomenting regional wars to sell mu-
nitions, provided Superman with his earliest adversaries . . . al-
though, really, you wouldn't call any of them well matched. He
could pluck bad guys into the air and juggle them. Bunch of
suits—what the hell could *they* do to *him?* He was incorruptible
and anonymous, interested only in having a ball doing good.
Could there be anything better?

In *Superman* number 5, cover-dated Summer 1940, all four
stories are fundamentally gangster melodramas, no matter how
many spiky, fiery, or gassy death traps get sprung: it's Superman
versus a slot-machine gang; an opportunistic politician; a gang
of stock market manipulators; and a local drug lord who uses
addicts to commit crimes. Jerry Siegel and Joe Shuster, civic-
minded reformers, at your service.

"We had a great deal of freedom," Shuster said, "and Jerry
wrote completely out of his imagination—very, very freely. We
even had no editorial supervision to speak of because they were
in such a rush to get things in before deadline. But later on we
were restricted" (Andrae, Blum, and Coddington, "Of Supermen
and Kids with Dreams," 18).

Maybe it was Donenfeld or Liebowitz, or Whitney Ellsworth,
the second editor of *Action* and *Superman*, but after a few years
somebody at National Comics told Jerry Siegel, Enough already
with the propaganda. Who do you think you are, Clifford Odets?

Superman had become a valuable property. His image needed mainstreaming. After 1940 Siegel routinely submitted his scripts for editorial vetting, and by the time the United States entered World War II, Superman stories dealt less with—hardly at all with—social injustice, and more with daring daylight bank robberies; Superman's never-ending battle against the forces of evil became a crusade against lone-wolf criminals and gangs of racketeers. He became a defender of the existing order and private property. The brief era of the activist Superman was over.

"In the hands of a corporation," writes Ian Gordon, "Superman was more important as a business asset than as a fictional character. Once [National] recognized Superman's status as a commodity, they defined and sold him as a product in all his incarnations. By 1941, Superman was not so much a character who helped sell comic books as a product that comic books sold" (*Comic Strips and Consumer Culture*, 134).

When populism vanished, so did Superman's sarcasm, his cocksureness, and an admirable capacity for moral outrage. In the beginning Superman *offered* his assistance, now the good citizens of Metropolis *clamored* for it, they *expected* it. Originally, civil authorities chased him as a hooligan, an outlaw—now they designated him an "honorary policeman" and charged him with things to do. ("Please and thanks.") Superman was perpetually on call. He turned humorless, and just the tiniest bit bumbling, perhaps so as not to seem threatening. His most common expression became a forced smile of bemusement that could easily

be decoded as a grimace. Only three years along in his career, Superman no longer seemed to be having so much fun. Heroing had become a job.

<div align="center">16</div>

There was so much work, *too* much work—every month, without letup, dozens of Superman pages, hundreds of panels, thousands of words in captions and dialogue. "When you forked over your dime for *Superman*," writes Ron Goulart, "you got four 13-page adventures of the Man of Steel plus assorted ads and filler material. The monthly Superman yarn in *Action Comics* also ran to 13 pages. So now, in a given year, Siegel and Shuster were responsible for 36 stories and 468 pages of artwork. On top of that, 18 covers showcasing the Man of Tomorrow were used each year. Not to mention over 300 dailies and 50 some Sunday pages for the newspaper strip. Promotional material was needed, too" (Foreword, 4).

Siegel and Shuster probably hadn't counted on things becoming such a grind. To hit his deadlines, Jerry keep reusing the same premises and plot hooks, producing virtually the same stories over and over again. Joe's solution was to cannibalize favorite compositions—for a time his right-facing single-bounding Superman turned up on every other page, each drawing almost identical—and to skimp on picture detail.

The board work stayed grueling, and Joe's vision, always poor,

kept worsening. Despite thick glasses, it became a struggle to draw. He was forced to hire some help. Wayne Boring, Paul Cassidy, Ed Dobrotka, John Sikela, Leo Novak, Dennis Neville, Ira Yarbrough, Sam Citron. They had names like major league baseball players, that initial lineup of Superman ghosts. Mostly they were young local guys, Clevelanders, but some came from out of town, out of state.

Once other cartoonists arrived, and Joe Shuster (eating candy bars all day long, now that his health-faddism was history) became essentially an expediter, the art director, Superman comics livened up pictorially. Character figures, especially Superman's, looked more solid, solid but rubbery, too. All-around better rendered. Panel borders turned plastic, elastic, and could stretch out, or be stretched out by the tumult inside, reconfigured into gobsmacking shapes. Shuster's ratty lines and minimal attention to backgrounds and props were replaced by crowded, voluptuous cartoons teeming with information. Siegel and Shuster "were very easy to work with," said Cassidy, whose primary assignment was to draw the earliest newspaper strips. "They didn't interfere in any way with how we interpreted the script. It was just at the beginning then, and I'm not sure they realized . . . what they had going on for them, that Superman was going to become as big a deal as it did" (quoted in Vance, "A Job," 10).

There was a charming ordinariness, a primitivism to the pictures when Joe Shuster drew them. His was a guileless and low-budget storytelling, the comic-strip translation of a Warner

Brothers mean-streets melodrama: cheap and tawdry and rushed, but snappy and impromptu. It related itself and was convincing. After Shuster, and despite the professional polish and more creditable, more variable compositions, Superman never again seemed as integrated into his environment, or as spiritedly alive.

17

The mythology of the superhero and the post-Depression re-industrialized wartime United States were made for each other. "Between 1941 and 1944," writes Ian Gordon, "sales of comic books doubled from 10 million to 20 million copies a month despite paper shortages. Much of this increase can be attributed to the reading habits of servicemen" (*Comic Strips and Consumer Culture*, 139).

At basic-training camps, 44 percent of inductees read comic books regularly—"regularly" defined as more than six a month—and 13 percent read them occasionally. Every other month, the army distributed at least one hundred thousand copies of *Superman*, or about 10 percent of the title's circulation. Comic books were cheap (when they weren't free), quick and easy to read, and eminently swappable, and they weighed next to nothing. But they also, Gordon suggests, may "have echoed pinups as reminders of home and like them given the individual soldier a reason to fight" (141).

Joe Shuster was rejected for military service because of poor

eyesight, and in the comics so was Clark Kent after he accidentally used X-ray vision during his physical exam and read an eye chart in another room down the hall. (Credit where credit is due: that brilliant, even legendary, bit of narrative weaseling, reiterated in dozens of stories later on, was the brainchild of a National Comics editor named Jack Schiff.) But Jerry Siegel was drafted, in 1943. By then a local hero in Cleveland, he'd been sworn into the armed forces with great fanfare (at any rate, upon a parade float) during the city's Fourth of July celebration. Ordered to report to the service newspaper *Stars and Stripes*, he remained stateside, in Georgia, for the duration of the war.

Upon leaving the army in 1945, Siegel discovered that his and Joe Shuster's combined annual Superman income — accrued from the comic books and the newspaper strip, plus any merchandising "bonuses" Jack Liebowitz chose to give them, *everything* — had slipped to forty-six thousand dollars. A drop, he would claim, of roughly sixty thousand.

During his two years away, Siegel had written only the occasional Superman script. Most had been contributed by slumming pulp-fiction (primarily science fiction) writers who charted the course for Siegel's creation, taking, he felt, money from his wallet.

It could make Jerry Siegel nauseous, the chagrin he felt at having signed away his property rights to Superman. His and Joe's. Liebowitz had bested them both, and Siegel's pride was hurt, bruised. He griped about it to anyone who'd listen. He was

a monoglot, his language complaint. His condition was victim-hood. He could get on people's nerves, even those who sympathized.

Siegel had a difficult time after the war. He left his wife Bela (the terrible-tempered former girl next door) and their four-year-old son, Michael. After they were divorced, he started paying alimony, child support: he needed more money. At last—in 1947, with just one year remaining in their ten-year contract with National—Siegel wrote a testy letter to Jack Liebowitz demanding for Joe and himself five million dollars in back compensation (a figure more or less plucked out of thin air) and a significantly larger cut of all future Superman revenues. When he was brushed aside—Liebowitz tended toward condescension and tart lecturing—Jerry Siegel, with Joe Shuster's nervous assent, hired an attorney, an old army buddy named Albert Zugsmith.

After that came the calamitous lawsuit.

Separated from National Comics following a decade of contractual employment, ten years of good to fabulous incomes—outplayed, their bluff called, their lawsuit a debacle—Siegel and Shuster must have felt scared, in free fall. (And maybe like schmucks.) Now what? They needed to create something new, but what could match Superman?

On the basis of their names, their reputation, their still-remembered byline, they sold a new strip called *Funnyman*, to comic books and for newspaper syndication. This time they retained copyright, moot ultimately and something of a bad joke.

Within a year their painfully unfunny and ghost-drawn feature about a superpowered clown had disappeared, and the partners, dispirited and facing middle age, decided to call it a day. Jerry Siegel got married again, to Joanne Kovacs, moved to New York City, and continued writing comics, only not for National, placing work with almost every other publisher in the field. For a couple of years he edited a line of notoriously awful comic books (which he'd created) for Ziff-Davis. No matter what he did, though, or where he landed, or who he worked for, it always ended suddenly or badly and left Siegel no better off financially and looking around for the next thing. The next bone.

Joe Shuster stayed behind in Cleveland, no longer drawing, no longer able to. And when he was no longer able to support himself, he moved in with his brother.*

18

National Comics "used the Second World War to make Superman not only a defender of virtue and wholesomeness," writes

*Recently, the designer Craig Yoe confirmed one of the oddest and longest-lived rumors in American cartooning: that, post-Superman, Joe Shuster contributed illustrations to a number of fetish magazines, among them all sixteen issues of *Nights of Horror*—the kind of slapdash things once upon a time sold under the counter in pool halls and cigar stores. The characters in Shuster's erotic drawings—all of which have been reproduced in Yoe's weird and discomfiting *Secret Identity: The Fetish Art of Superman's Co-Creator Joe Shuster*—bear unmistakable resemblances to Superman, Lois Lane, Jimmy Olsen, and Lex Luthor. Although published anonymously, a few of the drawings are signed "Josh," a pseudonym apparently derived from the first two letters of the artist's first and last names.

Ian Gordon, "but synonymous with American democracy. All six 1941 *Superman* comic books contained war-related stories about saboteurs, terrorists, and fifth columnists" (*Comic Strips and Consumer Culture*, 137).

As time passed and the war dragged on, Superman's patriotism was expressed more subtly, expressed but not flaunted, and usually on the covers of his comic books, rarely inside. While dozens of formulaic comic book heroes, all of them Superman facsimiles of one kind or another (come-laters like Captain Marvel, the Human Torch, Spy Smasher, and the Flash), took on the Nazis and the bucktoothed "Nips" every issue, the Man of Steel pretty much stayed out of the war. Kept to the cheerleading sidelines. "The American armed forces," he tells Lois Lane in a newspaper strip from 1942, "are powerful enough to smash their treacherous foes without the aid of Superman." (Nice try.)

Superman couldn't very well defeat the Axis powers single-handedly in his comic books, not when American soldiers (avid readers in most cases) were still fighting in Europe and the Pacific, so it's easy to see why National decided to position and play him the way they did. Except for some flag-waving dialogue and periodic salutes to the armed forces, Superman ignored the conflict, and Metropolis, his adopted home, became like a neutral principality.

The city did, however, become increasingly vulnerable to serious havoc (although minor in comparison to the wholesale destruction in today's superhero comics and movies) created by

CERTIFICATE

OF

ACHIEVEMENT

Presented by

**The War Savings Staff of the U.S. Treasury,
The U.S. Office of Education and its Wartime Commission**

to

in recognition of the exemplary support shown our nation's war effort by successfully
reaching the individual goals so pledged for the sale or purchase
of War Bonds and Stamps during the Third War Loan Drive.

_____ _____
SCHOOL PRINCIPAL

Awarded November 1943

Although Superman stories rarely dealt directly with World War II, DC Comics
flaunted his patriotism in other ways, as demonstrated by this 1943 War Bonds
certificate (from the collection of Harry Matetsky, © DC Comics)

the first wave of (apolitical, civilian, native-born) "supervillains"
and mad scientists with round bald heads. The city was also prey
to the anarchist—the Dadaist—shenanigans of Mr. Mxyzptlk
(originally spelled Mxyztplk), a derbied Bugs Bunny of an imp
from the Fifth Dimension (and thus, strictly speaking, an alien,
though nonetheless apolitical and civilian). None of the wartime
villains (with the notable exception of Luthor, a Jerry Siegel crea-
tion) were especially malevolent, or even terribly menacing, and

they grew less menacing month after month as Superman kept getting bigger, stronger, smarter.

I'm picking a World War II–era comic book, here, at random. *Superman* number 27, March–April 1944. Three twelve-page stories, one eleven-pager. Each story carries the "by Jerry Siegel and Joe Shuster" credit in an oval floating directly under the logo on the title page. But I'm reading this particular issue as it has been reprinted on slick paper in a hardcover "DC Archives Edition"—*Superman Archives* volume 7, which gives the old comics a Godiva finish and costs $50 (well, $49.99)—and in this deluxe presentation there's a table of contents, so I know that all four stories actually were scripted by Don Cameron, a former newspaper reporter and pulp novelist from Detroit. The art is mostly if not entirely drawn by a longtime hand at the Shuster studio in Cleveland named Ed Dobrotka. (You can almost always tell Dobrotka's stuff from the broad Slavic faces of his characters and his perfectly rendered, but never-quite-in-correct-perspective big red *S*).

In the lead story, Toyman (a villain Cameron created) snatches Lois Lane and seals her inside a glass cylinder "immersed in a vat of acid." To rescue her, Superman must struggle through a "passage of many perils," but it's nothing he can't handle and hasn't seen before: just your typical needle-sharp spikes, high-tension electric current, and "white-hot flames of oxyacetylene flame." In the second story, Clark and Lois take shelter from a

storm in the North Woods and listen as a lumberjack spins a tall tale about the time Paul Bunyan met Superman. In the third story, Superman assists a millionaire rube who's been fleeced by a criminal gang that uses homing pigeons to pick pockets. In the last story Superman comes to the aid of a reckless WASP investor tricked by a con man. All in all, a safe budget of boy's adventure stories. Although packed with stunts (Superman stopping a subway, tearing open a vault, tumbling automobiles), the stories are noticeably less impromptu, better structured than Jerry Siegel's. Cameron was a superior craftsman, but nowhere near as exuberant. Reading the comic book you would never know there was a world war going on, with still no end in sight.

Probably it was a wise editorial decision, shutting out current events. Sales indicated that it was. During the war, *Superman* magazine, published bimonthly, sold one and a half million copies per issue, and the monthly *Action Comics* only slightly less.

After the war it was a different story.

19

Once they came home, stowed their duffels, and resumed civilian life, ex-soldiers who had pored over and passed along Superman comic books on destroyers and in barracks—and who, according to Les Daniels, had found "special resonance during wartime" in "the idea of the superhero who gave up his ordinary life to

put on a uniform and battle the bad guy"—were done with them (*DC Comics*, 64). There were careers now, and marriages, college and children and home buying, and if the ex-GIs still had time to read, they read something like *Fortune* or *Look* or a Mickey Spillane paperback.

The children who had discovered Superman, the first fans, who had been nine-, ten-, eleven-year-olds in the late thirties and had grabbed each new issue of *Action Comics* as soon as it appeared—they were in high school now, or had graduated, and had outgrown their childhood hero. If they still wanted to read comic books, and millions did, there was always the true-crime and horror, science fiction, war, and romance stuff taking up rack space in candy stores and drugstores by the late forties, postwar genres geared toward "mature readers." Such as themselves.

And thanks to the Great Depression, fewer nine-, ten-, eleven-year-old replacements were around in 1946, '47, '48 to spend allowance and grass-cutting money on *Superman* and *Action*. Fewer preteens, but, thanks to the erupting baby boom, a lot more—millions and millions and millions more—infants and toddlers.

During the war, overall circulation of comic books had tripled. More than one hundred titles had been sold at a combined rate of twenty million copies a month. As much as eighty percent of reading material available to soldiers and sailors in the European and Pacific theaters had consisted of comic books. After the war,

though, sales crashed. But it wasn't too long before they climbed right back up. By 1949 the number of comic books purchased monthly exceeded one hundred million copies, and it remained at that level or slightly higher through the middle 1950s.

Just about the only titles not selling as the Cold War began were the ones that featured weird crime fighters, superpowered or just snazzily costumed. They were like a craze when it's over; they *were* a craze when it's over. The Charleston, contract bridge, knock-knock jokes. Superheroes. Dozen of them disappeared (Green Lantern, Doll Man, the Atom, the Sandman, Hawkman . . .), but not the original, not the first. Not Superman. He kept chugging along. And once the first boomers—males, anyhow—learned to read, his comic books started selling millions of copies again every month.

20

Superman survived the change of taste and shifting demographics that produced the great peacetime superhero rout, and then—after the pop psychologist Frederic Wertham convincingly argued a flawed cause-and-effect relationship between comics reading and juvenile delinquency in his best-selling book *Seduction of the Innocent*, published in 1954—he survived scapegoating anti-comic book PTA crusades, Sunday sermons, and congressional hearings. According to Wertham, comic books incited children

to violence, sadism, drug addiction, and chronic masturbation. It made no sense—logical, sociological, or statistical—but that's what he wrote, that's what he proselytized. And he was an authority—the man had a Ph.D. Wertham became the comic book industry's real-life supervillain. So what if he opened a free mental health clinic in Harlem and palled around with Ralph Ellison and Richard Wright, the guy almost killed comic books.

He tried branding Superman a Strong Leader figure, intrinsically fascistic, dangerous, and antidemocratic: "We should, I suppose, be thankful that [Superman's 'S'] is not an 'SS'" (quoted in Jones, *Men of Tomorrow*, 273). But his slurs never stuck.* Americans would have none of it. Batman, okay: possibly that whole situation with Robin was a little suspect, but Superman? Superman was a visitor from another planet, yeah—but *strange?* What was strange about him? He embodied our values, celebrated our holidays, cherished our traditions. Superman was all right. Superman was—if not *us*, exactly, then *ours*. Superman, by then,

*Nor, ultimately, did his flawed logic. Mort Weisinger, the longtime editor of the entire Superman line of comic books, once wrote of a radio debate between Wertham and himself: "For his trump card, the good doctor displayed a set of statistics. 'Here is a list of more than 200 inmates I interviewed in various reform schools,' he thundered. 'Each of them admitted having read Superman. That's your common denominator for juvenile delinquency!' 'Dr. Wertham,' I said, 'did you get them to confess that they also chew bubble gum, play baseball, eat hot dogs and go to the movies?'" (quoted in Weisinger, "I Flew with Superman"). Touché! (But considering Weisinger's lifelong tendency to make up more stories than he edited, the Great Debate probably never happened. His friend Julius Schwartz proposed once that his tombstone be engraved "Here Lies Mort Weisinger—As Usual"; *Man of Two Worlds*, 34.)

was ours. He was finned cars and a smoking gross national product, he was the interstate highway system, he was Cinerama. He was big, larger than life, and he was American.

In the comic books of the 1950s, he grew stronger and stronger, displaying more talents, powers, and abilities. Super-memory, super-ventriloquism, super-typewriting, super-hypnosis. Super-sensitive nostrils. The same guy who used only to leap tall buildings in a single bound could fly out into space now (holding his "powerful vacuum breath") and pulverize an asteroid, ignite a sun with his heat vision. The guy who used to eavesdrop at high windows, cupping an ear to overhear criminal conversations inside, could now detect a cry for help from half a world away, the rumble of a rock slide on the Annapurna range. "Invulnerability, strength and speed that would put a platoon of gods to shame — and these were only the more noticeable of Superman's powers," said Dennis O'Neil, who was to take over scripting Superman comics early in the 1970s.

> In April of 1939, he acquired x-ray vision with which he could look at the far end of the cosmos and, in 1959, he "projected [it] across the time barrier" to locate an ape trapped in prehistory; microscopic vision; "supersensory vision," which enabled him to see in total darkness; and "heat vision," which functioned like an extremely powerful laser beam that he used on one occasion to melt a meteor hundreds of thousands of miles away. . . . Even his *breath* became incredible.

In 1939, he could "hold his breath for hours underwater"; in 1941, he blew out a raging fire; in 1947, he sucked back an escaping rocket; and in 1959, he extinguished a star with a single mighty puff. ("Man of Steel," 51)

Because suspense had become impossible, slapstick comedy was ratcheted up till the world's mightiest hero was slinging bad puns on every other page or playing awkward straight man to Lois Lane's insufferable niece Suzy. "Superman covers, once the stamping-ground of boundless action," writes Jim Steranko, "began looking like vaudeville blackouts as Superman defrosted Lois' icebox, got a haircut with scissors breaking on every strand, performed as a one-man band, blew the candles out on a birthday cake and (who can forget this classic of the action cover) yelping with pain as Lois dropped a biscuit on his foot" (*History of Comics*, 41).

The stories, meanwhile, slanted for younger and younger readers (simpler words, fewer words, shorter stories, clearer pictures), became a monotonous record of nuttier *stunts*. Although Superman had started out as a fighter, says Tom Crippen, by the postwar years, he

was branching out into high-speed assembly of dinosaur bones. Pretty soon the fights had reduced themselves to rounds of "light taps" received by men wearing hats. Superman had found his vocation. He did things like read all the

Metropolis municipal archives at once, or transport industrial sites. In 1951, he started making coal into diamonds. Superman's role in life [was] to engage in fussy interventions with incredible physical reality . . . always imitating a factory or contriving work around physical setups that [depended] on him as lynchpin: plug that volcano with that iceberg! ("Big Red Feet," 171)

He was Can-Do America's paradigmatic Can-Do Guy. Superman could do *everything*, and do it all better and faster. Even if sometimes it really wasn't worth doing, was show-offy.

At the same time, as Thomas Andrae puts it, Superman was transformed into a "vapid establishmentarian . . . which the public, ironically, came to accept as the 'real' Superman. A Superman dedicated, it seemed, to showing all of his young new readers"— the great majority of them only recently weaned from Dick and Jane—"the many benefits of a law-abiding life, a Superman who scrupulously followed the rules and vigorously protected the status quo" ("From Menace to Messiah," 132). Jerry Siegel's original New Deal Democrat had switched allegiance and was now, quietly but indisputably, an Eisenhower super-Republican.

In the Cold War America of hydrogen bombs, stratofortress bombers, nuclear submarines, and Univac computers, Superman had more raw power than was good for him, or than he (or his writers) knew what to do with. Well, he could always break the time barrier again, or memorize the complete archives of the

Daily Planet. Well, he could always break the time barrier again, or memorize the entire Metropolis telephone book. Well, he could always break the time barrier again . . .

21

The same year Siegel and Shuster were dumped and their byline vanished, 1948, Sam Katzman, a producer at Columbia Pictures best known for his Bowery Boys featurettes, brought out the first live-action Superman motion picture: a schlocky fifteen-chapter serial jointly directed by Spencer Gordon Bennett and Tommy Carr.

It starred Kirk Alyn, an ex-hoofer and a veteran of minor-studio quickies who bore a natural resemblance to Joe Shuster's original character: average height, average weight, Black Irish good looks. A regular guy. Alyn wore no significant padding under his costume, which bagged slightly on his frame (elbows, waist, knees), but looked comfortable, something you might actually wear if you spent much of your time racing locomotives and deflecting death rays.

Despite robotic acting, a shabby overall look, the tendency to shoot daylight scenes in blinding glare, and some undistinguished gouache animation (for the flying sequences), Katzman's *Superman* played in first-run theaters, "at night as well as matinees," according to James Vance, "the first cliffhanger to enjoy such popularity since the original *Flash Gordon* twelve years be-

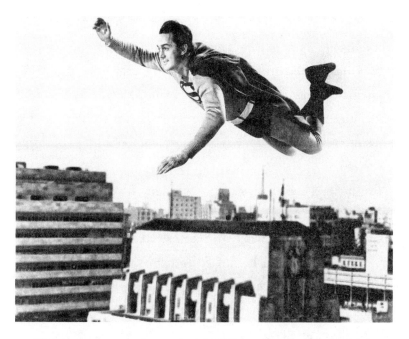

Kirk Alyn, an uncanny incarnation of Joe Shuster's original Man of Steel, played the title role in two successful Columbia Pictures Superman serials in the late 1940s (PhotoFest Digital, © DC Comics)

fore" ("Superman," 11). It also earned more money than any other movie serial. Ten years on, ten years after *Action Comics* number 1, Superman still had major chops. A sequel (featuring Lyle Talbot in a skullcap as Luthor the mad scientist) was thrown together and released in 1950, *Atom Man vs. Superman*. In both pictures Kirk Alyn made for a near-perfect incarnation of the Joe Shuster-era Superman, and he played the character with the pluck and boyishness, if not the anarchic swagger, of Jerry Siegel's earliest vision.

Meanwhile, over in the comic books and the newspaper strip, Superman presented a vastly different appearance and mien. There, he'd bulked up, become monumental—the revisionist contribution of a veteran cartoonist named Wayne Boring, who had always felt (maybe because he'd gone to art school) that Joe Shuster's original version was too squat and too short to be properly heroic.

Boring had been Shuster's first assistant, hired after responding to an ad in *Writer's Digest*. He'd arrived in Cleveland from Norfolk, Virginia, around 1939 and started out drawing backgrounds. Pretty soon he moved into foreground storytelling, penciling and inking everything except Superman's head. At the studio Joe Shuster had insisted upon inking every single one till he finally got too busy, and his eyesight became too poor, even to maintain that last consistency and hands-on connection.

When Boring was offered the job drawing the Superman newspaper strip, he left Shuster's employ and moved to New York, and from then on was paid directly by National Comics, which quietly had begun grooming a cadre of house artists and script writers capable of producing Superman stories, just in case. By the end of the Second World War, Boring's radically reconstituted Superman—older-looking, barrel-chested, a towering nine-heads-high (Shuster's barely had been six) halfback-and-a-half with a bland-and-patrician face, became the defining look—the company standard.

Somehow the new physique managed to convey, simultaneously, gravitas and easygoing goofiness. Power and passivity. Shuster's Superman jumped around like a cricket; Boring's, sculptural and iconic, mostly posed. Boring's Superman was part Charles Atlas, part Li'l Abner, and part Burne Hogarth's Sunday-supplement Tarzan. He seemed to *jog* through the air, one leg jutting forward, the other bent back at the knee. As a kid reading that stuff, I thought it made it seem as though Superman had just one leg and a stump, like the war vets I'd see around my hometown. Joe Shuster's feisty regular-guy original, Superman as lug, was replaced by a muscle-bound version with a face that rarely smiled, essentially had just two expressions (stern and surprised), and in profile looked like George Washington's.

Wayne Boring introduced a weighty grandeur to Superman's mise-en-scène (his futuristic Metropolis skyline was crisp and convincing, a little awesome), but his storytelling lacked drama, because in the scenes that he staged and drew almost no one actually *looks* at anyone else. Characters are blocked standing at weird, ungainly angles to one another. They chatter or intone or threaten maniacally below their carefully placed speech balloons, but don't make direct eye contact. And because they don't, everyone seems just slightly . . . oh, I don't know—autistic. (Boring—or else his usual inker, Stan Kaye—also managed to make Lois Lane seem cross-eyed, or blind.) Boring's heroes and villains appear self-conscious, preening; arranged together in a

composition, each remains isolated. A chill pervades the panels, and there's an unnatural solidity to his figures, a bulk reminiscent of kinky Richard Lindner paintings and 1950s pen-and-ink motorcycle-men porn. But maybe that's just me.

<center>22</center>

Robert Joffee Maxwell went to work for National Comics in 1939, hired by Harry Donenfeld and Jack Liebowitz to take charge of "Superman, Inc.," an in-house franchise set up to license the character's name and likeness for toys and novelties and apparel, whatever conceivably might benefit from Superman's connection to a product manufactured, processed, packaged, bottled, or canned. For as long as there had been newspaper comic strips, since the mid-1890s, there had been comic-strip character merchandise—Yellow Kid gravy bowls, Buster Brown shoes, Dick Tracy pot-metal prowl cars with screaming sirens—so why not merchandise featuring comic *book* characters? Or at least one comic book character in particular.

There was immediate interest, followed by a small batch of authorized products: Superman billfolds, puppets, sweatshirts, greeting cards, beanies. Maxwell believed that there was potential for much more, and with greater returns, if he could arrange to get Superman regular exposure on coast-to-coast radio—which in 1940 meant soap operas during the day; kids' serials in the late afternoon; dramas, comedies, quiz shows, and musical variety

<center></center>

programs throughout the evening, with signoffs and silence as early as 10 P.M.

It was the perfect moment to pitch Superman because radio programs featuring comic-strip characters had multiplied throughout the late thirties. Nearly all of the major newspaper strips (*Little Orphan Annie, Terry and the Pirates, Blondie, The Gumps* . . .) and a large number of second- and third-tier strips (*Smilin' Jack, Red Ryder, Brick Bradford* . . .) had been adapted successfully to the broadcast medium. Superman would fit right in.

Working with a publicist named Allen Ducovny, Maxwell had four audition episodes written and recorded in New York City, hoping to interest a sponsor. Hecker's Oats, out of Buffalo, signed on, but when none of the major networks agreed to carry *The Adventures of Superman*, the company purchased airtime itself on regional stations, just ten at first, distributing the prerecorded series on sixteen-inch "electrical transmission" disks.

Almost all of Superman's signature boilerplate ("Faster than a speeding bullet . . . More powerful than a locomotive" . . . "Look! Up in the sky! It's a bird, it's a plane," etc.) started on radio, as did many of the most durable elements of the mythology—a newspaper called the *Daily Planet* (in Siegel's early scripts it was called the *Daily Star*, a tip of the hat to Joe Shuster's original hometown newspaper, the *Toronto Star*); an editor named Perry White; an office boy, later a cub reporter, named Jimmy Olsen, and kryptonite, deadly bright-green kryptonite. It was on radio,

too, that Superman quit leaping all of those tall buildings and started flying over them instead (Tollin, *Smithsonian Historical Performances*, 8, 16).

A hit, the program was picked up later for national saturation by the Mutual Network. In 1942 the Kellogg Company signed on as exclusive sponsor, and the relationship between Superman and the cereal maker (more specifically between Superman and "super delicious" Kellogg's Pep) lasted just under two decades. Eventually the program moved to the ABC network, remaining on the air for eleven years.

By the time radio's *Adventures of Superman* came to the end of its broadcast life in March 1951, television's *Adventures of Superman* was already in the works.

That April, Jack Liebowitz sent Maxwell to California. The plan was to shoot an inexpensive Superman featurette that could serve as the TV pilot but also be distributed as a theatrical B-picture to recover costs. Liebowitz hoped to get the featurette plus fifty-two half-hour television episodes all for about $400,000. Maxwell convinced him otherwise, and they settled on one featurette and twenty-four episodes. Even so it was a miserly budget (the flying effects cost a whopping $175 per episode), but first things first: who was going to play Superman?

Bud Collyer, radio's Superman, was a voice, not a presence; besides, he was too old and wasn't a screen actor. Kirk Alyn, who had played the character twice before in the serials, the second time scarcely a year earlier, apparently wasn't considered for the

job. According to the serials' codirector Tommy Carr, it was Alyn's histrionic acting style that disqualified him—too broad, it was felt, for the intimacy of TV (Grossman, *Superman*, 80). That's one explanation.

Another is Alyn's trim, lithe, whippetlike build and bearing, which no longer matched National—or as the company was better known by then, DC—Comics' Superman ideal: aloof, self-assured, and big. *Massive.*

Casting scouts checked out bodybuilders and wrestlers, the Mr. Universe pageant, Venice Beach, anywhere with free weights and cocoa butter, but eventually, after two hundred auditions, Maxwell hired the thirty-seven-year-old George Reeves (born George Bessolo): tall, dark, handsome—and decidedly thick around the middle.

A pretty good movie actor, Reeves had been headed for stardom (so he thought) during the 1940s, but never got there. He'd landed a tiny part in *Gone with the Wind* (playing one of the Tarleton twins), later acted opposite Claudette Colbert in *So Proudly We Hail*, and appeared in two B-pictures directed by Fritz Lang. He was on the brink—one good part would do it, all he needed was The Call—when the war came and he was drafted. He missed his shot. Afterward, the best George Reeves could get was playing Buffalo Bill in a garish Technicolor second feature and Sir Galahad in a crummy-beyond-belief serial from Columbia Pictures.

Then Bob Maxwell's coproducer—Bernard Luber—spotted

him (or, more likely, his profile) at a Hollywood restaurant and thought he'd make the perfect Superman.

At that point Reeves couldn't afford to turn down work, even when he wanted to. Superman, though. Ay yi yi.

When he got the role, soft-bodied George Reeves (cocktails at four, then drinks before dinner and after-dinner drinks) in no way physically resembled Superman in the comic books—except in profile. His six-times-broken nose (he'd boxed professionally) had the same Roman arc as Wayne Boring's Superman, and his jaw the same confident thrust. Otherwise, even the wool costume's foam-rubber padding, twenty pounds of it, couldn't make him look buff. Yet for more than two decades—until Christopher Reeve, in the late 1970s—it was most likely/almost certainly knock-kneed middle-aged George Reeves with his brilliantined hair (no spit curl for him, just a slight pomp) and obvious tummy girdle that most of us saw as a momentary flash in our minds whenever the name Superman was mentioned.

23

Superman and the Mole Men, the sixty-seven-minute black-and-white featurette intended for theaters, began filming in mid-July 1951, mostly around the rocky and alkaline back lot at the RKO Pathe Studios in Culver City. Directed by Lee Sholem, it wrapped in eleven days. Following a one-day break, Sholem and Tommy Carr divvied up the TV scripts, many of them based on

Superman radio programs (just as many of the radio programs had been based on comic book stories), and shot those at a rate of five or six every two weeks, Saturdays just another workday. There were always a couple of episodes, at least a couple, filming simultaneously, which, according to Gary Grossman in his book about the series, explains (and frankly I'd always wondered) why the actors wore the same street clothes all the time: "so that footage from different episodes could be shot at the same time without having to worry about matching costumes" (*Superman*, 164).

Nat King Cole's "Too Young" played across the radio dial that summer, and every week there were roughly five hundred more American casualties—killed, wounded, missing, or captured—in the bogged-down and increasingly unpopular Korean War. That summer in Cicero, Illinois, there was also a race riot (black man, rented house, white neighborhood, National Guard), worst one of those since before the war. That summer, too, G.M.'s rocket-like experimental convertible LeSabre, three feet low, bristling with switches and gadgets, and powered by a three hundred-horsepower V-8 engine, reached a speed of 110 miles per hour at a proving ground in Milford, Michigan. And that summer Dashiell Hammett, creator of Sam Spade, Nick Charles, and the Continental Op, was jailed in Washington, D.C., for contempt of Congress after he refused to give up the names of Communist acquaintances. By summer's end, a first season's worth of episodes for *The Adventures of Superman* was completed.

A year and a half passed before the series premiered on television, even longer before it was seen coast to coast, but *Superman and the Mole Men* arrived in theaters just four months later. November 1951. Cowritten by Whitney Ellsworth and Bob Maxwell under the pseudonym Richard Fielding, it included only two members of the television cast, Reeves as Clark Kent and Superman, and Phyllis Coates as Lois Lane.

A former movie-serial scream queen, Coates plays Lois straight out of the earliest comic books: sharp-tongued, efficient, cool under pressure; a crack reporter, a pro, a pistol, a broad—"quick," writes Joseph McCabe (in "Speeding Bullets and Changing Lanes," his homage to the First Lady of Comics), "to call Clark or any other man a fool" (164). She gives good scorn.

George Reeves, on the other hand, entirely disregards Jerry Siegel's (and everyone else's) fumbly, craven Clark Kent persona, instead playing Kent as a hardboiled newshound straight out of some rat-tat-tat film noir. No stammering g-gulps, w-wells, or r-rights for *him*. With bluntly aggressive body language, *this* Kent talks fast, looks sharp in his snap-brim fedora and boxy gray suit, *and takes charge*. Firing questions, acting skeptical, refusing to be budged, blocked, sidetracked, or intimidated. A no-nonsense postwar he-man.

Reeves snaps out Kent's dialogue, then presses his lips into a grim line. He does the same thing as Superman. Never—not here and not later in the television series—does he play Clark Kent

as Superman in disguise. He plays him as Superman in street clothes, out and about in his cool fifties threads, the tortoise-shell eyeglass frames merely a fashion accessory. Both personae speak the same way, glare the same way, move and stride and gesture and abruptly pivot the same way. Of *course* they're the same guy. But nobody notices. And Lois Lane especially doesn't: Kent faces down a lynch mob and *still* the woman snipes at him as contemptuously as she'd been doing in the comics for thirteen years.

It wasn't as if Reeves had simply decided to play Clark Kent the opposite of how he'd always been played. The new macho Kent, completely at odds with the one familiar to comic book readers and radio audiences, had been written into the script. With little money for special effects, even cheesy ones, Maxwell decided early on to make Superman's appearances brief and confine them mostly to the picture's (and later the TV program's) climax and conclusion. "Reeves eschewed stereotypical bumbling as Clark Kent," Grossman says, "which worked particularly well because Kent had to carry most stories" (*Superman*, 116).

Unlike the two Columbia serials, *Superman and the Mole Men* was intended for general audiences, not just balconies acrawl with Raisinettes-box-honking twelve-year-olds, and despite a dipsy-doodle premise, the movie—like *Invaders from Mars*, like *Invasion of the Body Snatchers*, like *The Day the Earth Stood Still*—fits neatly, if not notably, into that oddball subgenre of midcentury science fiction, the ambiguous political parable.

After a well six miles deep is drilled near the western town of Silsby, two bald, glow-in-the-dark mole men (think Munchkins with bear claws) clamber to the surface for a peaceable look around. Spotted, they're pursued by a posse of armed xenophobes and accused of everything from murdering an old night watchman (they didn't touch the man, he had a heart attack) to menacing a little blonde girl (they were just playing catch with her) to poisoning whatever they touch (they're *phosphorescent*, not radioactive). After one mole man is shot and another trapped inside a cabin that is set on fire, a handful of brother subterraneans come skulking out of the well, dragging a ray gun that looks like a stainless steel Electrolux vacuum cleaner. Pick your metaphor. Class? Race? Communism? They all work. Sort of.

In Silsby to write about "the world's deepest oil well," reporters Kent and Lane try defusing the crisis. They fail. At which point Kent slips away (the first of many, many sprints Reeves will take down a happily convenient alleyway) to become Superman. When he appears, not even Lois finds it peculiar. He just happened to be flying over the neighborhood — twenty-five hundred miles from Metropolis? Oh. Okay.

During the ten or fifteen minutes Superman actually is on screen, he bends a bar of steel, lets bullets ricochet off his chest, disarms a crowd, peers through a couple of walls, and catches a mole man after he has toppled from a hydroelectric dam. (Smudgy animated flying effects kick in the moment Reeves is clumsily hoisted away on "invisible" wires. *Your legs, George, pick*

George Reeves suited up for the first time in *Superman and the Mole Men*,
the 1951 B-film that also served as the pilot for the television show
(PhotoFest Digital, © DC Comics)

up your legs!) Primarily, though, what Superman does is talk — de-
livering testy lectures about tolerance to a bigoted, parochial 1951
American lynch mob. "They look strange to us, it's true. But we
must look just as strange to them. Be reasonable. *Stop acting like
Nazi storm troopers!*" Whoa.

In the end, with Superman's protection, the mole men collect
their wounded and retreat to the center of the earth, protectively
blowing up the shaft behind them. The flames die, the smoke
(naturally a midget mushroom cloud) dissipates, and the dust

settles around Silsby. While Superman nods soberly, Lois Lane, centrally positioned and foregrounded, speaks the final line of dialogue: "It's almost as if they're saying, you've got your home and we've got ours."

Hooray for peace, love, and understanding, and let's hear it for universal brotherhood—so long as things are kept "separate but equal." Or is that not the point? Then what *is* the point? The script hedges its humanism and plays things safe, managing to be both preachy *and* vague. But at least it has more on its mind than cheap thrills and the Boy Scout motto. (Which couldn't be said for any of the Superman stories being churned out for comic books in 1951.)

Like Jerry Siegel, Robert Maxwell—who in his capacity as show runner had repeatedly unleashed radio's Superman on religious bigots and the Ku Klux Klan during the late 1940s—preferred his Man of Steel with a liberal (although perhaps not a *flaming* liberal) conscience.* As Superman's primary handler for radio, television, and the movies over the course of a decade, Maxwell, not Siegel, may well have been the most responsible for establishing the character as an American icon embodying com-

*In one memorable radio serial broadcast during the summer of 1946, Superman took up the cause of religious tolerance when he championed an interfaith community center terrorized by a gang of vigilantes. "Remember this as long as you live," he lectures at the close of the story. "Whenever you meet up with anyone who is trying to cause trouble between people—anyone who tries to tell you that a man can't be a good citizen because he is a Catholic or a Jew, a Protestant or what you will—you can be sure he's a rotten citizen himself and an inhuman being. Don't ever forget that" (quoted in Tollin, *Smithsonian Historical Performances*, 26).

George Reeves suited up for the first time in *Superman and the Mole Men,*
the 1951 B-film that also served as the pilot for the television show
(PhotoFest Digital, © DC Comics)

up your legs!) Primarily, though, what Superman does is talk—delivering testy lectures about tolerance to a bigoted, parochial 1951 American lynch mob. "They look strange to us, it's true. But we must look just as strange to them. Be reasonable. *Stop acting like Nazi storm troopers!*" Whoa.

In the end, with Superman's protection, the mole men collect their wounded and retreat to the center of the earth, protectively blowing up the shaft behind them. The flames die, the smoke (naturally a midget mushroom cloud) dissipates, and the dust

settles around Silsby. While Superman nods soberly, Lois Lane, centrally positioned and foregrounded, speaks the final line of dialogue: "It's almost as if they're saying, you've got your home and we've got ours."

Hooray for peace, love, and understanding, and let's hear it for universal brotherhood—so long as things are kept "separate but equal." Or is that not the point? Then what *is* the point? The script hedges its humanism and plays things safe, managing to be both preachy *and* vague. But at least it has more on its mind than cheap thrills and the Boy Scout motto. (Which couldn't be said for any of the Superman stories being churned out for comic books in 1951.)

Like Jerry Siegel, Robert Maxwell—who in his capacity as show runner had repeatedly unleashed radio's Superman on religious bigots and the Ku Klux Klan during the late 1940s—preferred his Man of Steel with a liberal (although perhaps not a *flaming* liberal) conscience.* As Superman's primary handler for radio, television, and the movies over the course of a decade, Maxwell, not Siegel, may well have been the most responsible for establishing the character as an American icon embodying com-

*In one memorable radio serial broadcast during the summer of 1946, Superman took up the cause of religious tolerance when he championed an interfaith community center terrorized by a gang of vigilantes. "Remember this as long as you live," he lectures at the close of the story. "Whenever you meet up with anyone who is trying to cause trouble between people—anyone who tries to tell you that a man can't be a good citizen because he is a Catholic or a Jew, a Protestant or what you will—you can be sure he's a rotten citizen himself and an inhuman being. Don't ever forget that" (quoted in Tollin, *Smithsonian Historical Performances*, 26).

mon decency, civility, and the democratic ideal—whose persona *fuses* decency, civility, and the democratic ideal.

<div align="center">24</div>

In the fall of 1952, Hemingway's *The Old Man and the Sea* and Salinger's *The Catcher in the Rye* were published. Fred Zinnemann's subversive "adult" western *High Noon* was released. The State Department canceled Charlie Chaplin's visa pending investigation of his alleged "un-American" activities. And on Friday, September 26, just two days after vice presidential candidate Richard Nixon humbly delivered his famous/infamous "Checkers" speech, *The Adventures of Superman* finally premiered, on the fledgling ABC television network's Chicago outlet. The Davenport, Iowa, affiliate picked up the program in October, followed by Buffalo, New York, in November, the same month Dwight Eisenhower was elected president. By the following spring, it could be seen every week coast to coast. The first season consisted of twenty-six half-hour episodes, twenty-four originals and a two-part season finale entitled "The Unknown People," which was actually the theatrical *Mole Men* featurette reedited.

Bob Maxwell created a program whose look, content, pacing, and tone derived almost entirely from postwar Hollywood noir. Homunculi-from-the-center-of-the-earth notwithstanding, these were tough little one-camera crime melodramas. "Gone were the mad scientists and supervillains of the comics

and animated shorts," writes Joseph McCabe, "and in their place marched an endless procession of mobsters and hit men. The world of Metropolis, so full of color in the Fleischer cartoons, was now rendered in the moody black-and-white hues of such films as *Double Indemnity* and *Night and the City*. Superman found himself battling a grittier, more realistic criminal element" ("Speeding Bullets," 164).

Despite the naturalness, amiability, and rapport of the permanent cast (which in addition to Reeves and Coates included a nineteen-year-old Jack Larson as a gulping Jimmy Olsen and John Hamilton as the ill-tempered Perry White), Maxwell's show, with its frequent spikes of cruelty (a cocker spaniel gassed to death, a little girl's polio braces torn off by gangsters, an old biddy in a wheelchair pushed down a flight of stairs), caused the keenest distress both in Battle Creek, Michigan, and New York City. Kellogg's believed that it had signed up to sponsor a show for kids, a *kiddie* show, and DC Comics—well, DC wanted to keep Kellogg's happy and Superman unobjectionable.

Jack Liebowitz was displeased that Maxwell had produced the kind of pulpy, preachy crime stories he thought he'd seen the last of when Jerry Siegel got the hook. "I always wanted to do the films myself," he said. "I didn't want to send them out to subcontractors" (quoted in Daniels, *Superman*, 95). Suddenly Bob Maxwell was a "subcontractor." His days masterminding the Man of Steel were over. Maxwell quit, or (more likely) was fired, after the

first season (he went on to produce the *Lassie* television series) and was replaced by DC's editorial director Whitney Ellsworth.

When he left New York by train for California to take charge, Ellsworth brought along an assistant, another longtime DC editor named Mort Weisinger. "Together," said Ellsworth, "we knew as much about Superman as it was possible to know. So in advance of production we'd lock ourselves in a room and work on stories. By the time we were ready to hand out writing assignments we were able to give the writers outlines of what we wanted—not just so-called premises but complete step-by-step story lines" (quoted in Daniels, *Superman*, 95). Step-by-step story lines that, beginning with the second season and continuing through the sixth and final one, made *The Adventures of Superman* closer in spirit to *The Roy Rogers and Dale Evans Show* than to *Dragnet*.

Ellsworth was the anti-Maxwell and filled his version of the program (seventy-eight shows, the majority presciently filmed in color) with boxy blinking robots and fake swamis, ditsy inventors and two-bit con men as sinister and capable as the Three Stooges. Over four years—1953 through 1957—the Ellsworth-stamped *Adventures of Superman* sold an awful lot of breakfast cereal and inspired millions of American kids to knot Turkish towels around their necks and leap from the Castro Convertible to the coffee table to the armchair to the floor (but none to leap fatally from a roof or a high window, contrary to popular legend).

Each fall's new batch of shows was slighter and sillier and schmaltzier than the last, but the audience stayed loyal, the ratings held, and, like Lucille Ball and Desi Arnaz, the Superman cast became something new in American popular culture. They became TV Stars, showing up on the covers of *TV Guide* and middlebrow magazines, quoted in syndicated gossip columns, recognized on the street, and paid to appear in character at state fairs, amusement parks, and supermarket openings.

Meanwhile, none of the actors was paid more than a few hundred dollars an episode, their take-it-or-leave-it contracts denying them residuals following the seventh rerun. Jack Larson and Noel Neill (who replaced Phyllis Coates as Lois Lane beginning with the second season, and softened the role to the point of wide-eyed innocence) had to watch their budgets, and John Hamilton, despite increasingly poor health, walked or caught a bus to the studio every morning from his apartment in a run-down residence hotel. Even George Reeves—who'd sued for more compensation halfway through the first season, and lost—lived in a modest bungalow in Benedict Canyon.

Another world, no? Another time. When you could be a television celebrity, your face so recognizable you draw crowds of gapers at the ballpark and the A&P, but still find yourself strapped for the rent two, three times a year.

25

In 2006 Focus Features released *Hollywoodland*, Allen Coulter's film about the problematic death of George Reeves. Although Paul Bernbaum's script presents the guy, played by Ben Affleck, as a likable loser, a lush, a bit of a blowhard, and a case study in self-deceit, it's neither unfair nor unsympathetic—and let's face it, Reeves's violent end, the whole sad and smarmy business of it, *did* resemble a quick read by Horace McCoy: kiddie-show actor finds himself typecast, unemployable, a joke around the industry; dumps his aging and jealous mistress (who's married to a mobbed-up MGM big shot) after falling hard for a sharp-tongued young femme fatale from the East Coast; then in his bedroom one night in June 1959, bombed on cocktails and under the influence of painkillers (prescribed after a recent car accident—*had his spurned lover tampered with the brakes?*), he shoots himself, or is shot, in the temple with a Luger pistol. TV's Superman Dead at 45.

Poor George Reeves, immortalized, but as what? An Unsolved Tinseltown Mystery.

You can't (or at least I can't) watch any of those fifty-odd-year-old TV shows (which occasionally are still broadcast, usually in weekend "marathons," although the complete run, all six seasons, naturally is available on DVD in handsome boxed sets) and not think, He's the guy who killed himself. Or was murdered. You're watching George Reeves as Clark Kent snap his head suddenly

to one side and pull off his horn-rimmed glasses preparatory to shucking his suit and becoming Superman; next second he'll be in costume bounding through an open casement window, and you think, I wonder if he really killed himself. Or was murdered. It can't be helped. He was *Superman* (he *was* Superman), and he died violently.

People—mostly aging boomers in their fifties and sixties for whom TV's *Adventures of Superman* has survived as a treasured artifact of childhood—continue to visit his remains, in the Sunrise Corridor of the Pasadena Mausoleum at Mountain View Cemetery, Altadena, California. Still do. Former towel-caped children standing there thinking, I bet he was murdered. Thinking, He probably killed himself. Thinking, Poor George Reeves. Poor George Reeves.

26

During the 1950s and '60s, seven monthly or bimonthly comic books featured Superman (or Superboy, a character DC had introduced in 1944).* The editor of the sprawling line, the overseer, the *auteur* (I'm kidding, but not really) was Mort Weisinger, Bronx-born, morbidly obese Mortimer Weisinger—picky, petty, intimidating, overbearing, and monstrously cruel to the men (or,

* *Action Comics, Superman, World's Finest* (in which Superman teamed up with Batman and Robin), *Adventure Comics, Superboy, Superman's Pal Jimmy Olsen,* and *Superman's Girlfriend Lois Lane.*

as he called them, the "idiots") who wrote and drew for him. "It was my job," he wrote after his retirement in a whining article for *Parade* magazine, "to plot his adventures, invent startling super-feats, create new villains, [and] manipulate his romantic life." But it turns out, this schmo didn't even *like* Superman! "To be honest, Superman gave me a hang-up. I resented basking in his reflected glory. I was jealous of him" (quoted in Weisinger, "I Flew"). And blamed him for his hypertension, his insomnia, his stomach ulcer, and the need to visit a psychiatrist twice a week.

Before he joined National Comics in 1941, Weisinger had edited *Thrilling Wonder Stories*, one of the lesser science fiction pulps of the era (and the one with the dubious distinction of featuring on its varnished cover each month a different big-headed Bug-Eyed Monster, situated usually in close, fondling proximity to a buxom Blue-Eyed Blonde).* Before that, Weisinger had worked as a literary agent for the Solar Sales Agency, which he'd cofounded, representing dozens of pulp writers, including H. P. Lovecraft, Robert Bloch, Leigh Bracket, Ray Bradbury, and Edmond Hamilton. And before *that*—much to his father's consternation and dismissive contempt—he was a nebbishy science fiction nut, cranking out mimeoed fanzines, corresponding with other teenaged aficionados, starting clubs (and then pocketing the dues), sharing the passion, spreading the gospel. One

*In the beginning, Weisinger's responsibilities included writing stories as well as editing them, and he's credited with the cocreation of a number of long-lived second-string superheroes, including Green Arrow and Aquaman.

of Weisinger's correspondents in the mid-'30s was Jerry Siegel. Early science fiction fandom was a small community, but from its ranks eventually came some of the comic book field's most significant editors, writers, and artists, carrying with them natural penchants for invention, monomania, sadism, masochism, deliberate malice, and feuds.

While television's *Adventures of Superman* remained in production, and throughout its run as a top-rated show, Mort Weisinger, in a commercial move counter to his own tastes, scaled back most of the science fiction elements in the comic books, bringing the stories closer in tone, and often in their plots, to the lighthearted trifles kids saw week after week on the small screen. But once the TV show ended in 1957, Weisinger organized and implemented (with, according to professional legend, the executive flair of Pol Pot) a series of radical changes to the Man of Steel that ushered in the most colorful and consequential era in the character's history.

The Weisinger formula (devised to boost sales and amuse himself, not to revolutionize the way readers would ever after respond to and "consume" monthly comic books, although it did that as well) introduced some major new element—a premise, a concept, an affiliation—into the Superman series every six months or so, then braided each element throughout all of the titles. The intent was to widen, then widen again, Superman's context, his *identity*, and to invest them both with a vibrant lore. It worked.

After he took over supervising the full line of Superman comics

in the early fifties, the first significant textural changes Mort Weisinger introduced concerned Lois Lane. Maybe hoping to pick up some new female readers, the ones who bought Archies and romance comics, he replaced the fearless and often foolhardy big-city reporter with an irritating newsroom pea brain whose only concerns were uncovering Superman's secret identity and then (sigh) marrying him. It may have been misogynist, but it was also Shakespearean the way so many stories during Weisinger's first years as king of the realm revolved around disguise, trickery, and matrimony—although in his Superman comics, matrimony seemed more akin to a game of schoolyard tag than a lifetime partnership.

Just as on television the no-nonsense Phyllis Coates version of Lois Lane ("Always such a headstrong girl," as she's described by Perry White in the first season) gave way to the pleasantly bubbleheaded Noel Neill version, the original Lois Lane as created by Jerry Siegel and then carried on by Siegel's comic book successors became the Mort Weisinger Lois, a Cold War–era female nuisance and wife-wannabe.*

The kind of Lois Lane stories Weisinger demanded from his writers (all of them male: Otto Binder, Leo Dorfman, Robert Bernstein, Bill Finger, and Alvin Schwartz) were fluffy little sit-

*Neill had played Lois Lane for the first time in the two Superman movie serials of the late 1940s—and she'd played her long-haired, big-hatted, spunky, fearless, and capable of scorn, all traits she was forced to relinquish while playing Lois in *The Adventures of Superman* from the second season through the sixth.

coms. She's a nurse, she's an ingénue, a factory girl, a pop star. A princess. A jailbird. A blonde bombshell. She's Mrs. Superman! (It's a dream! It's an Imaginary Story!) She's crying, she's raging, she's trying to make Superman jealous. She's trying to make him jealous. She's feeling jealous. She's jealous. She's trying to make Superman jealous.

And so it went.

Since 1938 each six-, eight-, nine-, twelve-, or thirteen-page Superman comic book story had been a discrete and isolated event. Nothing that occurred in any one adventure affected what happened in the next, and the permanent cast, since the days of Siegel and Shuster's authorship, had stayed amazingly small.* There was Lois Lane, there were Jimmy Olsen and Perry White, there was Luthor the mad scientist, there was Mr. Mxyzptlk, there were the Prankster, the Toyman, and J. Wilbur Wolfingham (a blatant W. C. Fields rip-off), and that was about it for regulars

*In Umberto Eco's famous essay "The Myth of Superman," it's that absence of causality, or "the notion of time that ties one episode to another," that constitutes the central dilemma/fascination of the character's primal version: "In the sphere of a story, Superman accomplishes a given job (he routs a band of gangsters); at this point the story ends. In the same comic book, or in the edition of the following week, a new story begins. If it took Superman up again at the point where he left off, he would have taken a step toward death. On the other hand, to begin a story without showing that another had preceded it would manage, momentarily, to remove Superman from the law that leads from life to death through time. . . . The stories develop in a kind of oneiric climate—of which the reader is not aware at all—where what has happened before and what has happened after appear extremely hazy. The narrator picks up the strand of the event again and again, as if he had forgotten to say something and wanted to add details to what had already been said" (153).

and semiregulars. Oh. And little Susie Tompkins, the eight-year-old fibbing brat.

Under Weisinger, Superman comics acquired a repertory company that eventually numbered in the many hundreds. Beginning around the time of the character's twentieth anniversary in 1958, and working in close (many would claim meddling, maddening, overbearing, bullying) collaboration with his small stable of freelance writers, he also devised a preposterous yet consistent series history and culture that allowed for the steady production of well-plotted stories triggered by motivations subtler than greed and the will to power, and an emotional range considerably wider and more enriched than aggression, frustration, and triumph. Gradually, the permanent cast members were endowed with charged and significant memories, which readers were expected (and only too happy) to share.

The comic books in Weisinger's bailiwick evolved into a benign, optimistic, unboundedly "wholesome" science fiction series for children, with more and more of Superman's allies and adversaries (almost everyone superpowered and dressed in tights) dropping in from the far future or, more likely, some distant planet. And of all the planets in the universe the one that most interested Mort Weisinger, to the point of obsession, was Krypton.

The Man of Steel, for two decades a guy who'd seemed never to wonder, even a tiny bit, about the world of his birth (who, for

that matter, hadn't even known its name till 1948; readers did, of course, but he didn't), now found himself habitually crashing the time barrier in reverse and traveling there — spectrally in one story, corporally in the next — to familiarize himself with Krypton, its flora and fauna, its geography and civilization before it exploded. Will Jacobs and Gerard Jones, in *The Comic Book Heroes*, their history of the "Silver Age" of superhero comics, describe the Weisingered Krypton as "a wonderland of robot factories, jewel mountains, sky palaces, fire-falls, scarlet jungles, interplanetary zoos, jet taxis, fire-breathing dogs, scientific tribunals, and even anti-gravity swimming pools" (24).

Usually, and despite the planet's often-stated immensity, Superman managed, on just about every visit, to bump into his parents, Jor-El and Lara, as either young lovers or young marrieds; occasionally he'd even have a peek at himself as the short-pants-wearing toddler, Kal-El. And always — with the realization that Krypton was doomed and there wasn't a damn thing he could do about it — he would suffer the agony of helplessness, of insufficiency: survivor's guilt.

Whether Mort Weisinger and his virtually all-Jewish cadre of creative talent were *consciously* using the Krypton adventures of the late 1950s and early 1960s as metaphors for the European Holocaust of the 1940s is anybody's guess (they never said, not that anyone ever *asked*), but there's no denying that, individually and cumulatively, those stories' subtext added a pathos to the character. "The realization that not even all his powers could

give him back what he loved most in life," write Jacobs and Jones, "raised him from a mere costumed crime fighter to something close to a tragic figure. Weisinger had discovered that Superman grew more heroic as he grew less powerful" (24).

In depicting, for the first time, Superman *as* an alien, *as* an immigrant, *as* a survivor, and in presenting those attributes as consequential and defining, the comic books, heretofore homely and slapdash things, developed a coherence and an inviting, elevated *meaningfulness* that very young readers responded to as they responded to parables and fairy tales.

Weisinger took seriously his grade school clientele: he offered letters pages in all of the Superman titles ("Metropolis Mailbag," "Smallville Mailsack," "Letters to Lois," "Jimmy Olsen's Pen Pals"), permitting fans to compliment, criticize, and vent—and, thanks to the now-inconceivable practice of printing home addresses, to correspond with one another, as science fiction fans of the '30s and '40s had done. According to Mark Waid, Weisinger, who lived on suburban Long Island, also "regularly solicited story ideas from neighborhood children, so if one clamored to see Superman as a fireman, Weisinger found a way to make Superman an honorary smoke-eater. If another wanted to see him as a millionaire, well, any number of contrivances could saddle Superman with an inherited fortune" (Introduction, 8).

Once the planet Krypton was no longer merely the source of lethal meteorites but a kind of heaven, heaven as the home place ("a paradise of happiness," is how Superman himself once re-

ferred to it), Mort Weisinger's series (like *Father Knows Best*, like *The Adventures of Ozzie and Harriet*, like *Leave It to Beaver*, like practically every successful television comedy of the period—organized itself around a grand new theme of family and kinship. In 1955 Superman (actually his teenaged self, Superboy) was reunited with his long-lost childhood pet, a bone-white spaniel (or was he a beagle?) named Krypto.

In *The Great Superman Book*, an insanely exhaustive encyclopedia, Michael Fleisher explains that "as the hour of Krypton's doom drew ever closer, Superman's father Jor-El, nursing the faint hope that [he] . . . might yet save his son, launched Krypto into outer space in a tiny rocket as a final trial run, intending for the dog-carrying rocket to return safely." But when a meteorite knocked the prototype out of orbit, Krypto drifted for years through space, "ultimately to arrive on Earth, where, like any native of Krypton, [he] acquired super-powers . . . and was happily reunited with his beloved master" (315). Thereafter, Krypto sported a yellow dog collar and a bright red cape.

Then, in 1958, while clashing with a green-skinned adversary called Brainiac, Superman discovered—stowed away in the space pirate's flying saucer—an intact and thriving Kryptonian city (the capital of the planet, no less) reduced (via something called a "hyper-force ray") to the size of a Revell model kit and preserved inside of a watercooler bottle. Brainiac had hijacked Kandor some years prior to the planet's destruction and kept it ever since as a trophy.

Krypto was one thing—but this! This was big. This was monumental. Kandor changed everything. Any kid could see that. (I was nine when the story appeared, and I sure could.) Superman was no longer the sole survivor of Krypton but merely one of millions. Millions! And that wasn't all. He suddenly had a mission (with attendant yearnings) separate from that of protecting (mere) earthlings. After dispensing with Brainiac, Superman transported the bottled city back to Earth, then to the North Pole for safekeeping in his Fortress of Solitude, the coolest boy's bedroom *ever*, introduced into the series by Weisinger only a month earlier. There, he took a solemn vow "to find a way to restore it to normal size and live with my people again . . . someday."

I wanted to live in Kandor myself; who cared if you were the size of a flea when you had an artificial sun to keep every day bright and toasty, monorails, rocket cars, and "tireless robot farmhands" to raise all the crops? That place was way better than Disneyland.

After Kandor, the Kryptonians (Caucasians all, the adult males generally resembling Victor Mature; the women, Loretta Young), just kept coming, and Superman comics became an Ellis Island for immigrants and refugees from the lost planet. In 1959 Superman's cute blonde teenaged cousin, Kara Zor-El (a dishy mix of Sandra Dee and Tuesday Weld), showed up.

And where did *she* suddenly come from? Well, it seems that— as she told Superman—when Krypton exploded, "by sheer luck," a large urban neighborhood in Argo City had been "hurled away

intact with people on it." Not only that, "a large bubble of air" came along with it. This unlikely Kryptonian archipelago survived for decades, just floating around in outer space, until it too suffered a cataclysm and Kara's father (Superman's uncle) sent her to earth in a blue leotard and miniskirt. And a bright red cape.

Dubbed Supergirl, she was promptly handed a brown wig and a secret identity (Linda Lee) and sent to live in a rural orphanage until Superman determined she was ready — sufficiently mature — to make her presence known on earth. (Gee thanks, cuz.)

Next came the Phantom Zone, a spectral dimension that served as a penitentiary for Krypton's most dangerous convicts. Existing there in a permanent ethereal state, they had managed to survive the planet's destruction. And now, of course, the very worst of them (murderous reprobates with names reminiscent of license plates or prescription drugs: Jax-Ur, Than-Ol, Vakox) started busting out of disembodied bondage every few months and going after the Man of Steel. (The Phantom Zone was one of the few elements from the Weisinger-era package, or, in fanspeak, "mythos," that found its way into the 1970s Superman movies starring Christopher Reeve.)

For six or seven years, roughly from the rise of Elvis Presley through the death of John F. Kennedy, Krypton and everything Kryptonian (including a supercat, a supermonkey, and various invidious isotopes of kryptonite — red, white, blue, and gold) defined and propelled the Superman series. The celestial immi-

grant of yesteryear had been transformed into (so to speak) a naturalized American citizen whose extended family—kinsmen, black sheep, poor relations—keeps showing up, in dribs and drabs and droves, from the Old Country. Small wonder the guy spent more and more time at the Fortress of Solitude, dusting trophies, working out in his supergym (although whatever for?) and "painting Martian landscapes as observed by [his] telescopic vision." Maybe it was better when he'd been the sole survivor? Nah. (But maybe *some*times.)

27

Discussing the science fiction that characterized Weisinger's Superman comics (in *Disguised as Clark Kent: Jews, Comics, and the Creation of the Superhero*), Danny Fingeroth observes that it "had a feel that harked back to the past. [His] stable of artists were all competent, even gifted, but their work had a sensibility reminiscent of the future seen in the pulps of the '20s and '30s" (83).

Did it ever. All of the resplendent cityscapes—whether in Kandor, on Krypton, or on Earth in the thirtieth century—were obviously inspired by the architectural and dioramic visions of "tomorrow" on display two decades earlier at the 1939 World's Fair, and the rocketry, gadgetry, and haberdashery, not to mention the never-ending parade of Bug-Eyed Monsters, seemed recycled from the illustrations young Mort Weisinger had thrilled

to in magazines like *Astounding* and *Super Science* and then later purchased himself for *Thrilling Wonder Stories*.

Narratives, too, were closely modeled upon Depression-era pulp formulas. Premises and stakes were clear, plotting was tight, endings were neat, humor was absent, dialogue was functional and flat. Men were manly, and women, in general, icky nuisances. (They were also noticeably slender and modestly endowed, in striking contrast to their zany voluptuousness in contemporary superhero comic books.)

Weisinger started his career as both a writer and editor of magazine prose fiction (as had most editors at DC Comics before 1970), and he usually privileged the word—in dialogue, in captions, even, as time went on, in expository footnotes—over the picture. (In *The Krypton Companion*, a fan's history of "Silver Age" [fifties and early sixties] Superman comics, Will Murray writes that since Weisinger was creating a product for kids, he "felt the need to explain every abrupt change of scenery or to recap a villain like Brainiac's origin every time he appeared" [13].) While Jack Kirby, Wally Wood, Bernard Kriegstein, Harvey Kurtzman, C. C. Beck, Carl Barks, and others toiling as cartoonists for DC's competitors created stories *with* pictures, pictures in temporal sequence (setup, development, payoff), Weisinger's principal artists—Wayne Boring, Al Plastino, George Papp, Jim Mooney, and Curt Swan—operated more like old-fashioned magazine and book illustrators, producing unshowy clear-line drawings that identified a story's key moments. Time was arrested, marked, but

rarely generated. The result was legible, uncluttered exposition, and frozen, no-fizz Polaroid storytelling.*

28

Superman's archenemy Luthor didn't arrive in the comic books till 1940. At first he was just another one of Jerry Siegel's criminal masterminds, a type that had entered popular fiction with Poe's Minister D in "The Purloined Letter" and then, because you can never have enough of a good thing, just kept coming back — Dr. Jack Quartz in the Nick Carter dime novels of the 1880s and '90s, Sherlock Holmes's Dr. Moriarty, Dr. Fu Manchu, James Bond's Hugo Drax and Ernst Stavro Blofeld.

Luthor is not only a criminal mastermind, he's also a mad scientist, and several of those had also preceded him in the earliest Superman stories. But only one had had a recurring role to play, the wheelchair-bound bald-headed Ultra-Humanite, a name Jerry Siegel threw together probably from a handy thesaurus, using one-to-one synonyms for "super" and "man." Ultra, who looked like the vampire in *Nosferatu*, came with typically grandiose schemes of world conquest, and usually dressed in a lab

* Otto Binder, who had scripted hundreds (451, to be exact) of *Captain Marvel* comic book stories between 1941 and 1953 before going to work for Mort Weisinger, was often chagrined by the visual stodginess of the Superman titles. "Many artists kill the story or make it dull," he complained, "by failing to make good transitions from panel to panel. To keep continuity intact, choosing how (to illustrate) each scene is vital" (quoted in Voger, *Hero Gets Girl*, 44).

smock. He could transport himself mentally into another person's body, including, in 1940, a woman's, a movie star's. At the end of that adventure the transgendered Ultra died in a volcano, and didn't return.

A few months later, in *Action Comics* number 23, Luthor showed up, Ultra's match in gadgetry and goals, but without any physical handicap and sporting a full head of red hair in a bowl cut. When Siegel and Shuster's Superman first meets Luthor and confronts him in a dirigible-lofted hideout, the villain has been inciting an armed conflict between two European nations as part of his greater plan to engulf the continent, then the whole world, in all-out warfare. Although he wears a red cassock and sits on a throne (like Ming the Merciless in *Flash Gordon*), Luthor introduces himself to Superman as "Just an ordinary man—but with th' brain of a super-genius." You can't tell whether he's supposed to sound like a Bowery Boy or some chappie out of a P. G. Wodehouse novel. I tend toward Wodehouse.

Eventually, Luthor moves his criminal operation back to the States, to hideouts in the vicinity of Metropolis (mountaintop citadel, submersible lab). He shuts off the water supply to extort the city, employs narcotic incense to seize mental control of stockbrokers. By his fourth appearance in *Action Comics*, Luthor has managed to lose his red hair and become the familiar cueball-headed villain dressed sometimes in lab whites, other times in Capone/Soviet Politburo pinstripes. (Supposedly he was first drawn bald by accident, in one of the newspaper strips ghosted

by Leo Novak, who might not have been following his appearances in comic books and may have mixed him up with the Ultra-Humanite. Joe Shuster supposedly decided bald was better.)

During the early years of the series, Luthor developed a psychotic hatred for Superman. Eventually he became consumed more by a desire to kill him than to take over the world. His motive for such malevolence, whenever it was mentioned, was attributed to fury at Superman's "meddling." A fairly typical rant: "I'll make him suffer for all the times he defeated me before. I'll play with him like a cat with a mouse! I'll humiliate him again and again until he begs for mercy. Then I'll destroy him."

Not until the Weisinger years, beginning with a story published in *Adventure Comics* number 27 in 1960, did Luthor acquire a *personal* motive (and, for the first time, a first name: Lex. Lex Luthor). The tale introduces readers to a teenaged Luthor (son, we're told, of a traveling salesman) who has moved to Smallville with a creepy celebrity fixation on the town's famous Superboy. He and his hero meet and hit it off (quick-thinking Lex operates a bulldozer to get rid of a kryptonite meteor that has paralyzed Superboy in the middle of a cornfield). Once Superboy discovers that Lex is a "scientific genius," he builds him a backyard laboratory, stocking it with "rare chemicals, some still unknown which [he] burrowed out of the ground, at super-speed."

Young Luthor isn't going to waste time on high school science projects, naturally, and turns his attention to the development of a "kryptonite antidote," a thank-you gift for his new best pal

and benefactor. When Lex accidentally knocks over a flask and the lab goes up in flames, Superboy extinguishes the blaze "with a mighty super-puff of breath," only to discover moments later that it also tipped an acid bottle against the antidote bottle, and the resultant fumes that Lex breathed in caused all of his hair to fall out. Luthor is enraged. "You were jealous of my genius!" He believes Superboy deliberately caused his baldness. Clearly, this supergenius hadn't been wrapped too tightly from the start.

The "origin" of the Superman-Luthor feud, reiterated for decades in stories and footnotes throughout the Superman series, is, you must admit, pretty fruity, but for its intended audience of ten-year-olds it had logic and power: *blamed for something you didn't do!* And in 1960, a completely bald head wasn't quite the macho thing it is now. Yul Brynner. Who else? So, if you were ten, you could see how Luthor might hate Superboy for turning him into a freak, *even if he didn't do it on purpose.*

Probably it was a coincidence—or at least done unconsciously—but during the late 1950s and early 1960s, Wayne Boring, DC's chief Superman artist, drew Lex Luthor with more and more physical bulk and increasingly deeper scowls till he came to resemble a thuggish (or more thuggish) Mort Weisinger. If Weisinger had noticed, he most likely would have been amused. He savored his reputation as a bully, as a barking heavy straight out of gangster movies—a reputation only enhanced one day in 1966 when he summoned Boring to his office and fired him after almost thirty years of uninterrupted service to the company and

the character. "Do you need a kick in the stomach," asked Weisinger, "to know when you're not wanted?" (quoted in Duin and Richardson, *Comics Between the Panels*, 56). You couldn't make this guy up, you could not. Maybe Damon Runyon could.

This wasn't the first betrayal in Boring's long career on Superman. As related by Steve Duin and Mike Richardson in *Comics Between the Panels*, "When Shuster and Jerry Siegel finally sued DC [in 1946–47] over the ownership of the character, Boring wound up in the thick of the fight. 'Jerry hired a lawyer, the lousiest lawyer I've ever seen,' Boring told Richard Prachter. Because Boring was drawing Siegel's character, Siegel sued him for abrogation of contract and told him he was fired. 'Why Siegel's lawyer advised him to do that, I don't know,' Boring said. Jack Liebowitz at DC vetoed Boring's dismissal; DC figured only DC could fire Wayne Boring" (56). Which it did, strikingly so, two decades later.

According to Lynn Wooley, Weisinger had decided "to put Superman in more 'situation' stories rather than in stories involving crime and super villains," and had come to feel that Boring's iconic muscleman, the company standard for twenty years, was wrong for the new style. It projected strength, unassailability— but sensitivity? Not so much. The "emotional stories featured no villains at all," says Wooley, "but rather had Superman return to Krypton to fall in love with a beautiful Kryptonian woman— or, meeting up with another beautiful girl who turned out to be a mermaid—or reliving his college days and how he outwitted a wily professor who was on to his secret identity—or, various

Weisinger 'imaginary' stories about 'what ifs' in Superman's life. This was a natural evolution for a god-like hero who had no real peers among his adversaries" ("'Twixt Joe and Kurt," 29).

Wooley's argument makes sense: Weisinger's new type of Superman stories did, indeed, focus more on emotional events, their plots pivoting on situational premises rather than crime or adventure. But the odd thing is, each story she mentions that typified the "new intimacy" was, in fact, illustrated by Wayne Boring. Maybe her point is that Weisinger was disappointed at how Boring had done them. Which is conceivable. As I've mentioned, the characters Boring drew rarely if ever *looked* at each other, a sizable problem in melodramas of doomed romance.

After Boring got the boot (right in the solar plexus), Curt Swan took over as Weisinger's primary Superman artist. Swan's regular-guy version of the Man of Steel, like Boring's granitic one before him, would remain the house style for a solid twenty years. And there are still plenty of people — the comedian Jerry Seinfeld among them — who insist Swan's Superman is the definitive one.

Described by his daughter as resembling someone straight out of *A Prairie Home Companion* ("'You know, Lutheran. Scandinavian good guy that would never impose his will on anybody'" quoted in Zeno, *Curt Swan*, 52]), Swan began to freelance for DC Comics in 1946, illustrating some of the first Superboy adventures. By 1954 he was penciling (he never inked his own work) the occasional Superman story and all of the stories, three

eight-pagers per issue, for the then-new *Jimmy Olsen* bimonthly, launched to cash in on the character's television popularity and in which Superman invariably appeared. Although Swan never drew his Jimmy Olsen to resemble Jack Larson, he did model his first-pass Superman on George Reeves.

Later on, once Weisinger had brought him onto the *Action* and *Superman* titles, Swan abandoned the Reeves resemblance, instead basing the look of his Superman on Johnny Weissmuller and his Clark Kent on Alex Raymond's comic-strip private eye Rip Kirby. "Mort Weisinger told me early on to soften the jaw that Wayne Boring had put on Superman," he wrote in a brief memoir that appeared in *Superman at Fifty*. "I guess it had been Wayne's way of showing strength and power. Mort wanted the drawing to be more illustrative and less cartoony, maybe a little more handsome" (Swan, "Drawing Superman," 43). Superman's hairline began to recede, fractionally and steadily over the months and then years of Swan's tenure, but that might have been the artist's own autobiographical contribution.

Like everyone else who worked for Mort Weisinger, Curt Swan came in for his full share of verbal abuse. He once quit and took a job at an ad agency after connecting the migraine headaches that floored him to his humiliating experiences with Weisinger. Swan eventually returned to DC because comic books offered a better income (it must have been a really small ad agency) and realized that if he ever hoped to be rid of his headaches, he would have to stand up to Weisinger the bully. "He was a very sick, inse-

cure man," Swan said. "Most people were cowed by his presence. Eventually I had no fear of Mort and I would chew his ass out" (quoted in Duin and Richardson, *Comics Between the Panels*, 431).

With that ogre you had to, it was the only way. You needed to put down your foot when he demanded another (the fourth? the fifth?) round of corrections or revisions. You had to raise your voice. Stick up for yourself. If you didn't, you were super-mincemeat. Some of Weisinger's contributors could stand up to him and some couldn't. Otto Binder, creator of Brainiac, Kandor, Supergirl, the Legion of Super-Heroes, and the Bizarro World, by far the most inventive and reliable of the Superman writers at the time, could not; rather than continue to work for Weisinger, he quit the field in 1960.

Don Cameron, who had scripted Superman stories since the 1940s, once became so enraged that he tried to push Weisinger out of his office window, nine stories above Lexington Avenue. "I gladly would have started the fund to hire a good defense lawyer," Murray Boltinoff, another DC editor, quipped about the famous assault (quoted in Duin and Richardson, *Comics Between the Panels*, 463).

The horror stories still told about Weisinger are legion. You'd pitch him a story and he'd call it crap, then kick you out and hand over your idea to the next writer who showed up. He'd ridicule your tie, your suit, your shoes if they were scuffed. He'd send a writer, *any* writer, *every* writer, home on the subway to revise a script—again!—again! This is *dreck!* This is worse! Do it

over. You moron! You idiot! Mort Weisinger was a mean son of a bitch, no getting around it. Focused, populist, visionary; hurtful, ornery, egotistical. The John Ford of comic books.

29

Weisinger claimed he'd first started trying to quit the Superman grind around 1965. Times had changed—alarmingly for a political reactionary like himself who had railed in the past against pinkos and commie symps on the DC payroll. The future just wasn't what it was supposed to be. He felt out of touch. As Will Murray observes, writers of letters to the editor who previously had "challenged logical lapses or crowed over boo-boos that had gotten past Weisinger [now] wondered why Superman wasn't solving social ills or dealing with the seemingly endless stalemate in Vietnam" ("Superman's Editor," 13). But Superman didn't *do* social problems. At least that's not how Weisinger understood him. Or wanted him.

But whenever he said he was quitting, Jack Liebowitz just gave him another big raise and sent him back to work.* In 1970, though,

* Scrappy Harry Donenfeld died in 1965. The story of his last years, as related by Gerard Jones in *Men of Tomorrow*, is bizarre. The week before he was to wed his longtime mistress in 1962, Donenfeld, who'd been drinking alone in a hotel room, fell and struck his head. "Injured as he was," writes Jones, "he managed to crawl into bed. The next day [his son] Irwin found him there. . . . When Harry finally woke, he was blank. He seemed not to recognize his son. He didn't speak. . . . Harry lived for three more years. He became more functional with time, but he never regained his memory" (293).

Liebowitz himself was preparing to move on—the former accountant, now a fabulously wealthy man of business, a philanthropist with his name all over the place in New York City and on Long Island, had been offered a seat on the board of directors of Warner Communications, which now owned DC Comics—and Mort Weisinger's resignation as the uncontested Superman czar at last was accepted. He was only fifty-five, but "suddenly," according to Murray Boltinoff, "he was a poor old man, really sick." Weisinger weighed three hundred pounds, give or take, his breathing was labored, his digestion was shot, and he had heart troubles. "Which," said Boltinoff, "proved he had a heart anyway. A lot of people doubted that" (quoted in Duin and Richardson, *Comics Between the Panels*, 464).

As Weisinger reckoned things, he had edited more than two thousand Superman stories—each one specifically written and drawn to entertain a readership of nine-, ten-, eleven-, and twelve-year-olds. But so had almost every other comic book story (whether about a superhero, a billionaire duck, Gene Autry, Jerry Lewis, or a company of U.S. soldiers still fighting World War II) published in the United States since the establishment of the Comics Code Authority in 1954. The postage-stamp-sized official seal of approval printed large on the cover (upper right-hand corner) guaranteed the contents to be as morally unobjectionable as a seed catalog.

Because of the code, which the industry established to regulate (read: save) itself following the Wertham attacks and the night-

marish U.S. Senate investigations, comic books were scoured not only of violence and gore, "salacious illustrations and suggestive posture," but of anything, anything at all, that didn't corroborate every hypothetical rock-ribbed Main Streeter's ideals of prudence or commendable conduct, or adequately "emphasize the value of the home and the sanctity of marriage." Crime was to be punished, authority and authority figures were to be depicted favorably, "slang should be discouraged and whenever possible good grammar . . . employed." Characters even had to be "depicted in dress reasonably acceptable to society" ("Code"). (Masks, capes, leotards, and utility belts all fit the bill.) "That meant," writes Gerard Jones, "that comics could show even less than TV, and every one of them would have to be aimed at kids" (*Men of Tomorrow*, 278).

So?

Although the first comics I read were syndicated newspaper strips, by the age of eight I'd already developed a parallel and often stronger passion for comic books: not so much because they were produced specifically for me and my kind, but because they were things I could choose for myself, stopping after school into one, or all, of my neighborhood candy stores. I could select, discriminate, make value judgments depending upon the cover. I could evaluate, determine favorites. That seemed important, an important pleasure to indulge and develop. A *skill*.

Before I started revisiting Superman comics to write about them, there were at least a dozen stories I read during the late

1950s, early '6os that I still distinctly remembered (the memories, I admit, more beguiling than treasured, but still, beguilement is not too shabby a pleasure) and could tick off without trouble, among them the first Bizarro story (in *Superboy* number 68), the first Kandor story (*Action* number 122), the arrival of the mermaid Lori Lemaris, Clark Kent's college sweetheart (*Superman* number 129), of Titano the superape (*Superman* number 138), of Metallo and of Supergirl (both in *Action* number 252).

While I bought a lot of comic books as a kid that weren't Superman titles (or DC titles for that matter), and while I preferred *Flash* and *Green Lantern* and *The Atom* for their sleek illustration-based art and faster plots, I always picked up and read (maybe not first, but always on the day of purchase) every title in the Superman line whenever a new one appeared in a spinner rack.

If I were sick in bed with measles or the mumps, those were the comics I'd ask someone to bring home for me: they gave the most solace. Superman's world was comfortable and comforting, and in its own loony but legitimate way, ethically articulate. "Of all the superheroes, Superman made the biggest impression," the graphic designer Arlen Schumer has written in a memoir about growing up fatherless in the 1950s. "I barely knew how to read, but I could 'read' Superman! Through him, I understood the difference between right and wrong—what it meant to be a hero. If moral instruction and inspiration are what fathers are supposed

to provide, then Superman was my de facto father" (*Silver Age*, 176).*

Growing up in circumstances similar to Schumer's (absent dad), I felt pretty much the same way. Superman didn't take me out to ball games at Yankee Stadium or show me how to build an operating Ferris wheel from an erector set, but he was a reliable presence in my life, and an example.

Weisinger's Superman may well have been, as David Mamet wrote, "a dull fantasy" in many respects, but it was a *consistent* fantasy, you could live inside of it, it made sense. To a ten-year-old it could sometimes make profound sense.

Stories often turned on the obligations of loyalty or the hero-ism of taking a difficult stance. And it wasn't so much invulner-ability and superstrength that saved the day, it was good thinking. And not always *quick* thinking, either—but tactical and strate-gic thinking. Weisinger presided over the creation of both an integrated fantasy and an extended family (and vice versa) that children could believe in and belong to. In those comics were everything a kid's imagination needed for nourishment, except the glamour of rebellion. But for that we had *MAD* magazine—twenty-five cents, cheap!

Weisinger also abetted something he may not have consciously

*And moral instruction wasn't the only perk: "Comic books," says Schumer, "taught me everything I know! How many other 8-year olds had a vocabulary *rife* with words like *invulnerable—elongated—incognito—origin*—and *hoax!* And phrases like 'to no avail'" (176).

intended but that was at least as significant. By publishing a letters page in each of the seven titles, he encouraged—stoked—the kind of clubby, chummy fandom for readers of Superman comics that as a kid he'd helped create for like-minded teenagers obsessed by the science fiction pulps. His letters to the editor columns invited readers to comment on stories as they came out, which in turn influenced the kinds written and published later. Because their comments were taken seriously (and acknowledged, often praised, in italicized replies by the editor), Weisinger's readers took the stories and characters seriously, feeling free to point out, gloating with self-satisfaction, errors of consistency and motivation.* Weisinger sometimes tried to weasel out of a mistake, but more often simply admitted the "boo-boo" and promised to do better. Fair enough.

With close readers dogging every panel, Weisinger wanted all of his Superman stories, about twenty a month, to fit together logically. He also demanded that his writers contrive plots that built on previously introduced hooks and devices. Something called "continuity" entered the fan lexicon and gradually became its fundamental dogma. By 1970, when Mort Weisinger retired, that byzantine cohesion had become the hallmark of American

*Traditionally (before, say, 1965), you didn't "collect" comic books: you bought one, you read it, you rolled it into a tube and stuck it into your back pocket or school bag—then maybe you passed it along to a friend or it was confiscated by a teacher or parent, but pretty soon it disappeared. It cost a dime. It killed half an hour. It certainly wasn't a *lifestyle*.

superhero comic books, driving away casual readers and stopping younger ones dead in their tracks. After decades of being a narrative medium where nothing ever changed, it had become one in which change virtually described the covenant. (Second-tier or middling popular characters could even die.) (They just couldn't *stay* dead.)

As a boy I never wrote to any of the Superman titles. I wanted to, but how could I have competed in fluency or analytical intelligence with the handful of readers whose cocky and enthusiastic letters appeared month after month? Those letters read as though they'd been composed by—well, by high school seniors on the honor roll, or college students, or grown-ups! And for the most part they had been.

Weisinger's (and later over at Marvel Comics, Stan Lee's) integrated titles had the unplanned effect of attracting a new kind of fan, older than ten, older than fifteen, often older than twenty, the first generation of bona-fide geeks who simply forgot to stop reading comic books in ninth grade and kept on going until not reading them became unthinkable. By the early 1970s, nearly all of the rookie editors and writers and artists entering the comic book field came from that first wave of boomer correspondents who knew the ephemera and incunabula (the name of Supergirl's orphanage, the distinctive properties of various kryptonites, the permanent menagerie at the Kandoran zoo) and discussed newsstand comics with a priestly seriousness and reverence aging pros

of Mort Weisinger's generation could never have imagined with a straight face.

When Weisinger had taken over as editor, Tom Crippen points out, Superman comics, "the baby boomers' elemental comic book experience . . . were read by the most kids at the youngest age" ("Night Thoughts," 166). By the time he quit, things had changed, drastically. Thanks in large measure to those letters pages (or in geekspeak: "lettercols"), the genre had become less and less (and then not at all) something produced for young children. It became entertainment for adolescents; for seasoned readers, for *initiates*. And for adults pleading a harmless lifetime hobby.

<div align="center">30</div>

That the Superman stories he'd edited would ever be collected into books the way the stories of Bernard Malamud or Katherine Anne Porter were collected would have seemed absurd to Mort Weisinger, as it would have to his fellow editors—all of whom were old-school profit-and-loss magazine men, most of whom held the stuff they produced in varying degrees of contempt. At the very least they maintained a self-deprecating perspective; Vincent Sullivan, the first editor of *Action Comics*, once opined that publishing comic books was like operating a candy bar factory.

But with the gradual elevation of comic books in the precincts

of popular culture (and as the ever-nostalgic boomer genera-
tion becomes the Social Security generation), more and more of
Weisinger's stuff has been finding its way into pricey full-color
"archival" hardcovers, as well as inexpensive black-and-white
paperback collections published under the generic title *Showcase
Presents Superman.*

For good reason, the first *Showcase* (released in 2005) opens
with *Action Comics* number 261, cover-dated June 1958. Although
Mort Weisinger had been assigned to the Superman titles since
the early 1950s, it wasn't until late 1957, following the departure
of supervising editor Whitney Ellsworth (lost forever to Holly-
wood) that he took absolute control.* The June 1958 issue not
only marked the twentieth anniversary of *Action* number 1 (June
1938) but also introduced Superman's Arctic-based Fortress of
Solitude and featured Batman and Robin as costars, underscor-
ing their mutual friendship outside the pages of *World's Finest*,
the regular team-up book. In temperament, emphasis, and look,
Action number 261 inaugurates Weisinger's absolutist reign.
The initial volume of *Showcase* reprints every subsequent issue
of *Action* through number 257 (October 1959) and every issue
of *Superman* from number 122 (July 1958) through number 133
(November 1959). All told, 560 pages.

Holding this mammoth thing, you realize just how much new

*Whitney Ellsworth developed a pilot for a Superboy TV series in 1961, but it
didn't sell. A few years later, however, he was invited to help create the Adam West
Batman series. He retired in 1970 and died in 1980.

material came out of Weisinger's mill each month. Individually, stories run from howlingly stupid to clever to genuinely touching. They are almost never exciting, or suspenseful, but they are almost always sincere. No, not almost. Always.

More satisfying than the actual stories (at least to the writer-me) are the creator credits on the *Showcase* table of contents, credits that didn't appear in the original comic books. Writer: Jerry Coleman/Artist: Wayne Boring. Writer: Otto Binder/Artist: Al Plastino. Writer: Bill Finger/Artist: Kurt Schaffenberger. Writer: Alvin Schwartz/Pencils: Curt Swan/Inks: Stan Kaye. Writer: Ed Hamilton/Pencils: Curt Swan/Inks: Sheldon Moldoff.

Some names show up frequently, some occasionally, some just once or twice. And then there's a name that doesn't show up till the very end of the table of contents. It appears as the writer credit for two consecutive nine-page stories reprinted from *Superman* number 133, cover-dated November 1959, the first story drawn by Al Plastino, the second by Curt Swan, and the name practically leaps off the page: Jerry Siegel. "How Perry White Hired Clark Kent." Writer: Jerry Siegel. "Superman Joins the Army!" Writer: Jerry Siegel.

Jerry Siegel?

After twelve years spent schlepping around the comic book wilderness, writing for every publisher but DC, writing and then not-writing, editing and then sacked, struggling, slipping, living near poverty, then actually falling into it, desperate and

frightened and sullen—after twelve years and at the age of forty-four, Jerry Siegel returned to DC Comics in late 1959 and began scripting Superman stories again. How it happened might have been dreamed up by Rod Serling or Paddy Chayefsky for some neoproletarian live television drama of the period. Gerard Jones in *Men of Tomorrow* credits Siegel's second wife:

> The former Joalan Kovacs had an angry, Hungarian loyalty that fixed itself on an enemy and lashed out. She had already been nagging [DC Comics] off and on for years. When financial crisis struck—the diaper service cut off, the rent on their one-bedroom apartment missed—she would call *Superman*'s publishers and demand that they help. She even told them Jerry was writing letters to newspapers telling his side of the story. And the money came, a hundred here, two hundred there. This time, though, the situation was too dire for a hundred or two to bail them out. "This is Jack Liebowitz's fault," she insisted. "He owes you something." When Jerry refused to go contact Liebowitz, Joanne said she'd do it for him.
>
> Jack agreed to see her, but he wouldn't agree to give Jerry work. He'd done everything for Jerry he'd been legally bound to do and then some, he said, and Jerry had repaid him with an expensive and embarrassing lawsuit. In Jack's mind Jerry was out of the family.
>
> "Listen," said Joanne. "Do you really want to see a news-

paper headline reading 'Creator of Superman Starves to Death'?"

Liebowitz knew he couldn't afford to call her bluff. He told her he'd ask Mort Weisinger to assign Jerry a Superman script and see how it went. [He] did impose one condition: that Jerry never claim publicly to be one of the creators of Superman. Joanne agreed. (283)

So did her husband. But despite that mortification, compounded by another, equally bitter one that slashed his writer's fee to a baseline ten dollars a page from the fifty a page he'd earned back in 1947, Siegel reclaimed his creation with a vigor and earnestness no one had any right to expect.

The first handful of stories he contributed during his anonymous second coming are crude concoctions, rife with dated tomfoolery and a juvenile fondness for practical joking ("How Perry White Hired Clark Kent," for instance, finds the Man of Steel dressing up in a cheesy Abbott and Costello gorilla costume). You can't tell whether he's trying too hard, which he probably was, or not trying at all. Soon, though, Siegel's work, appearing regularly in both *Superman* and *Action Comics* (and reprinted in subsequent volumes of *Showcase Presents*), has a clarity it never showed, or seemed capable of showing, before. His captions are still clunky and his dialogue is nearly as lugubrious as before (although who can say how much is Siegel's and how much the meddling Weisinger's?), but this is not the disorganized, free-

associational, agitprop writer of yesteryear and Cleveland; this is somebody new: a craftsman, a pro. Seasoned, to say the least.

Mort Weisinger had found in Jerry Siegel the perfect writer to give him the kind of "emotional" stuff he wanted and believed his readers instinctively craved. "Most of the stories," writes Gerard Jones,

> still turned on goofy shenanigans or evil schemes of Luthor and Brainiac, but they were regularly punctuated by tear-jerking returns to Krypton, "imaginary stories" in which Superman's loved ones died, and churning melodramas of betrayal and loss. . . . [Siegel] found every way there was to have Superman marry or lose Lois, every way for Superboy to encounter his real parents or lose his foster family. All the implicit but unexamined themes in Superman's origin— orphan hood, immigration, lonely American boyhood, the passage of Moses—were laid bare on the page now. (*Men of Tomorrow*, 288)

Jerry Siegel's original Man of Steel had been nothing like this. The first Superman was "above caring that he'd been sundered from his home world and his parents. His charm was his laughing invulnerability. Jerry's new Superman was a superhero because of his tragedy. His power was his superhuman grief" (288). Imagined and dramatized by a middle-aged man who knew a little something himself about grief—not to mention separation, loss, iniquity, and cosmic bad luck. To Danny Fingeroth, Siegel's new

stories displayed "a distinct yearning . . . for things lost, whether for European Jewry itself, or, more personally for Siegel, for the glory days of his own lost youth, specifically the days when he was reasonably well paid and respected—if not by his employers, then by the greater world—as the co-creator of perhaps the best-known popular culture figure in history" (*Disguised as Clark Kent*, 84).

But as inspired as Siegel was, ten dollars a page was still ten dollars a page, and no matter how much material he turned out over the next six years, he never could make a decent living. (In any given month, he might contribute a twelve-page lead story to *Action Comics* and two or three six-pagers to *Superman* and *Adventure Comics*. Do the math.) In private, Weisinger confided to colleagues that Siegel was the "most competent" writer in his stable (quoted in Murray, "Superman's Editor," 13), but he'd be damned if he'd tell *him* that. What he mostly told Siegel was "do it over."

Jerry Siegel simmered again with resentment. It was galling! He shouldn't have to work so hard. He should be rich, he ought to be famous. Knowing that DC Comics would have to renew the Superman copyright in 1964, Siegel hired another lawyer and filed a second lawsuit to contest it. Joe Shuster, who by then had moved with his brother to a rundown neighborhood in Queens, New York, and was working intermittently as a deliveryman and courier, declined to participate. As had happened in 1947, the court, with a shrug, found for the defendant, who promptly fired

the plaintiff. And this time Jack Liebowitz made it clear: Jerry Siegel would never work for his company again.

Relying on pro bono legal aid, Siegel appealed the court's decision, futilely. In the meantime he picked up some freelance work at both Archie and Marvel Comics, and turned out the occasional Donald Duck story for Disney's Italian comic book division. It wasn't enough. He struggled on in New York for several more years (at one point selling off his comic book collection to pay bills), then moved with his wife and daughter to southern California, where at the age of sixty, he took a civil service exam and landed a clerk-typist's job at the Public Utilities Commission. It paid around seven thousand dollars.

31

Even before Jerry Siegel got the axe at DC that second time, my years as a constant reader of Superman comics had ended. I was fourteen, fifteen, in high school, and the stuff that once enchanted me no longer did. I'd moved on to more angsty superheroes like Spider-Man, to Ian Fleming and Eric Ambler novels, to science fiction, *Newsweek*, the Beatles, Motown. (I'd even read *A Portrait of the Artist as a Young Man*. Most of it.) I was—to paraphrase Bob Dylan, yet another then-new interest of mine—just doing what I was supposed to do. I was growing up.

Anyway, as Mark Waid observes, "innovations in the Superman saga were coming fewer and much farther between now that

his alien heritage had been strip-mined for potential and Earth had become overpopulated by Kryptonians" (Introduction, 9). The eccentricity and relaxed confidence slowly drained out. With Curt Swan still doing most of the drawing, or at least providing the template, Superman comics continued to *look* the same; it was the stories, and the quality of storytelling, that deteriorated.*

Throughout the comic book medium's so-called Golden and Silver Ages, the same bunch of freelance writers from Manhattan, north Jersey, and Long Island had provided most of the scripts at DC. They'd been loyal, they'd been reliable, but now they were guys (all guys) in their forties and fifties, even sixties, and the future was making them nervous. In 1968 they tried to organize a company union. According to Steve Duin and Mike Richardson, they "were looking for better pay rates, reprint rights, medical insurance, and a noose for the cantankerous Mort Weisinger" (*Comics Between the Panels*, 180). But when they brought their grievances and proposals to Jack Liebowitz, they were summarily and permanently dismissed. The Great Philanthropist. Take a hike. And that was that. In a period of months, practically all of the old pros at DC were gone, replaced by young and eager comic book geeks tribally steeped in finicky trivia but glaringly deficient in narrative skills. The English majors among

*That would seem to be the prevailing judgment even at the House of Superman itself; in an anthology published by DC Comics purporting to contain the "best" of the 1960s stories, only one out of seventeen stories collected was originally published after 1964.

them came in determined to raise literary standards and ended up just being wordy.

By decade's end, most Superman stories were as ungainly as they were self-referential. Asterisks and footnotes superabounded for close and serious readers—the only ones who counted—needing to confirm an allusion to some years-old episode involving, oh, say, the Legion of Super-Villains. The fans had taken over the fantasy, and for the first time since the early 1950s, sales of the Superman titles fell off. But as far as Warner Communications was concerned, that was okay or at least no cause for alarm: the new owners seemed more interested in licensing their "properties" than in publishing comic books anyway.

32

After TV's *Adventures of Superman* finished its six-year run in 1957, the Man of Steel became strictly a comic book and newspaper-strip franchise again.* It remained so for almost a decade, till Filmation Studios, a budget animation shop that primarily served ad agencies, optioned the character for a series of Saturday morning color cartoons. The executive producer was Allen Ducovny,

*Like nearly every other syndicated adventure strip, *Superman* had been steadily losing client newspapers since the early 1960s, its popularity undermined and dimmed by simply drawn gag-a-day features like *Peanuts*, *B.C.*, *Beetle Bailey*, and *Hi and Lois*. It was finally discontinued in 1967, after a run of twenty-seven years.

who'd developed the original Superman radio program with Robert Maxwell a quarter of a century earlier. Which explains, I guess, why Bud Collyer, by then an avuncular television game-show host (*Beat the Clock, To Tell the Truth*) was invited back to contribute the voice acting for Superman and Clark Kent. He wasn't the only radio veteran, either. Joan Alexander did the voice of Lois Lane again, and Jack Grimes returned as Jimmy Olsen. Even Jackson Beck, Superman's longtime broadcast announcer (". . . yes, Superman! . . . Strange visitor from another planet . . ."), came back. Ted Knight, later to become famous as goofus anchorman Ted Baxter on *The Mary Tyler Moore Show*, provided the exasperated voice of *Daily Planet* editor Perry White.

The New Adventures of Superman, each half-hour show comprising three six-minute cartoons (the first and third featuring Superman; the second, Superboy), premiered in September 1967 on CBS. Despite scripts of unfailing blandness and limited animation that made characters move like placards bobbing on a tired picket line, it scored a hit with millions of preschoolers in footed pajamas hunkered scarfing Trix on living room sofas. Eventually expanded to sixty minutes and televised under a variety of different titles (*The Superman-Aquaman Hour of Adventure, The Batman/Superman Hour*) the series continued until 1973, when the rights passed from Filmation to Hanna-Barbera. H-B simplified figures and backgrounds even further, added a few second-string DC heroes and a couple of kid characters to the cast, and rechristened the whole lusterless package *Super Friends*, a show

Throughout the 1970s, Superman and several of his equally stiff *Super Friends* showed up every Saturday morning in a series of lackluster Hanna-Barbera limited-animation cartoons (PhotoFest Digital, © DC Comics)

meant not really for *watching*, but for *being on*. It didn't interfere with homework, board games, listening to records, or tormenting siblings. It never presumed.

For children born around the time of the Woodstock Music and Arts Festival and the Manson murders, *this* was the imprinted Superman: the blue-haired, small-headed stiff guy on *Super Friends* who told everybody what to do in a pompous baritone (by then, Danny Dark had replaced Bud Collyer) but hit the ground like a felled ox the second some cackling villain produced a hunk of kryptonite ore, which seemed as plentiful as boulders in Maine.

Who do you like better, Superman or Batman?

What're you, kidding me?

33

Most people I've mentioned it to have been surprised to hear there had once been a full-blown musical about Superman. A Broadway show about *Superman?* Are you sure? I'm sure, yeah, and it premiered at the Alvin Theatre in New York City on March 29, 1966. Those handful of people who *vaguely* remember hearing about *It's a Bird, It's a Plane, It's Superman* always "seem to recall" its being a major flop, something along the lines of *The Moose Murders* or *Carrie*. But it wasn't. Most reviews were positive, Patricia Marand won a Tony Award for her portrayal of Lois Lane, and while the production ran only through the middle of the following summer—129 performances—it hardly ranks among notorious show business fiascos. I was seventeen, a junior in high school, when the show opened, and even though I lived just an hour and a half from midtown Manhattan, it never crossed my mind to go see it. That winter I was still playing Bob Dylan's *Highway 61 Revisited* over and over and couldn't imagine myself enjoying a *musical*, even it *was* about Superman.

Many years later, at the end of the 1980s, when I was a member of the BMI theater workshop in New York and drafting (floundering, *trying* to draft) a libretto (those things are *hard!*) with two songwriter friends of mine, somebody mentioned the Superman

musical one evening and immediately somebody else started to sing:

> Every man has a job to do and my job is doing good
> Every night when the job is through, I fold my tights, proud
> to know
> I've done all I could
> It's a satisfying feeling when you hang up your cape
> to know you've avoided murder, larceny and rape
> Every man has his job to do
> (Well, back into the old Clark Kent disguise)
> I'll never stop doing good! (Adams, "Doing Good")

After he'd gone through all of the verses, I asked the singer if he'd seen the original production; no, he said, but when he was a kid he'd gone to a revival in St. Louis in 1967 or '68 (Bob Holiday, who'd played Superman on Broadway, reprised the role there) and grown up listening to the cast album, which his parents owned. I left the workshop that evening with the song lyrics rattling around in my head, although the tune had vanished utterly, my first clue why the show had played just five months in New York and then been generally forgotten.

The songwriting team of Charles Strouse and Lee Adams, who'd been successful with *Bye Bye Birdie* in 1960 and the musical adaptation of Clifford Odets's *Golden Boy* in 1964, were looking for a next project when they asked the magazine writers David Newman and Robert Benton whether they had any interest in

producing the book. And if so, did they have any good ideas? It was Newman's wife, Leslie, who suggested Superman after picking up a bunch of *Action Comics* from their kid's bedroom floor. Newman and Benton thought it an inspired recommendation—this was, after all, the Pop Art era of Warhol lithographs and Lichtenstein paintings—and so did Strouse and Adams. Although usually it had taken the composers at least two years to write a score, *It's a Bird, It's a Plane, It's Superman* was finished in just thirteen months.

After listening half a dozen times to the original cast recording, available again on CD, I think maybe they should've taken those extra eleven months. A few of Strouse's melodies are middling catchy, but most are shapeless and forgettable, the kitschy production numbers so dated you could frug to them. Adams's lyrics are flat and thudding, syllables missing notes far more often than they hit them.

Directed by Harold Prince, *It's a Bird, It's a Plane, It's Superman* at first enjoyed good box office, particularly at matinees, whose audiences were filled mostly with children. But after several weeks, writes Jake Rossen in *Superman vs. Hollywood*, "ticket sales slowed to an absolute crawl. . . . In all probability the matinees infected the show with the stink of juvenilia; adult theatergoers likely dismissed it as little more than a place to take listless kids on rainy afternoons" (47). At least until Andrew Lloyd Webber and the Disney organization colonized the street, audiences for musicals generally considered themselves a fairly sophisticated

Bob Holiday belting out a tune by Charles Strouse and Lee Adams as he
swoops across a Broadway stage in *It's a Bird, It's a Plane, It's Superman*, 1966
(PhotoFest Digital, © DC Comics)

bunch. Superman was no Henry Higgins, Lois Lane no Dolly
Levi — and besides, the competition on Broadway that season in-
cluded *Man of La Mancha*, *Cabaret*, *Sweet Charity*, and *Mame*. The
Man of Steel was no match for a deluded prisoner of the Spanish
Inquisition, a couple of party girls, and a wealthy bohemian with
flair.

"We thought we had caught the crest of the Pop Art trend . . .
but we were wrong," Charles Strouse said many years later about

the show. "Broadway audiences were not aware of the trend, and, as a matter of fact, Pop Art did not have the effect a lot of art critics thought it would have. At the time, everyone thought that it was such a breath of fresh air, but it became only a passing trend, and riding a trend can be a very dangerous thing. . . . Audiences took the story at face value and didn't respond to it the way we thought they would" (quoted in Scivally, *Superman on Film*, 69).

It's also likely that the success of Adam West's *Batman* series, which by a fluke had premiered on ABC-TV only two months before the show's opening, shortened *Superman*'s Broadway lifespan. "Audiences," writes Rossen, "may have considered it redundant to go pay for the same kind of camp attitude found on TV for free" (*Superman vs. Hollywood*, 48). As David Newman put it at the time in his postmortem, the show was killed by "capelash" (Scivally, *Superman on Film*, 69).

I don't know about that. Maybe, but after reading the libretto, lyrics, and book, I can't help thinking the root cause of the show's failure boiled down to simple bad faith. Nobody involved seemed to have any real idea of who and what Superman is, or what makes him tick. What makes him work. What the fable is.

Newman and Benton's book takes every opportunity to shift the focus away from Superman to the tiresomely stock character of gossip columnist Max Mencken (played on Broadway by the scene-stealing Jack Cassidy, the only undisputed "star" in the production) and a cornball villain named Dr. Abner Sedgewick, who seeks vengeance upon the world for not awarding him the

Nobel Prize. (Why the whole world? Why not just Sweden?) The main plot, such as it is, revolves around Sedgewick's scheme to destroy Superman's fragile ego and self-esteem and break his heart by turning all of Metropolis against him — the wrongheaded assumption being that *Superman does what he does because he needs to be loved.*

But Superman does what he does because it's what he *likes* to do. It's a job he invented, a profession he made up. It has nothing to do with any ferocious need to be loved and worshiped as a *celebrity*. Superman "knows instinctively," says Mark Waid, "that it is only when he puts his gifts to use that he truly feels alive and energized. Only by acting to his full potential . . . can he genuinely participate in the world around him. . . . When he lives as who he really is, in full authenticity to his nature and gifts, and then brings his distinctive strengths into the service of others, he takes his rightful place in the larger community, in which he now genuinely belongs and can feel fulfilled" ("The Real Truth," 10).

What's love got to do with it?

34

In the first Superman adventure that Siegel and Shuster presented to Vincent Sullivan during the early winter of 1938 for inclusion in *Action Comics* number 1, it was a single "passing motorist" (a grim, hook-nosed ringer for Dick Tracy in a fedora and trench

coat) who risked life and limb to pull the extraterrestrial "sleeping babe" (sleeping? after *that* impact?) from the burning rocket ship, then delivered him to a nameless and nearby orphan asylum, where presumably he grew to adulthood. In that purest of origin stories, Superman the hero invented himself. No mention is made of anyone loving him or guiding him, attending to his social or moral instruction. Why does Clark Kent decide, upon reaching adulthood, to put on a tight-fitting caped costume and do good in the greater world? Because *he wants to;* because his benevolence and altruism are congenital, constitutional. (The debut storylines for both the daily and Sunday *Superman* newspaper strips that McClure launched and syndicated in 1939 and which Siegel scripted reiterate the single-motorist account.)

With National Comics' publication of *Superman* number 1 in the summer of 1939, the origin was expanded and reimagined, and now it was an "elderly couple, the Kents" who find the infant swaddled inside of a small, safely landed rocket ship (no fire this next time). The craft resembles an old-fashioned cradle plonked down in the middle of a grassy meadow. The Kents turn the baby over to an orphanage, where he wreaks immediate havoc, so much so that when the Kents later return, wondering whether they might adopt him, the director of the place is only too glad to hand him over. (Siegel's first, but probably unconscious, slap at institutional bureaucracy: you have in your care a baby that hangs from chandeliers *and you don't notify anyone?*)

In the following panel (Joe Shuster's drawing depicts the

seated couple addressing Clark, who looks by then to be around seven or eight years old) a caption informs readers that "The love and guidance of his kindly foster parents was to become an important factor in the shaping of the boy's future." Mr. Kent (he wouldn't be designated "Pa" or his missus as "Ma" for nearly another decade) rests a hand upon Clark's shoulder and says, "This great strength of yours—you've got to hide it from people or they'll be scared of you!" Which displays a pretty bleak notion of human nature he's passing on to his son. Mrs. Kent (her name is Mary, we're told, although Mr. Kent remains first-nameless) adds what will be Siegel's only nod to the humanizing benefits of his hero's having been raised in a good American home: "But when the proper time comes, you must use it to assist humanity." *Humanity consists of a grim and suspicious bunch of creatures, Clark, but spend your entire life helping them out anyway, why don't you?*

And that's it for Siegel and Shuster's take on family values. The rest of the first story in *Superman* number 1 is devoted to Clark's discovery of his abilities as an adolescent and a teenager—leaping moderately tall buildings, lifting sedans, racing trains, breaking vaccination needles—and it's interesting to notice that his early adventures occur in an urban milieu. Apparently *these* Kents, the ur-Kents—like the Siegels and the Shusters of Cleveland—are city dwellers. Not until the late 1940s would Superman's heartland upbringing become central to the story line. By the close of the two-page origin, the gray-haired Kents have passed away; Clark is fully grown, and a caption explains that while their

deaths "greatly grieved" the young man, they also "strengthened a determination that had been growing in his mind. Clark decided he must turn his titanic strength into channels that would benefit mankind. And so was created Superman, champion of the oppressed, the physical marvel who had sworn to devote his existence to helping those in need!"

Siegel and Shuster's meaning seems clear: while the Kents were kindly and had obviously steeped Clark in their compassionate values, they were only "one factor" in his deciding how to comport himself as a grown man; their example only "strengthened" the idea that already "had been growing" in his mind. Consider the use of the past perfect tense there, and here too: "And so was created Superman . . . who *had sworn* to devote his existence to helping others in need" (my emphasis). *Had sworn even before his foster parents passed away.* (Jerry Siegel may not have been the most felicitous of prose writers, but the guy knew his English grammar.) The original Superman made his own choices; he invented himself. He was a creature of free will. *That* was the hero a million American kids seized upon as their avatar, their hero, in the final years of the 1930s.

Once the original Superman made his career decision, he never looked back; the Kents were not mentioned again in the stories that Siegel and his first ghostwriters turned out during the initial run of the series—nor were they referenced at all in the popular radio program: in the broadcast series' peculiar spin on the origin, Superman left Krypton as a baby and arrived on

Earth an adult with a deep baritone voice and a superb grasp of snappy American speech.

It fell to George Lowther, the program's original announcer (and later its producer) to introduce and finesse the idea that Clark Kent became Superman primarily because of the moral instruction he received throughout childhood from his foster parents, a farming couple who embodied the ideal Jeffersonian rural life.* In *The Adventures of Superman*, a children's novel published in 1942 by Random House (with drawings and paintings provided by, or at least credited to, Joe Shuster), Lowther presents the Kents, Eben and Sarah, as the shapers of Clark/Superman's altruism while also larding the story with overt New Testament elements: "Destiny perhaps played a part in directing the rocket to the Kent farm, for the Kents were childless and desired a child above anything else on earth. And here, like a gift from Heaven, was the infant Kal-el. The old couple took him into their home and raised him as their own" (24). Lowther also created a detail, a bit of business, that has carried across seven decades: the boy was named Clark because that was his foster mother's family name.

It was Lowther, as well, who invented and first dramatized the

*In addition to his work on the Mutual Radio Network's *Adventures of Superman*, Lowther, who was born in 1913, produced, directed, and wrote for a number of other successful radio programs, including *Dick Tracy*, *Roy Rogers*, and *Terry and the Pirates*. Later, on television, he wrote, directed, and produced for the *United States Steel Hour* and for the long-running afternoon soap opera *The Edge of Night*. In 1963 he joined the faculty of the Famous Writers School, headquartered in Westport, Connecticut, where he lived for most of his adult life. He died in 1975.

now-famous deathbed scene between Clark and his father that has been recapitulated numerous times since in comic books, films, and television. As he lays dying, Eben, sounding more like a nineteenth-century man of the cloth than a Depression-era farmer, tells his son, "Y're a—a modern miracle, that's what ye be. 'Tis not for you nor me to question the ways of God. But these powers ye have, lad, and it rests with you whether ye'll put them to good use or to bad! There's great work to be done in this world, and you can do it. Ye must use these powers of yours to help all mankind. There are men in his world who prey on decent folk—thieves, murderers, criminals of every sort. Fight such men, son! Pit your miraculous powers against them! With you on the side of law and order, crime and oppression and injustice must perish in the end."

By the time Lowther invented Eben Kent's entreaty that Superman should always act on the "side of law and order," over in the comic books, the character's first years of vigilantism already had drawn to a close, and when the character's origin was retold there again in 1948 (*Superman* number 53, script by Bill Finger), his paralegal mission was once again embedded in his foster father's deathbed soliloquy: "There are evil men in this world . . . criminals and outlaws who prey on decent folk. You must fight them . . . in cooperation with the law!"*

*In that story from 1948, Mr. Kent is referred to as John, but in 1949—in *Action Comics* number 49—he was called Silas. The name of Superman's foster

In 1961, when DC Comics decided it was time again to trot out and present their flagship hero's origin for yet another generation of readers, Otto Binder, scripting "The Story of Superman's Life" (*Superman* number 146), virtually paraphrased Lowther's deathbed scene: "No one on earth has your amazing super-powers. And you must always use them to do good! You must uphold law and order, and those in need, and save lives." Two years later, Leo Dorfman (in "The Last Days of Ma and Pa Kent," *Superman* number 161) did his own deathbed scene, again with identical stress: "You must always use your super-powers to do good . . . uphold law and order."

By then, and ever since, Clark Kent becomes Superman principally because he was instilled with the viewpoints of plain American heartlanders who stressed the value of legal authority. He has no choice but to be good and to do good, and while it surely makes him a hero, it does strip away the majesty of self-invention, and goes against Jerry Siegel and Joe Shuster's initial creative impulse: that Superman does what he does because he chooses to; that his greatness is a matter of will rather than of expectation and a promise.

In the spring of 2008 (*Action Comics* number 870), Jonathan Kent, who'd been alive again in the comic book series since 1986,

father was slippery and ever-changing, until 1971, when he was definitely and forever after referred to as Jonathan. The same flip-flopping (sloppy?) indecision caused Clark's adoptive mother to be called variously Mary, Sarah, and Marthe, till she was officially named Martha.

died of a heart attack in his wife's arms, this latest time without having imparted to his son, who wasn't even present, the traditional urgent fatherly advice.* But because of how it's all been played in Superman comics for the past twenty-odd years, no such scene seemed any longer necessary. Current canon has had it that Clark Kent's foster parents raised him through childhood and adolescence and then remained alive and healthy (usually) well into his adulthood and deep into Superman's career. This time, lucky guy, Clark got the full-blown all-American family package deal, the whole megillah.

Still, I think I miss the passing motorist.

35

By 1970 Superman: The Property was in bad shape. He'd been around for more than three decades, and while he was, along with Sherlock Holmes, Tintin, Mickey Mouse, and Tarzan, still one of the most recognizable fictional characters in the world, his popularity was in a steady decline. These were the Superman Doldrums. He continued to appear month after month in devitalized comic books and on Saturday mornings in cheesy half-watched television cartoons. Fans who now called practically all of the shots in mainstream comic books preferred Batman, no

*As played by John Schneider in *Smallville*, Jonathan Kent died of a heart attack in 2006 at the end of the fifth season.

contest, and compared to Marvel's roster of hipster heroes like Spider-Man, X-Men, and Dr. Strange, the Man of Steel seemed dull-normal, middle-aged. Establishment. Strange visitor from another time and nation.

After Weisinger retired, the separate titles in his once-mighty Superman domain were dealt out among several DC editors. Even the two major titles, *Action* and *Superman*, were split up, *Action* going to Murray Boltinoff and *Superman* to Julius Schwartz, the man always credited with (and who always took the credit for) reintroducing superheroes to mainstream comic books (thus inaugurating the "Silver Age" of comic books) when he successfully brought back the Flash in 1956. Schwartz followed that up with reintroductions of Green Lantern, the Atom, and Hawkman, and then, in 1960, he launched the *Justice League of America*, a superhero club that supposedly inspired Stan Lee to create the Fantastic Four.

Before Schwartz reinvented the Flash, the only regularly issued superhero comic books in the United States were published by DC and showcased the three major costumed characters who'd survived the industry implosion of the late 1940s: Batman, Wonder Woman, and Superman. Following the adoption of the Comics Code, most comics produced and sold through the middle 1950s consisted of westerns and funny animals, teen comedies and romance.

Schwartz had argued that superheroes could make a successful comeback, could even become the dominant genre again, if—

if—they returned fitted to new times, and were styled for a transitioning America only just learning how to compartmentalize its Cold War dreads and yield to the (shallow but so what?) optimism of novelty and novelties: drive-in movies, calypso music, rock and roll, the cha-cha, hula hoops, yo-yos and Silly Putty, split-level (or "raised ranch") houses, and the "open-floor" plans of Levittown starters.

While he recycled the names of the primitive Golden Age heroes (might as well; the company already owned the copyrights and trademarks), Schwartz and his writers and artists created new origin stories, new personalities, new environments for their new superhero comic books. Gone were the bumbling proletarian and glib millionaire alter egos of yesteryear; in their place were sophisticated urban bachelors in sport jackets, slacks, and loafers, with the kinds of professional careers likely to appeal to middle-class white kids: police chemist, test pilot, university researcher, museum curator. And they were *guys with girlfriends*. Hawkman was even married, to a leggy redhead. In the new day of *Peyton Place*, Douglas Sirk movies, and *Playboy* magazine, even superheroes liked girls. Schwartz insisted that the outdated "action costumes" of the 1940s—garish, baggy, booted, and usually encumbered by utility belts—be replaced by snazzy new skintight bodysuits. And with no capes. Why would anyone fighting crime in 1956 need four yards of fabric hanging from his neck?

Schwartz developed a stable of strong writers and artists, and a reputation for putting out DC's slickest superhero comics—

Flash and *Green Lantern* offered plots that turned on physics and astronomy (scientific footnotes were a feature of Schwartz's books)—and for a bright graphic look that seemed contemporary and polished; the figures were lean and balletic, landscapes and buildings resembled stylized architectural drawings.

Told in 1970 that he had to take on the stodgy *Superman* title after Weisinger left, Schwartz wasn't thrilled.

> I really didn't want to do [it]. . . . So I said I would . . . if I could make changes. The way Mort did Superman, he could balance the earth on one finger. But when I did Superman, he would have to use *both hands* to hold up the earth. I said, "I want to get rid of all the Kryptonite. I want to get rid of all the robots that are used to get him out of situations. And I'm sick and tired of that stupid suit Clark Kent wears all the time. I want to give him more up-to-date clothes. And maybe the most important thing I want to do is take him out of the *Daily Planet* and put him into television." (quoted in Daniels, *Superman*, 132)

As soon as DC's new editorial director Carmine Infantino gave him the go-ahead, Schwartz invited Dennis O'Neil to join him in the Superman revamp. O'Neil had started writing for the company in 1968. At thirty-one he was significantly older and more worldly—he'd served in the navy, worked as a journalist— than most of the boomer fanboys entering the field during those years. Although O'Neil was far from being countercultural, the

first time he had shown up at DC not wearing a coat and tie he'd found himself berated as a hippie. At DC cultural norms had frozen somewhere around 1957. The editors still dressed like bankers and ad men and played a few hands of gin rummy after work.

Despite his long hair, T-shirts, and jeans, O'Neil established himself as a professional, contributing scripts to titles edited by Schultz including *Detective Comics* (featuring Batman), the *Justice League of America*, and, most famously, *Green Lantern/Green Arrow*, in which for the first time, real-world tumults of the late sixties—racism, war, environmental degradation, drug addiction—invaded the heretofore sunny world of DC's blinkered super-characters.

O'Neil, like Schwartz, wasn't keen on doing Superman, considering him "a chummy, white-bready sort of fellow toting a complicated biography, a large extended family and godlike powers whose activities had become nearly as predictable as Dagwood Bumstead's." Both he and Schwartz agreed the first thing to be done was to ratchet down the powers. "We weren't cruel revampers," says O'Neil. "We'd let him keep the X-ray and telescopic vision and much of the invulnerability—he needn't sweat the exploding shells that would have done him in back in the '30s—and we were willing to concede the flying, but the godlike stuff had to go. Stars were therefore to be considered safe from Superman's breath. And while we were at it, we'd give his per-

sonality a good decloying, deep-six the white bread" ("Man of Steel," 53).

In late 1970, with issue 233 of *Superman* and the story entitled "Superman Breaks Loose," Schwartz and O'Neil's revisionism kicked in: not only is all of the kryptonite on Earth destroyed by a freakish laboratory experiment, but soon afterward Superman realizes that a secondary effect is a steady decrease in his abilities. According to O'Neil, the original intent was to scale them back "about to what Jerry and Joe started with in 1938. Actually, we never got that far back" (54). In the same issue, the new owner of the *Daily Planet*, an ethically sketchy media mogul named Morgan Edge, transfers Clark Kent from the newsroom to the anchor desk at WGBS-TV.

Big changes, but the only one that caught the attention of American media was Clark Kent's sharp new wardrobe. Gone was the thirty-year-old blue suit, replaced by a wide-lapelled tan one, dark blue striped shirt, white tie—and stylish (for the time: clear plastic frames) eyeglasses. *GQ* was impressed enough with the makeover to publish a feature about it.

Nobody seemed particularly interested in Schwartz's "new" Superman, and that even went for his colleagues editing the other titles making up the Superman line. In those comic books, kryptonite was still lethal and plentiful, Superman could still push around planets, and Clark Kent still reported for work every morning at the *Daily Planet*—where *else* would he go? After just

thirteen issues writing *Superman*, O'Neil quit. "I was spending up to three weeks on . . . scripts and not enjoying the work. By contrast, Batman scripts took three days and were often fun" (55).

By 1973 all of the tired Weisinger conventions—robots, Kryptonian immigrants, and lots of kryptonite, the old clichés that had stayed in service over at *Action*, *World's Finest*, *Jimmy Olsen*, *Lois Lane*, *Adventure Comics*, and *Superboy*—had been absorbed back into the flagship *Superman* title.

And the Doldrums continued.

<div align="center">36</div>

Although Jerry Siegel left New York City in defeat, middle-aged bitter, he didn't abandon his crusade after settling his family in southern California and taking a clerk-typist's job. If anything, he felt more injured, more victimized, more committed to redress. But as his legal options dwindled—in the early 1970s, a federal court dismissed yet another appeal—the years of frustration and humbled pride took their toll. He suffered a serious heart attack. He turned sixty and looked ten years older. Like some existential howling man, he was filled by a righteous, honed, ferocious anger. He'd never give up, never!

In April 1975 he was making plans to bring his case to the Supreme Court when his lawyer called to say that Jay Emmett, executive vice president of Warner Communications, wanted to

make peace—but only if Jerry for once and for all would lay the hell off. Siegel was understandably suspicious. After all, Emmett was the nephew of Jack Liebowitz, Enemy Liebowitz. Siegel and Shuster weren't being offered anything specific, mind you, but Emmett promised that once Jerry dropped all legal claims against DC and Warner and agreed to quit seeking legal ownership of Superman, the company would offer an annual payment to each of them. Siegel said all right, let's hear the actual offer. His lawyer said he'd convey the message. Just sit tight.

He did. For six months he sat tight. But Siegel never heard back from Jay Emmett. However, during that time he did hear about the multimillion-dollar Superman movie being developed by Ilya and Alexander Salkind, and also about the $350,000 that Mario Puzo would be paid to write the screenplay. Those bastards! *That's* why Jay Emmett had called. Warner just wanted to make sure Siegel didn't throw any conniptions that could damage the movie's luster; the company didn't want some crazy old coot rending his garments in public. Screwed again!

By the time Jerry Siegel got drift of the Superman movie, the project had been in the works for a while. The Salkinds, who had successfully produced Richard Lester's *The Three Musketeers*, contacted Warner in late 1973 about acquiring the rights. It'll give you some idea of how little the company held their flagship character in esteem by then when you hear the deal: the Salkinds picked up movie rights *for twenty years* at a cost of barely six million dollars, less than a million of which they had to pay in cash

up front. Although by then a few superheroes—Batman, Wonder Woman, the Incredible Hulk—had been translated successfully to television, it seemed ridiculous to Warner that anyone would make a movie with an A-picture budget about a forty-year-old has-been comic book hero.

But the Salkinds weren't stupid; they may have been sharks (virtually everyone who ever worked with them ended up suing them), but they weren't stupid, and they saw where American movies were heading. The Vietnam-and-Watergate period of dark "socially relevant" films, films like *Bonnie and Clyde*, *The Godfather*, *Carnal Knowledge*, and *McCabe and Mrs. Miller*, showed signs of giving way to a new era of escapist films. Movies. Escapist *movies*. The comforting historical amnesia of *Murder on the Orient Express*, the special-effects glamour of *Star Wars*, the amusement-park simulation of *Jaws*. Less realism, less nihilism, fewer feel-bad pictures like *Serpico*, *Klute*, and *Mean Streets*. Hollywood brats, the film-school whiz kids Steven Spielberg and George Lucas were poised to re-create American movies into spectacles, seasonal "blockbusters" that eliminated pesky distinctions between children's movies and movies made for adults.

What the Salkinds seemed to know was that Hollywood movies were tending away from being "serious" things, leaning more and more toward becoming *events*—long before they were even filmed, if possible. Warner may have thought them crazy for being interested in Superman (the company wouldn't even commit to distributing the movie, or put any money into the pro-

duction), but it was impressed by the producers' knack for public relations. The Salkinds announced that *Superman: The Movie* would be budgeted at an incredible (for the time) twenty million dollars; ads in *Variety*, blimps at Cannes, everything big, *huge*— including the talent. Marlon Brando, Gene Hackman. An A-list director, Richard Donner. And a big-name writer, Mario Puzo, already famous for *The Godfather*, who'd earned summer-movie cred for scripting the atrocious but profitable *Earthquake*.

The talk—the buzz—preceded actual production by a couple of years, and kept getting louder.

Till finally it drove Jerry Siegel right over the edge.

In October 1975 he sat down at his old typewriter and composed a screed of malice and grief, a cry for recognition and justice, and a thundering imprecation: "I, Jerry Siegel," it began, "the co-originator of SUPERMAN, put a curse on the SUPERMAN movie! I hope it super-bombs. I hope loyal SUPERMAN fans stay away from it in droves. I hope the whole world, becoming aware of the stench that surrounds SUPERMAN, will avoid the movie like a plague."

It all gushed out, especially Siegel's intestinal hatred for Jack Liebowitz, the "back-stabber" and "cheapskate" who "killed my days, murdered my nights, choked my happiness, strangled my career." Calling himself and Joe Shuster "victims of a monstrous injustice . . . doubledealing . . . chicanery," Siegel pleaded to the world to intercede and undo the wrongs that had destroyed him. "Joe and I suffer . . . we think of little else, and it makes us mis-

erable to see how our families suffer, too" (Siegel, "Superman's Originator").

Although full of quoted material, mostly from letters of Liebowitz's dating back to the original submission of Superman to *Action Comics* in 1938 and '39, Jerry's cri de coeur was full of factual errors and distortions, misrecollections. It was, for example, never the case that "in the first year of SUPERMAN's publication, when SUPERMAN earned a fortune for its publishers and became a smash hit, Joe and I earned less than $15.00 a week apiece for SUPERMAN. We were paid $10.00 per comic book page. That was $5 per page apiece to Joe and me." Mmmm, not quite.

After equating himself and Joe to "Oliver Twist asking for more porridge," Siegel wrote, "We have been victimized by evil men and a selfish, evil company which callously ruined us and appears to be willing to abandon us in our old age, though our creation . . . has made and continues to make millions for them."

There was good and there was evil, there was right and there was wrong. It was simple. And evil, like Lex Luthor operating the controls of a giant plunder machine, had crushed him and Joe. "You hear a great deal about The American Dream. But SUPERMAN, who in the comics and films fights for 'truth, justice and the American Way,' has for Joe and me become An American Nightmare. . . . I can't flex super-human muscles and rip apart the massive buildings in which these greedy people count the immense profits from the misery they have inflicted on Joe and me and our families. I wish I could."

The original of that thing belongs in the Smithsonian.

Jerry Siegel's anguish is frightening and heartbreaking (yes, a little embarrassing too; you're embarrassed for him), and while it's easy to imagine the expression on his face as he banged out the words, sentences, paragraphs, it's impossible not to see it in the comic book idiom: sweat drops flying, grimace doubling the width of his mouth, tongue stretched out, radiating quiver lines. A miracle he didn't suffer a second heart attack at the keyboard.

After spewing, Siegel ran off a thousand copies of the press releases cum manifesto cum malediction. According to Gerard Jones, he "mailed them to every national news program, every big-city newspaper, every LA-area media outlet from the *Times* down to weekly giveaways." Then he sat back and waited for calls from reporters. "The calls," writes Jones, "didn't come" (*Men of Tomorrow*, 317).

37

In 1978 I was a magazine staff writer working on East 42nd Street in New York City, directly opposite the *Daily News* building, which became the *Daily Planet* building that July during production of the first Superman movie. My editor had an office with a great view, and at some point every day the two of us would stand at the window with binoculars, trying to pick out Christopher Reeve in the crowd. Never could. We saw a lot of production people standing around, though, or suddenly scrambling, long

vans and quilted aluminum trailers parked at the curb, cameras, cables, and other equipment, onlookers contained behind barricades, but no Superman. The cast and crew had flown over from London to shoot in Manhattan for several weeks before moving on to Canada. The movie had been shooting since March.

Like everybody else, I knew about the Superman movie because of all the news stories and gossip columns about costly delays and bad blood between the director and the producers, Richard Donner and the Salkinds. The budget had ballooned from twenty million dollars to more than fifty million, with still no end of shooting near. I knew—who didn't?—about Marlon Brando's four million–dollar salary, which he was paid for less than two weeks of actual work, and about the protracted Superman star search that had considered everybody from Warren Beatty, Robert Redford, and Paul Newman to Al Pacino and Arnold Schwarzenegger, but had ended with the selection of an obscure but handsome six-foot-four off-Broadway actor and soap opera alum.

There'd been pictures of Christopher Reeve in newspapers and magazines, many showing him in the famous red, blue, and yellow Superman costume, and even though nobody knew whether he would be any good in the part, he *looked* perfect. He was not at all like the barrel-chested Superman of the 1950s television series, or the linebacker Superman of recent cartoons and comic books, but everybody, including myself, already seemed to agree that if

there really *were* a Superman, he'd look exactly like Christopher Reeve.

When *Superman: The Movie* opened the following December, everybody finally got to see just how really good Reeve was in the part—boyish and confident, graceful and witty, "true to Jerry and Joe's flamboyant, sanguine, self-satisfied hero of the early Forties," as Gerard Jones puts it (*Men of Tomorrow*, 325). More than anything else, he played Superman as a regular guy, smart and sincere, who loved what he did, was glad to be alive, and delighted in his gifts; he was amused and amazed, intoxicated by them, but lacked utterly in hubris. He was all four Beatles in *A Hard Day's Night*. A smidgen self-satisfied, but that was okay, who wouldn't be, just a little?

You ask me, it was Reeve's Superman that rescued the character from the irrelevance of so many other once-major fictional heroes. It's a screen performance perfectly suited to its historical, its generational moment—definitive 1970s male American movie acting, the way Jack Nicholson's achievement is in *Chinatown*, or Al Pacino's in *The Godfather*, but played with optimism dominant, instead of fatalism and tragedy. There weren't supposed to be selfless and unflawed heroes, not anymore, yet here's one who can say things like "We're all in this together" and leave an audience, then and now, disinclined to titter. He's great in the part.

The movie, though. What were they *thinking?* I've watched that first Superman movie at least half a dozen times, three times

in the past year, and it's never not incredible to me that something so poorly built, so full of bad choices, with so much bad script and so many throwaway performances, *something so fundamentally schizophrenic* . . . could still cast a charm. But it does.

Although Mario Puzo gets credit for both story and screenplay, virtually nothing in the movie comes from his three hundred-page epic, which everyone who read it pronounced unfilmable. (Lifting mainland China into the air is just one of the feats Puzo had Superman performing.) The script, in large measure, was written by Robert Benton and David Newman, who had collaborated a decade earlier on the Superman Broadway musical. (I can't help it, that Bob Dylan lyric "there's no success like failure" just popped into my head.) Newman's wife, Leslie, contributed Lois Lane material. Tom Mankiewicz, who'd written some of the earliest James Bond movies, finessed their work (for which he received a "creative consultant" credit), as did the British novelist George MacDonald Fraser (who goes uncredited).

Whenever I start watching the first Superman movie again, I think maybe *this* time the three separate parts—the worlds of Krypton, Smallville, and Metropolis—will link in ways I missed every previous time. Never happens. The *scatteredness* includes even the inexplicable prologue, which ought to beguile and ends up pointless, bewildering, and stupid. Following a barrage of stainless-steel credits that plunge at the audience from a cheesily rendered distant galaxy (as awe-inspiring as some out-of-the-box Fourth of July sparklers), enormous movie-palace curtains, in

nostalgic high-contrast black and white, fill the screen. Curtains part to reveal a boxy neighborhood-theater-sized movie screen, upon which a comic book cover is projected and a date—June 1938—superimposed. To anyone watching who doesn't know already that June 1938 was the cover date on the first issue of *Action Comics*, the information is meaningless. What's dopier, while the comic book on display is titled *Action Comics*, and features the distinctive logo, the cover drawing is not Shuster's famous Superman-hoisting-a-Huffmobile, but instead some drawn-for-the-movie-in-pulp-style rocket ship. Then, with a young boy's voiceover, we're told that the city of Metropolis was ravaged by hard times and despondency in the period of the Great Depression, how it was in need of a savior to lift its citizens from misery. Anyone watching for the first time would assume the picture to come is going to be a period-piece, Superman in June 1938, during the Great Depression. But no. Because suddenly—wham!— Alexander Salkind's chromium name comes whirling in from the background, John Williams's triumphal music blares, and in full color we're transported to a planet circling a humongous red sun that looks to be fixed about a thousand miles away from its surface. Even so, the planet is an *ice planet*.

Five minutes into *Superman: The Movie* and already it's a mess of miscues, tacky effects, and impossible logic. It gets worse.

You could take that first real part of the movie, the World of Krypton, and run it with those robot-and-human silhouettes from the Sci-Fi Channel's old *Mystery Science Theater 3000* kibitzing

throughout; that, in fact, might be the only way to watch it with enjoyment. Donner's Kryptonian civilization appears to consist of a gigantic white observatory-type edifice and a population of fewer than two dozen men and women who wear black or white togas and live underground in glass-fronted hives. This couldn't possibly be any further opposite the "paradise lost" of the comic books.

Surrounded by a handful of highbrow actors (Trevor Howard, Harry Andrews, Maria Schell, Terence Stamp), Marlon Brando fondles a phosphorescent crystal rod like it's a Prussian general's riding crop and wanders the Hall of Justice, delivering apocalyptic dialogue as though he's groggy with a migraine. Reportedly Brando suggested that his character, Superman's father, Jor-El, be portrayed on screen either as a giant potato or a blue suitcase, for which he could provide the voice. He was persuaded to go in front of the camera instead, but unfortunately sporting a preposterous white pompadour that makes him resemble an aging Nashville countrypolitan singer. "Claiming he wished to preserve spontaneity in his performance," says Jake Rossen, "Brando didn't memorize his lines. Instead, he tacked them up to every available surface out of the camera's view, including the forehead of . . . actor Sarah Douglas, who played one of the three traitors Jor-El banishes into the Phantom Zone" (*Superman vs. Hollywood*, 91). I watch Brando's performance and suddenly I'm doing what people sometimes do now when they're talking about how much CEOs are overpaid: I think, Brando probably earned

ten thousand dollars, there, just nodding his head; now he just made another fifty thousand, taking those mincing steps toward Susannah York; and for that pained grimace, at least another thirty . . .

The planet Krypton suddenly starts coming apart at the fault lines, and Jor-El and Lara tuck their infant son into a rocket ship that not only doesn't look like the rocket ship on the bogus comic book cover we saw in the prologue but resembles nothing so much as a gigantic Christmas tree ornament. And off the baby goes to Earth. Not soon enough.

The Krypton story is really Chicken Little retold, and it's the Moses story, too. The Christian allegory, when you think about it, doesn't work quite so well. If this is God sending his only Son to the world, then what kind of Supreme Being is Jor-El? Not so hot. He's about to *die*. He waited too long and didn't build a rocket large enough for the whole family; yes, he leaves a hologram to give his only son moral instruction upon reaching adulthood, but it's a *hologram*, it's not a *father*, or a Father either.

If Krypton's civilization is so super-scientific, I always wonder, why couldn't the other scientists corroborate those seismic pressures Jor-El warns them about? Why couldn't they take readings of their own? A seismic pressure is a seismic pressure, it doesn't require faith. The story doesn't make a whole lot of sense, and ends up seeming like science fiction of the Toga Age. Always best to get the Krypton stuff over with quickly and the baby speeding toward Earth. Donner takes his own sweet time

of it. The first part of *Superman: The Movie* couldn't have come out much worse if he'd gone with Brando's suggestion about the blue suitcase.

The second section, the World of Smallville (with Jeff East as the teenaged Clark Kent, his voice overdubbed, which you'd think would be a huge insult, by Christopher Reeve) is the part of the movie that plays things the straightest, hyperbolic but straight, and to the point—primarily because of its shot-to-shot narrative clarity, the shots as stylized as comic book panels, and the slightly speeded up Studio-era quality of the acting. Clark Kent in Kansas, in high school. Cornfields, blue skies, America the Beautiful. Judging by clothes, hot rods, letter sweaters, and soundtrack ("Rock Around the Clock"), the sequence is set during the mid-1950s, which would fit with that 1938 prologue. If Superman came to earth as an infant in the late thirties, he'd be in high school in 1955, '56. But then that would make him nearly forty in the "contemporary" Metropolis section which follows, and he's not; Christopher Reeve is a twenty-five-year-old. Donner's movie stumbles all over the temporal map; Gene Hackman's Luthor even comments at one point that he's seen confirmed reports about a rocket ship that arrived on earth in 1948. It's best not to pay attention to interior logic, since there isn't any.

The bridge between the second and thirds parts of the movie, the part when Clark Kent uses a crystalline cudgel to build a Fortress of Solitude in the Arctic wasteland and then confronts

the ghost of Jor-El, or rather his hologram, is more mysticism lite disguised as science fiction, *Lost Horizon* meets *The Ten Commandments.*

The third part of the movie, and the only one that's actually *about* Superman, the World of Metropolis, is a schizoid free-for-all, a hectic mixture of well timed-out screwball comedy and the dopiest buffoonery, of special effects that can get you giddy for being fooled so well (the flying, most of it), and others that simply look cut-and-paste (the flying, all the rest of it). And I want to reach out and smack Gene Hackman for hamming it up like he's playing the King from *Huckleberry Finn.* And Ned Beatty—who's he supposed to be, anyhow, Steinbeck's Lenny? No, wait, Steinbeck's Lenny in *Looney Tunes:* "Which way did he go, George, which way did he go?" Was there a lot of coke on the set, was that it, or was it just what always seems to happen to a movie whenever the source material is comics, rampant Adult Attention Deficit Disorder?

It's hard to put up with all the goony stuff, but impossible not to be gladdened and beguiled by the light comedy of Reeve and Margot Kidder, as Lois Lane, in their scenes together, when it's just the two of them. Starting with that first rooftop interview (famous line: "What color underwear am I wearing?"), the courtship of Superman and Lois has the chemistry of the best forties major-movie-star romances. Reeve lends Superman a grace and a *likability* he has never had before, never quite. He's slender, he's buff but still he's slender, he's no human bulldozer—he's sexy.

He's dressed in a blue bodysuit with a big red letter *S* appliquéd on the front, red high boots, red trunks, yellow belt, and a red floor-length cape, and still he's very sexy. *That's* a successful fantasy! And for the first time since Phyllis Coates played her back in the first season of the old George Reeves TV show, Lois seems the kind of female a guy like Superman might actually fall for. Margot Kidder is the Siegel original minus the cruelty that often crept in. She can wisecrack and deliver a zinger, but there's no venom. She plays Lois Lane as both a feminist and a postfeminist: demands respect for her skills (of which spelling is not one), but also likes to dress girlie (her underwear is pink, Superman answers in reply to her question, having used his X-ray vision), and she is obviously someone with an erotic life as well as a professional one. So, by the smile and the look in his eye as he takes her flying around Metropolis at night, is he.

Yes, and every time I watch the boy-girl stuff in the first Superman movie (and in the pretty lousy sequel, in Bryan Singer's movie, and in *Smallville*, maybe in *Smallville* especially, since the teenage hormones are so especially potent there), I can't not think of Larry Niven's smarty-pants scientific description of what would most likely occur if a humanoid superpowered alien ever actually mated with a mere earth woman. And I quote: "Superman would literally crush LL's body in his arms, while simultaneously ripping her open from crotch to sternum, gutting her like a trout. Lastly, he'd blow off the top of her head" ("Man of Steel," 53). With his super-ejaculation. Okay, enough.

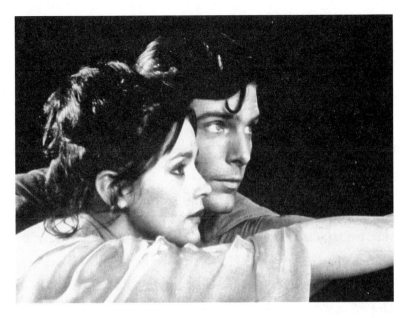

Christopher Reeve and Margot Kidder in Richard Donner's *Superman: The Movie*, 1978 (PhotoFest Digital, © DC Comics)

38

Not long ago I was visiting a friend of mine who lives in West-chester County, New York. As he was driving me from the train station to his house, we passed a walled-off property to our left and he told me, "That's where Christopher Reeve lived, right back behind there." I looked. "Died there, too, I think," my friend added. "Maybe. I'm not sure." Riding along the same road the next morning, I kept a lookout for that wall as it was coming up, now on our right. And that's all I could see, too, just a long curv-

ing high wall, but my friend said there was a large estate behind it and a big house. He didn't know who owned the place now.

I mentioned that it had always seemed to me—not to sound crass or anything—but it had always seemed to me that whenever people talked about Christopher Reeve after his riding accident in 1995—paralyzed from his neck down, life on a ventilator—whenever people talked about that, about him, in the next breath they'd always mention the morbid irony of his having played Superman. They couldn't not. *I* couldn't not. You'd see his picture sometimes, in magazines, on magazines covers, Reeve by himself or with his wife, Dana, and the headline or cover line would be something like "Superman Chris Reeve: Never Lose Hope." It was inevitably phrased some way in terms of Superman, to remind you that he'd once played the most powerful man in the world, the most perfect, the *healthiest* man, and now he was paralyzed. "The actor Christopher Reeve, best known for his portrayal of Superman . . ." In the public story about the post-accident Christopher Reeve, there was always a subtext, and it wasn't all that sub: How could such a thing happen to *Superman?* And if it could happen to *Superman* . . .

Talking about Christopher Reeve, and particularly his accident, reminded me of the so-called Curse of Superman, which I didn't bother mentioning to my friend; he'd already started talking about something else by then. Just as well. The Curse of Superman, which still pops up in both comics and movie discussion groups, refers to how supposedly it's bad luck for an actor to

play the role. George Reeves shot himself or was murdered, and Christopher Reeve—similar name, weird, spooky coincidence right there—Christopher Reeve was thrown off a horse that refused a jump. For terrifying examples of the Curse of Superman, though, that's about it. A lot of different actors have played the character over the past seventy-plus years, including Bud Collyer, who played him more often and longer than anyone, on radio and several different animated cartoon series, and he did just fine, became a famously affable network game-show host, died at a ripe old age. Kirk Alyn from the Columbia serials claimed that he was typecast after playing Superman and couldn't get any roles. Unfortunate, but not tragic. Bob Holiday, who'd played the part on Broadway in *It's a Bird, It's a Plane, It's Superman*, gave up show business soon afterward to build vacation homes in the Poconos. No tragic curse there, either. Very successful business. Dean Cain from *Lois and Clark* still shows up on TV, network and cable. If I were Tom Welling, from *Smallville*, or Brandon Routh, from *Superman Returns*, I wouldn't be worried about any curse.

No, the only verifiable Superman curse is the one that Jerry Siegel swore in April 1975 against Warner Communications, the Salkinds, and his old archenemy Jack Liebowitz.

One thousand press releases mailed out required a lot of postage, which Siegel could ill afford to pay for. I try to imagine what it must have been like for him after weeks passed and nobody called for more information or to request an interview, no-

body. I see him wearing a wrinkled white dress shirt and dark pilly trousers, bedroom slippers; slumped in a chair from Goodwill, staring off into space. It's late morning, it's midafternoon, it's nighttime. He looks exhausted, jowly. His wife, his daughter, maybe some guys he works with at the California Public Utilities Commission, everybody tries to snap him out of it, but no dice; he's done for. Nobody cares. He's finished. Then the phone rings.

It wasn't the *Los Angeles Times*, just a local weekly giveaway arts newspaper called *The Cobblestone*, a staff writer named Phil Yeh. Jerry's nine-page J'accuse had landed on Yeh's desk, and when he'd read it and finally called, he was expecting to be told to go to the back of the line. Despite the smallness of the newspaper, Jerry invited Yeh to his apartment. Any attention, any publicity was better than none. After Yeh's story came out, though, more nothing ensued.

But then late in October, a reporter from Washington happened upon the press release and contacted Siegel by phone, then took a train to New York and a cab to Queens and spoke with Joe Shuster. Contacted for comment, DC and Warner declined. Jerry's unchallenged version of things ran as a front-page story in the *Washington Times*.

At that point Tom Snyder, host of NBC's late-night *Tomorrow Show*, invited Jerry Siegel to tell his story on the air.

A successful political cartoonist and teacher, Jerry Robinson happened to be working late at his drawing table with the tele-

vision on the night Siegel appeared on Snyder's show. As a teen-ager, Robinson was Bob Kane's first assistant and then primary ghost-artist on Kane's Batman comic books. During their over-lapping stints at National Comics, he'd been acquainted with both Siegel and Shuster and was astounded now by what he heard Jerry tell Snyder. He'd known about the "troubles" the two part-ners had had in the late 1940s and was aware of the first couple of lawsuits, but he'd fallen out of touch with both men long ago and just assumed, since he'd never heard any further gossip, that they'd come to some kind of settlement with DC. It outraged him to realize that the creators of Superman were living in near-poverty, worried about their medical bills and money for their old age. It was unseemly. It was shabby. Well connected, not just in the New York cartooning community but in the theatrical, literary, and academic (he taught at the School of Visual Arts) communities as well, Robinson decided to do whatever he could to help. He telephoned NBC that night, to get in touch with Jerry Siegel.

Neal Adams, another, younger New York City cartoonist, also heard about Siegel's manifesto and situation. Adams had drawn Superman comic books himself during a brief period in the early 1970s and was admired by fans and peers for his illustration-based drawing style, a post–Alex Raymond loaded-brush real-ism. Although he no longer drew mainstream comics (he'd found ad work more lucrative), Adams was currently president of the Academy of Comic Book Arts, a recently constituted organiza-

tion lobbying for creator rights, including ownership of original artwork, and royalties. "Essentially," said Adams, "what I and the guys in my studio did was, we decided that day that we would make an effort that these two guys would at least be treated reasonably at the end of whatever that effort might be. That effort turned out to be about three-and-a-half months long" (Weisinger, introduction to Siegel, "Superman's Originator").

Combining their resources, Robinson and Adams and whatever volunteers they could find tried to make things embarrassing for Warner; any negative publicity about the ongoing plight of the two creators could leave an ugly blot on the upcoming Superman movie.

Robinson went to the National Cartoonists Society (which for years had excluded comic book artists) looking for support. He got it. "We wrote a resolution. We held a press conference. I took it to the Magazine Guild and got a resolution backed by them. I wrote organizations around the world. We really orchestrated a whole national campaign—international campaign actually." Celebrities such as Norman Mailer and Kurt Vonnegut signed petitions.

Still, Warner wouldn't open talks. "They felt if they gave an inch," said Robinson, "they would be subject to further and further litigation." Time has proved them right.

When the bad press continued, official company sentiment started to budge, a little. Warner's Jay Emmett told the press, "We are not indifferent to their plight, and we intend to do some-

thing about it. Legally, nothing has to be done. Morally, I think something should be done" (quoted in Daniels, *Superman*, 139).

When talks finally opened, Warner offered Siegel and Shuster each a ten thousand–dollar annual stipend for life, and medical insurance. Adams and Robinson, who had been designated negotiating agents, thought the offer nowhere near good enough. Back and forth it went. Warner raised the annual sum, to twenty thousand, with built-in cost-of-living increases. No, still not good enough. Finally Warner agreed to make provisions for the partners' heirs, and everything all of a sudden looked promising. Then Robinson and Adams made a potentially deal-breaking demand: the Siegel and Shuster byline had to be reinstated. Warner said, Out of the question. No. In your dreams.

At that point, Jerry Siegel, staying in New York and following the negotiations with increasing agitation, panicked. He was afraid he'd end up with nothing, again, and told Adams he could live without the credit. Joe would go along with anything Jerry wanted, he always had, and Jerry was willing to concede their credit. Adams begged him to reconsider, but Siegel was cracking. Just one more day, begged Adams. Jerry agreed, but just to one, one more day, one last try, and then they should just settle for the money and the health insurance.

That night, as Gerard Jones tells the story in *Men of Tomorrow*, Adams called Jay Emmett at home, saying let's end this craziness, come on, and they reached a deal: the Siegel and Shuster creator credit would be returned to the comic books and comic strips—

to everything, except toys. And that included the new Superman movie.

Done.

On December 19, 1975, the agreement was formally made, then reported by Walter Cronkite on Christmas Eve: "Today, at least, truth, justice, and the American way have triumphed."

It would've been nice if they'd actually become rich, but at least now they'd be comfortable. Their byline—"Superman created by Jerry Siegel and Joe Shuster"—returned to the comic books in early 1976.

Following Jerry's death in 1996 (Joe Shuster died in 1992 and left no heirs), his widow and daughter restarted the old Superman copyright wars, and in August 2007, Judge Stephen Larson, of the Central District of California, issued an opinion giving to Siegel's heirs ownership of the copyright to Superboy, a character DC Comics introduced in 1947 without permission from Siegel and Shuster.

More recently, on March 26, 2008, Larson ruled that Jerry Siegel's heirs were the sole owners, as well, of the original Superman *material*, of those first thirteen cut-and-pasted pages of story and cartoon art, published in *Action Comics* number 1. According to the *New York Times*, that means the family is now "entitled to claim a share of the United States copyright to the character" (Cieply, "Ruling"). Determining what that *means*, exactly, and then apportioning profits, should keep lawyers busy for years

to come as our own American Jarndyce and Jarndyce litigation creeps on and on and on.

Jack Liebowitz, the company accountant who'd told Siegel and Shuster back in 1938 that it was "customary for all of our contributors to release all rights to us. This is the businesslike way of doing things," died in 2000, aged one hundred.

39

For more than forty years, mainstream comic book culture, which refers almost exclusively to what's happening, and is expected to happen, in the superhero titles published by DC and Marvel, has embraced and been enthralled by the notion of "integrated continuity," which sounds like a term you'd find in *Dilbert.* Every angsty character in every title published by a particular company is connected somehow to virtually every other character in his or her home "universe." Superheroes (or, in more current and less loaded terminology, "meta-humans") constantly "cross over" into each other's comic books and story lines, while practically on an annual basis some multi-issue "limited" series introduces a variety of major new "events," catastrophic of course, into the different universes. All of this results in pretzel logic, slippery timelines, and narrative incoherence, then inevitably to yet another let's-blow-everything-up-and-start-from-scratch comic book Armageddon ("Crisis on Infinite Earth," "Countdown," "Final

Crisis," "Civil War," "Secret War," "Secret Invasion") involving the wholesale slaughter of costumed characters who either will be resurrected after a proper period of mourning (a year to eighteen months usually does it) or have their heroic mantles and noms de guerre assumed by somebody new. The New Atom! The New Iron Man! The New Captain America! To follow superhero comics these days, Superman titles included, is to make a commitment of time and concentration the equivalent of a second job. Which you'll also need in reality to pay for all of the three-dollar comic books you have to buy just to keep up.

I can't make much sense of what's going on in the Superman comic books these days. And God knows I've tried. But a story I'll start reading in *Action Comics* continues over in *Green Lantern*, or *Wonder Woman*, then picks up again in *Batman* or *Supergirl*, but I didn't *get* those, *I didn't know*, and when I open the next issue of *Action*, everything and everybody has moved on, and a lot of new brightly costumed characters I don't recognize are gathered on a strange space ship I've never seen before intoning gobbledygook about, oh, I don't know, *power stones*. What the hell are power stones?

The DC characters, the superheroes (each and every one a potential movie franchise) who wear sleek uniforms and fight crime and terrorism, celestial, interdimensional, and plain old terrestrial, when not realigning space and time, number in the many hundreds—and *everybody knows everybody else!* Hangs out

with, is on the same team/league/society/legion with, feuds with, marries, kills-when-they're-temporarily-insane, etc. Naturally, they all mix it up with one another's supervillains, too.

Superman doesn't fare so well, I think, when he's just one of countless supermen and -women who can be flung into a brick building or a black hole and come right back for more. Even in his own titles—down to just two monthlies now, *Action Comics* and *Superman*—he often seems lost, a bit of a wallflower, in the busy compositions. Three or four or five other just-as-well-put-together *but younger-looking* superfolk are always sharing the panel or page with him, in many cases wearing costumes that look Barney's of New York to his L. L Bean.

Right there, for me, is the problem. If Superman means something, some *things*, he does because he's one of a kind. He works best, and does his best work, always has, as someone unique in the world: there is nothing else and nobody like him, not even remotely. "Superman is an abstraction that exists because of other abstractions," Tom Crippen argues in the *Comics Journal.* "He exists because of ideas like *most*, fastest, *best*. There is some single grid of measurement underlying our sense of the universe, and Superman exists to represent its top rank" ("Big Red Feet," 169). Right. So if Batman can outwit him and the Flash outrun him, and this year's latest meta-human can make him seem like a boxer far past his prime—then, excuse me, but what exactly is the point?

40

How many different writers have taken a crack at writing Superman's adventures? It has to number in the thousands. For the first year of the strip, at least, Jerry Siegel produced every script and story line. Gradually, other writers—Don Cameron, Bill Finger (the cocreator of Batman), Don Samachson, even the young Mort Weisinger—contributed to the series, either by selling ideas to Siegel or, later, by composing scripts themselves. Although he's not credited, the scripts for those ponderously beautiful and threatening Fleischer animated cartoons from the early 1940s were written by a guy named Jay Morton, who actually coined the phrase "Fights a never-ending battle for truth, justice, and the American way." In his obituary it said he'd been proud of it, too. Well, *sure*. (Later in his career, Morton wrote for the Hanna-Barbera studio and played a part in creating Yogi Bear.)

God knows how many writers contributed to the Superman radio program. George Lowther started as the show's announcer, became its producer as well as a prolific provider of scripts, then went on to publish, in 1942, the first Superman prose novel. It was Lowther who changed Superman's birth name from Jerry Siegel's original Kal-L to Kal-el and his father's name from Jor-L to Jor-el (later comic book writers would capitalize the e), which is why I've never put any credence into the argument that Siegel intended Superman to be a Jewish avatar, since the suffix "-el" in Hebrew means "sent by God." All you can really argue

is that *George Lowther* possibly meant Superman to be a Jewish avatar, and so what, right?

Until the end of World War II, the number of writers who provided Superman with something to do probably adds up to no more than a couple of dozen, if that many; then it quickly explodes into higher math. Writers for the movie serials, for the George Reeves TV series, for coloring books, children's records, Saturday morning cartoons, for paperback novels, bubble-gum cards, the Broadway musical, the Christopher Reeve movies, for episodes of *Lois and Clark*, for the *Superboy* TV show that aired between 1988 and 1992, for the WB's animated Superman cartoons of the late 1990s, for *Smallville*. For computer games. Arithmetic workbooks. Several thousand writers creating tens of thousands of stories featuring hundreds of thousands of feats and saves about an imaginary character who's been around and famous since 1938.

But it's like I told those telephone interviewers who called me when *Superman Returns* was coming out. No matter how many writers have written his adventures, or how often he's been up-dated or "retro-configured," more than seventy years later Super-man remains fundamentally the same creation that emerged that first long day (maybe it was in the summer of 1934, maybe it wasn't) at the Shuster family apartment in Cleveland, Ohio.

Certain qualities of Superman are immutable. Change any of them, somehow they change back. Give him talents and powers, and inclinations, that aren't, somehow, *him*, and one day they're

just . . . gone. For a period during the 1940s, Superman could walk through walls, become invisible, and hypnotize anyone. Then he couldn't, and didn't—because he *wouldn't*. In the second Christopher Reeve film, Superman could simply will away his powers (for the love of Lois Lane, ordinary human being), and was saddled as well with some fairy-tale attribute called the Kiss of Forgetfulness. Kiss of Forgetfulness. Forget *this*, buddy. And we never heard of it again.

Producer Jon Peters spent a good chunk of the 1990s developing a new Superman movie in which Superman a) couldn't fly, b) was a master of martial arts, and c) Goodwilled away his familiar red, blue, and yellow uniform in favor of a shiny new black leather one. Nicolas Cage was set to play the character. Tim Burton was interested in directing. Several scripts and millions of dollars later, the whole enterprise collapsed. Cage had a son and named him Kal-El, but he never played his kid's namesake. "Sometimes," writes Les Daniels, "Superman seems more powerful than anyone who works to create his adventures" (*Superman*, 138).

41

Do you know what a *tulpa* is? The word is Tibetan, and refers to a "being"—nothing about "legendary" in the definition—"created by the imagination of another man"; a sentient being who comes into existence solely by the sheer force of another's will

and willed belief (Schwartz, *Unlikely Prophet*, 10). As I understand it, a tulpa is kind of like a golem, but not really. He's not made of anything, like mud, he just appears out of thin air, and I gather once that happens, he's not yours to command. Or she. There could be female tulpas, I guess. Not that I'm an expert.

I first came upon the word and its definition in a charming but deeply peculiar memoir by Alvin Schwartz called *An Unlikely Prophet*, published in 1997. The subtitle is *Revelations on the Path Without Form*, and the book claims to be the true account of the author's journey to spiritual enlightenment under the tutelage of a giant Tibetan tulpa named Mr. Thongdon, who shows up one day on a bicycle at Schwartz's house in Westchester County.

The only reason I picked up and read the book, I admit, is Schwartz's connection to Superman. For sixteen years, beginning in 1942, he was one of the half-dozen principal writers for Superman comic books and comic strips—he even created Bizarro, that chiseled and chalky-white imperfect copy of Superman whose permanence in our popular culture not to mention our vocabulary seems pretty much assured. ("How bizarro." The *Bizarro* daily newspaper cartoon. Bizarro Jerry on *Seinfeld*. Bizarro has even appeared on a baseball cover of *Sports Illustrated*.) After quitting the comics business in 1958, Schwartz went on to a career writing "philosophical novels," feature films, and documentaries.

While his adventures with Mr. Thongdon are delightful and funny and convincing (on the page, at least), what I found most

rewarding in *An Unlikely Prophet* were Schwartz's tales of the Golden Age comic book business and his insights into the stubborn character of Superman. Schwartz claims that Superman has acquired "a kind of reality" that controls his writers and editors "without their realizing it" (4). No matter how anyone, or any company (or for that matter, any media platform) decides to change him, reorganizing Superman's nature and physical appearance or replacing his old baggage with new, it will never entirely take. Some of it might, but not all of it, and probably not much. Spurious versions, fundamentally wrongheaded premises, can, and often do, prevail from time to time, but eventually the character, *Superman himself*, Tulpa Superman, will—somehow, somehow—resist and reverse the meddling, reconstituting himself in the world as he means to be.

"It wasn't I, or any of the other writers or the editors . . . who directed Superman's destinies," writes Schwartz. "Superman directed his own destinies. All of us were merely pawns" (5). Schwartz describes a ride he took once in a taxicab with the tulpa Superman, and he presents it as fact. But even if you don't buy that (you don't?), it's still a pretty good metaphor for how the character hews to certain conditions and boundaries; beyond this point, he will not go. Or this point, either. Or that one. *That* one looks interesting, though. Let me go beyond that point. Yes! (But maybe no.)

Not only can't you tug on Superman's cape, you can't make him act in ways that contradict his nature. His fixed integrity

is something Alvin Schwartz came to believe was real, as real as this book you're reading, and accounts for his abandonment of comics: "Like most others," he writes, "I found Weisinger difficult to deal with. But I endured until one day he insisted that I write a story in which Superman finds some way to transfer his powers to Lois Lane. I didn't want to do that story. I thought such a plot was out of character. In a deeper sense I thought certain quintessential elements of Superman's reality, as I understood it, would be compromised if he could transfer his powers so capriciously. So I wrote the story under protest. And then I left. The charm was broken. I never wrote comics again" (5).

But exactly what *are* those "certain quintessential elements of Superman's reality"? Jerry Siegel's earliest Superman didn't fly; he was a jumper, a mighty leaper of tall buildings. It wasn't until the character appeared on radio that he took off and flew. And forever after, in every medium, he has flown. Superman flies. It wasn't an original attribute, and obviously it was unnecessary to be accepted. But added later, perhaps even by mistake, flight seemed instantly *better*, and both its simplicity and romance made it a keeper, a dominant trait.

We think now that Superman's midwestern youth is an integral part of his makeup and appeal, maybe even part of his appeal problem. He's from corny-in-August Kansas. He grew up on a farm. He's "from" Kansas the way Davy Crockett was "from" Tennessee, but it wasn't until the late 1940s that Clark Kent's heartland upbringing even entered the story. Smallville itself was

not invented till later still, and for a long time not identified as being located in any particular region of the country. But like flight, a rootsy rural childhood seemed right, and what's more rootsy and rural, and what says "home place" better in our collective national fantasy, Dorothy, than the state of Kansas? It all resonated, and by repetition became part of the canon. Most things don't, but some things stick.

How powerful Superman is, and the limits of his strength are things that have never been fixed, either, but just keep being adjusted, up or down. Siegel's (and the Fleischers' animated) Superman existed comfortably with the strength of, say, ten men; he was always being sent rolling and tumbling or buried underneath building debris; he was marvelous, astounding, but still vulnerable. He'd often get a little . . . groggy, even wobbly kneed. No way could that guy go flying off into outer space.

But during the Mort Weisinger era, Superman not only could fly into space, he could fly at the speed of light to distant *galaxies*, maybe ignite a dying star or twenty while he was there, or visit some weird dimension of purple super-geniuses in jumpsuits. A character like that doesn't have time for cops-and-robbers stuff. Anyhow, in those years he couldn't even *punch* a bank robber, he'd knock the guy's head right off.

As different writers came and went, Superman's powers and abilities multiplied and then decreased, multiplied and then decreased. It still goes on. Whenever he has lost his human scale, plunged too far in the direction of godhood, eventually down go

the powers. When they become too limited, too limiting, they're amped up. Checks and balances. Mystically applied, if you believe Alvin Schwartz.

Hired by DC Comics in 1986 to restart the Superman saga from scratch, John Byrne—a Canadian-born cartoonist who'd come to prominence during the late seventies as the artist and coplotter of Marvel's *X-Men*—rejiggered Krypton to make it a planet populated by scientifically advanced emotional empties.* According to the first issue of his six-issue *Man of Steel* miniseries, Superman's asexual parents sent an artificially inseminated embryo, not an infant, to Earth. This gestating baby-in-a-rocket-ship is not Kryptonian, since he's actually "born" on earth. Clark Kent is the real guy. He's no alien, he's an earthling. An American, a rural Kansan kid who develops incredible abilities upon reaching puberty. In essence, Byrne was redesigning Clark Kent as an all-American boy struggling with the "otherness" of adolescence and deliberately "creating" the persona of Superman for his part-time altruistic career. *Man of Steel*, which decreed that every Superman story produced anywhere before that moment no longer counted, is at heart a coming-of-age romance about a self-assured baby-boomer named Clark Kent . . .

*DC also officially ended the Weisinger-edited Silver Age Superman series, with a two-part story that ran in *Superman* number 423 and *Action Comics* number 583. Alan Moore, still riding the crest of his *Watchmen* triumph, killed off a large number of the famous cast of characters, but took what he was doing seriously, respectfully though not reverently, and turned in one of the handful of indisputably great Superman stories.

. . . who is also Superman.

In Byrne's version, the Kents were still alive in Clark's adulthood, there never had been a Superboy, and Lex Luthor was not a mad scientist but a megalomaniacal capitalist, the corrupt CEO of LexCorp. Clark Kent grew up to be a real hunk with an Ivy League polish (where'd he get that?) who could hold his own in a Me Generation/Reagan Age workplace. And he was a bestselling novelist as well as an investigative journalist. Lois Lane became a martial arts–savvy no-nonsense Steven Spielberg kind of a heroine, positioned to fall in love gradually with Clark, not the Man of Steel.

Seventeen years later, in 2003, DC Comics decided to give the Superman saga yet another official reboot, and that time hired Mark Waid to write it for artist Lenil Francis Yu to illustrate.

In the proposal for *Superman: Birthright* that he submitted to DC Comics, Waid argued that this crown jewel of a character keeps dropping off people's radar because his essence, the things about him that everyone knows and instinctively responds to, keep being forgotten, misplaced, or ignored. He intended, Waid wrote, to get back to basics and rebuild Superman from the ground up. But what ground would that *be*, exactly, at that stage of the game?

As eventually published, *Birthright*'s version of Superman came close to being sweetly, too sweetly, New Age (he's a strict vegetarian, and can see "life auras"), but Waid tweaked his script in ways that not only recognized but engaged harrowing new-century po-

litical realities (terrorism, naturally, and genocide in Africa), trying to establish a Superman palatable to post-9/11 readers living in a digital age of lowered expectations. His Superman exists in a cynical, insecure American society with a shallow celebrity culture, in which a life of service, of purely philanthropic service, is met with suspicion, and a philanthropist viewed as being either secretly corrupt or a sap, but either way probably dangerous. Lois Lane tells Superman during their first long conversation in *Birthright*, "You can't show up nowadays and be a super-friend. We are a skeptical lot. Government . . . Advertising . . . God help me, the media . . . these things manipulate us 24/7, and worse, we *know* it. We claim to fight it, but most of us don't have the energy to struggle every moment of every day. Wear us down enough and the lesson we eventually take to heart is that it's easier and safer to be cynical than it is to trust someone."

Naturally, being utterly no-nonsense, she doesn't ask Superman to tell her the color of her underwear.

In developing and finessing his take on the character, Waid decided that Superman is, most authentically, an alien, a come-here. A classic American immigrant, yes—*that* again. But also, metaphorically, a "guest worker," an illegal, a refugee. He looks like us, but he's not. Approach with caution. As the citizens of Metropolis do at first in *Birthright*. And it worked. Waid's version? Worked just fine.

But, then, so did John Byrne's version. So did Siegel and Shuster's, so did Mort Weisinger's. And so did Dave and Max

Between 1996 and 2000, a sleek and angular Superman appeared in a
series of fifty-four smartly written half-hour cartoons broadcast on the
WB network (PhotoFest Digital, © DC Comics)

Fleischer's. So did Bud Collyer's, so did George Reeves's. So did Richard Donner's. So did Bryan Singer's.

So, for that matter, did the separate and stand-alone *All-Star Superman* comic book series that Grant Morrison and Frank Quitely collaborated on in 2007–8. Morrison's scripts imagined a macabre version of Superman that probably came closest to Mort Weisinger's robot-building, star-igniting demigod, but with a large dose of postmodernist mock-solemn Dada on every page. But it *worked*.

We can accept Jerry Siegel's, and Christopher Reeve's, bumbling, timid, masquerading Clark Kent, but also George Reeves's macho Kent, and John Byrne's and Tom Welling's Clark-the-popular-jock in *Man of Steel* and *Smallville*. We can accept a Superman built like a circus acrobat, and one built like a Russian weightlifter. No problem. A Clark Kent despised by Lois Lane, and one she loves and eventually marries? Either one. Married Superman, bachelor Superman, they're both okay. *We don't care.*

All we need, finally, from Superman, *any* Superman, are a few basics. Writers (and by extension, artists and actors and filmmakers) can play with them all they wish, but they can't remove them (for long) or mock them (ever). Superman (as toddler, infant, or even as a fertilized egg, they're all good) was sent hurtling toward Earth in a rocket ship moments before the planet Krypton exploded. He's an orphan and he's an alien. And he lives among us as Clark Kent. (Kent's occupation, I'd argue, doesn't make all that much difference, although every time he's been taken out of

the *Daily Planet* building—as happened during the 1970s, when he was briefly a news anchorman for a Metropolis TV station—it doesn't . . . feel . . . exactly . . . right.)

What else? He wears the costume. *The* costume.

Anything else? Well: Lois Lane. Naturally. Of course. Superman requires a Lois Lane.

Exploding planet. Rocket ship to earth. Secret identity. Original costume. Lois Lane. What about Lex Luthor? Essential? No, not really, none of the bad guys are. So. Anything *else?*

Then just this, the *basic*-basic, saved for last: he can fly, and perform marvelous feats of strength, which he chooses to do because it brings him great satisfaction.

Chooses to do because it brings him great satisfaction. The philanthropist's dirty little secret.

As with athletes and artists, there has always been a selfish, even a self-serving quality to Superman, to Superman's ego. He doesn't require love from the multitudes; Lois Lane will do. Basically, what he needs, and all he needs, is the freedom to act in ways that are satisfying to him.

That's why he'll "never stop doing good."

It makes *him* feel good, dammit.

Our hero.

Works Cited

Adams, Lee. "Doing Good." *It's a Bird, It's a Plane, It's Superman*. Original cast recording. Sony, 1992.

Andrae, Thomas. "From Menace to Messiah: The History and Historicity of Superman." *American Media and Mass Culture: Left Perspectives*, ed. Donald Lazere, 124–38. Berkeley: University of California Press, 1987.

Andrae, Thomas, Geoffry Blum, and Gary Coddington. "Of Supermen and Kids with Dreams: A Rare Interview with the Creators of Superman, Jerry Siegel and Joe Shuster." *Nemo: The Classic Comics Library*, no. 2 (1983): 6–19.

Benton, Mike. *The Comic Book in America: An Illustrated History*. Dallas: Taylor, 1989.

Brown, Nicky. Personal interview. November 17, 2008.

Cabarga, Leslie. *The Fleischer Story in the Golden Age of Animation*. New York: Nostalgia, 1976.

Cieply, Michael. "Ruling Gives Heirs a Share of Superman Copyright." *New York Times*, March 29, 2008. http://www.nytimes.com/2008/03/29/business/media/29comics.html?_r=1&scp=1&sq=%22Share%20of%20Superman%20Copyright%22&st=cse.

"Code of the Comics Magazine Association of America, Inc." Adopted October 26, 1954. Posted at Comicartville Library, http://www.comicartville.com/comicscode.htm.

Crippen, Tom. "Big Red Feet, Mighty Chest." *Comics Journal*, no. 289 (2008): 169–73.

———. "The Night Thoughts of Mort Weisinger." *Comics Journal*, no. 287 (2008): 166–69.

Daniels, Les. *DC Comics: Sixty Years of the World's Favorite Comic Book Heroes.* New York: Little, Brown, 1995.

———. *Superman: The Complete History.* San Francisco: Chronicle, 1998.

Dietrich, Bryan. "The Fourth Man in the Fire." *Krypton Nights*, 5. Lincoln: Zoo, 2002.

Dooley, Dennis, and Gary Engle, eds. *Superman at Fifty: The Persistence of a Legend.* Cleveland: Octavia, 1987.

Duin, Steve, and Mike Richardson. *Comics Between the Panels.* Milwaukie, Ore.: Dark Horse, 1998.

Eco, Umberto. "The Myth of Superman." In Heer and Worcester, *Arguing Comics*, 146–64.

Feiffer, Jules. *The Great Comic Book Heroes.* New York: Bonanza, 1965.

Fingeroth, Danny. *Disguised as Clark Kent.* New York: Continuum, 2007.

Fleisher, Michael L. *The Great Superman Book.* New York: Warner, 1978.

Gordon, Ian. *Comic Strips and Consumer Culture, 1890–1945.* Washington, D.C.: Smithsonian Institution Press, 1998.

Goulart, Ron. Foreword to *Superman Archives*, vol. 2. New York: DC Comics, 1990.

Grossman, Gary. *Superman: Serial to Cereal.* New York: Popular Library, 1976.

Hajdu, David. *Ten-Cent Plague.* New York: Farrar, Straus and Giroux, 2008.

Harvey, Robert C. *The Art of the Comic Book: An Aesthetic History.* Jackson: University Press of Mississippi, 1996.

Heer, Jeet, and Kent Worcester, eds. *Arguing Comics: Library Masters on a Popular Medium.* Jackson: University Press of Mississippi, 2004.

Inge, M. Thomas. *Comics as Culture.* Jackson: University Press of Mississippi, 1990.

Jacobs, Will, and Gerard Jones. *The Comic Book Heroes: From the Silver Age to the Present.* New York: Crown, 1985.

Jones, Gerard. *Men of Tomorrow.* New York: Basic, 2004.

Keefer, Truman Frederick. *Philip Wylie.* Boston: Twayne, 1977.

Lowther, George. *The Adventures of Superman.* Bedford, Mass.: Applewood, 1995.

Mamet, David. *Some Freaks.* New York: Penguin, 1989.

McCabe, Joseph. "Speeding Bullets and Changing Lanes." In Yeffeth, *Man from Krypton*, 161–74.

McLuhan, Marshall. "From the Mechanical Bride: Folklore of Industrial Man." In Heer and Worcester, *Arguing Comics*, 102–6.

Mietkiewicz, Henry. "When Superman Worked at the Star." *Toronto Star*, April 26, 1992. http://members.tripod.com/~davidschutz/superman3.html.

Morris, Tom, and Matt Morris, eds. *Superheroes and Philosophy: Truth, Justice, and the Socratic Way*. Chicago: Open Court, 2005.

Morrow, Lance. "Society." *Time Annual 1992: The Year in Review*, 134–35. New York: Time, 1993.

Murray, Will. "Superman's Editor, Mort Weisinger." *The Krypton Companion*, ed. Michael Eury, 8–11. Raleigh, N.C.: TwoMorrows, 2006.

Niven, Larry. "Man of Steel, Woman of Kleenex." In Yeffeth, *Man from Krypton*, 51–58.

O'Neil, Dennis. "The Man of Steel and Me." In Dooley and Engle, *Superman at Fifty*, 46–59.

Rossen, Jake. *Superman vs. Hollywood: How Fiendish Producers, Devious Directors, and Warring Writers Grounded an American Icon*. Chicago: Chicago Review Press, 2008.

Schumer, Arlen. *The Silver Age of Comic Book Art*. Portland, Ore.: Collectors, 2003.

Schwartz, Alvin. *An Unlikely Prophet: Revelations on the Path Without Form*. Denver: Divina, 1997.

Schwartz, Julius. *Man of Two Worlds: My Life in Science Fiction and Comics*. New York: HarperEntertainment, 2000.

Scivally, Bruce. *Superman on Film, Television, Radio, and Broadway*. Jefferson, N.C.: McFarland, 2008.

Scott, A. O. "The Sun Rises, Again, in the West." *New York Times*, June 11 2006. http://query.nytimes.com/gst/fullpage.html?res=9A04EED81431F932A257 55C0A9609C8B63.

Siegel, Jerry. "Superman's Originator Puts 'Curse' on Superman Movie," "The Victimization of Superman's Originators, Jerry Siegel and Joe Schuster . . ." Press release [October 1975]. Posted, with an introduction, as "Jerry Siegel's 1975 Press Release" by Mike Catron at http://homepage.mac.com/ mikecatron/.Pictures/SiegelPR1975wm.pdf.

Steranko, James. *The Steranko History of Comics*. Reading, Pa.: Supergraphics, 1970.

Sulcas, Roslyn. "Reflections on Baryshnikov's Latest (Not Last) Legs." *New*

York Times, June 22 2007. http://www.newyorktimes.com/2007/06/22/arts/dance/22hell.html?_r=1&pagewanted=print.

Swan, Curt. "Drawing Superman." In Dooley and Engle, *Superman at Fifty*, 37–45.

Tollin, Anthony. *Smithsonian Historical Performances: Superman on the Radio.* Schiller Park, Ill.: Radio Spirits/Smithsonian Institution Press, 1997.

Trexler, Jeff. "Russell Keaton, Superman's Fifth Beatle." Newsarama.com, August 20, 2008. http://blog.newsarama.com/2008/08/20/russell-keaton-supermans-fifth-beatle/.

Vance, James. "A Job for Superman." *Superman: The Dailies, 1939–1940*, vol. 1, ed. Peter Poplaski, Dave Shriner, and Christopher Couch, 6–11. Northampton, Mass.: Kitchen Sink, 1998.

———. "Superman Goes Hollywood." *Superman: The Dailies, 1941–1942*, vol. 3, ed. Peter Poplaski, Dave Shriner, and Christopher Couch, 7–14. Northampton, Mass.: Kitchen Sink, 1998.

Voger, Mark. *Hero Gets Girl: The Life and Art of Kurt Schaffenberger.* Raleigh, N.C.: TwoMorrows, 2003.

Waid, Mark. Introduction to *Superman in the Sixties*, 6–9. New York: DC Comics, 1999.

———. "The Real Truth About Superman: And the Rest of Us Too." In Morris and Morris, *Superheroes and Philosophy*, 3–10.

Walker, Brian. *The Comics Before 1945.* New York: Abrams, 2004.

Weisinger, Mort. "I Flew with Superman. *Parade*, October 23, 1977, 10, 12. Posted by Mike Catron at http://homepage.mac.com/mikecatron/.Pictures/Parade%20Weisinger/Weisinger-Parade-Superman01.jpg, http://homepage.mac.com/mikecatron/.Pictures/Parade%20Weisinger/Weisinger-Parade-Superman02.jpg.

White, Ted. "The Spawn of M. C. Gaines." *All in Color for a Dime*, ed. Dick Lupoff and Don Thompson, 17–39. New York: Ace, 1970.

Wooley, Lynn. "'Twixt Joe and Kurt: The Art of Wayne Boring and Stan Kaye." *Comic Book Marketplace*, September–October 1998, 26–29.

Wright, Bradford W. *Comic Book Nation: The Transformation of Youth Culture in America.* Baltimore: Johns Hopkins University Press, 2003.

Wylie, Philip. *Gladiator.* New York: Shakespeare, 1930.

Yeffeth, Glenn, ed. *The Man from Krypton.* Dallas: Benbella, 2006.

Yoe, Craig. *Secret Identity: The Fetish Art of Superman's Co-Creator Joe Shuster.* New York: Abrams Comic Arts, 2009.

Zeno, Eddy. *Curt Swan: A Life in Comics.* Lebanon, N.J.: Vanguard, 2002.

Index

Index